AFGHANISTAN
ON THE BOUNCE

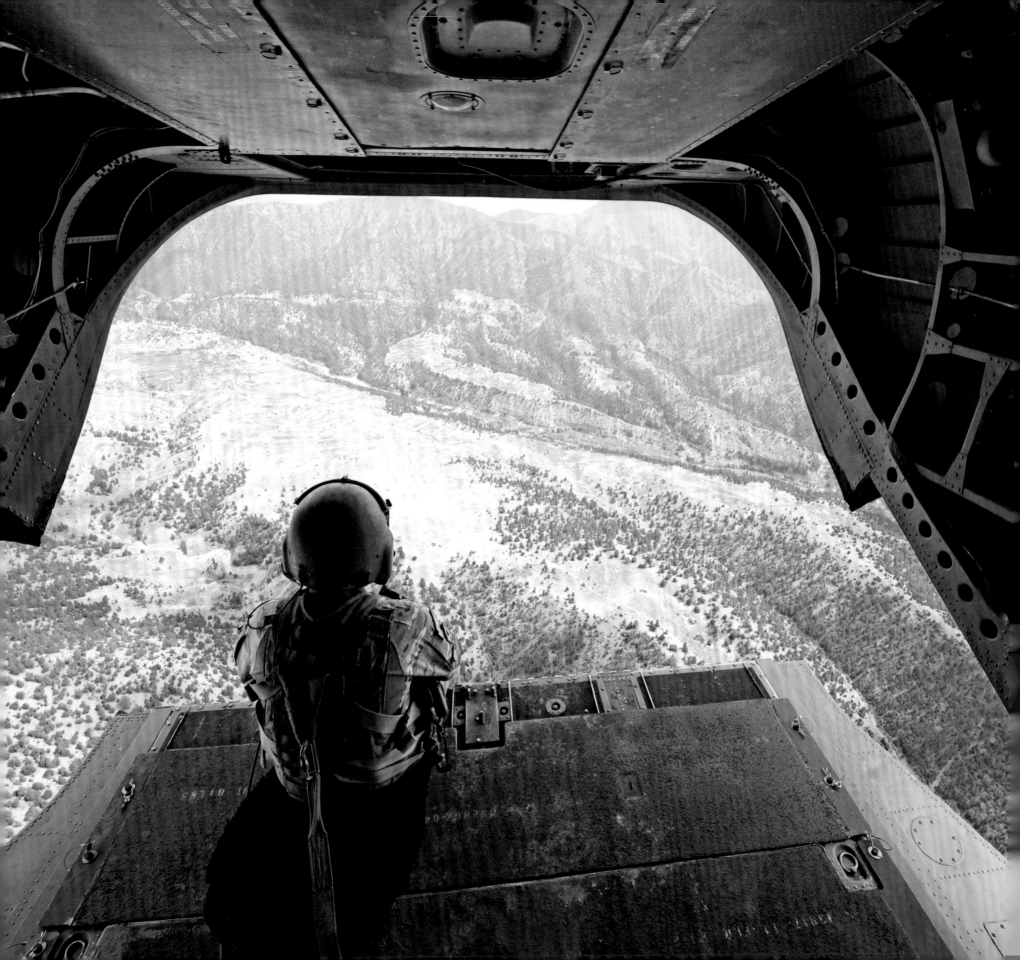

AFGHANISTAN
ON THE BOUNCE

BY ROBERT L. CUNNINGHAM
WITH STEVEN HARTOV

Library of Congress Cataloging-in-Publication Data
ISBN: 978-1-60887-218-3

Manufactured in Hong Kong by Insight Editions
www.insighteditions.com

10 9 8 7 6 5 4 3 2 1

Contents

1

WARNO

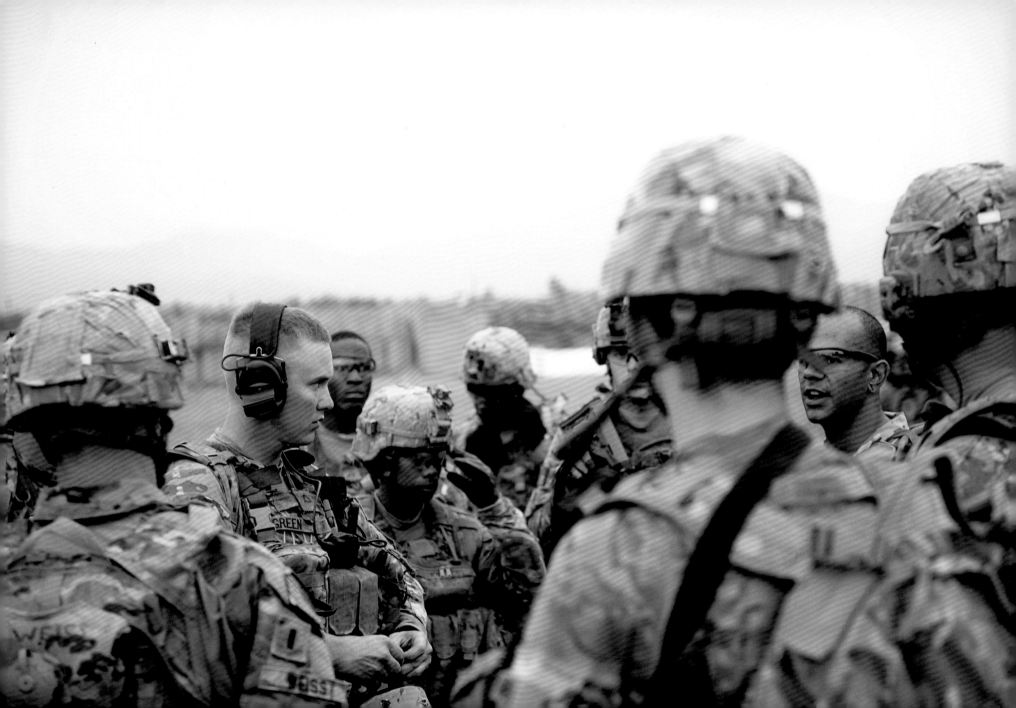

WARNO

Definition (DOD, NATO): Warning Order (*noun*) 1. A preliminary notice of an order or action that is to follow.

I am the luckiest man alive. I am not a soldier, but I've had the privilege of living with our men and women at arms and witnessing their courage and dedication. I have been welcomed by those heroes as a brother, though I've sometimes been thought of as crazy for bringing a camera to a gunfight.

In August 2011, I stepped off a plane for my first foray into Afghanistan. My family had been in the defense industry for decades, and I'd been raised at the feet of this nation's finest warriors. Having been so blessed, and armed with only my knowledge and a Nikon, I sought a way to honor those who would lay down their lives for our country, and I was prepared to lay down mine next to theirs if need be. Acceptance, at first, wasn't easy. As in all combat environments, an individual has to prove himself. However, as time passed, and the warriors who had agreed to host me understood the intent of my mission, I became another grunt on the line. This is not the kind of acceptance you can buy, and it is now my most precious possession.

Over the course of two years and multiple tours downrange, I traveled aboard more than one hundred military aircraft and vehicles, from Bagram to Herrera, from Kandahar to Shindand. I was hosted at multiple forward operating bases and more than twenty-two combat outposts, and I spent many nights "outside the wire" sharing a rock for a bed and waiting to be hit. During 132 combat missions, my guides were US Army soldiers, US Air Force pararescuemen, special operations forces, US Navy explosives experts, US Marine Corps infantrymen, military working dogs, and Afghan officials and civilians, to name a few. The people I was with were much more than objects of my curiosity. They were my protectors, and I was their witness.

On the following pages, my intent is to give you a sense of the warriors, weapons, and wonders of Afghanistan that I saw firsthand, close-up, and personal. It is my hope that when we're done here, you will feel as blessed as I do to have these brave men and women standing atop our battlements of freedom.

But that's enough about me. Let's get on the bounce.

Robert L. Cunningham

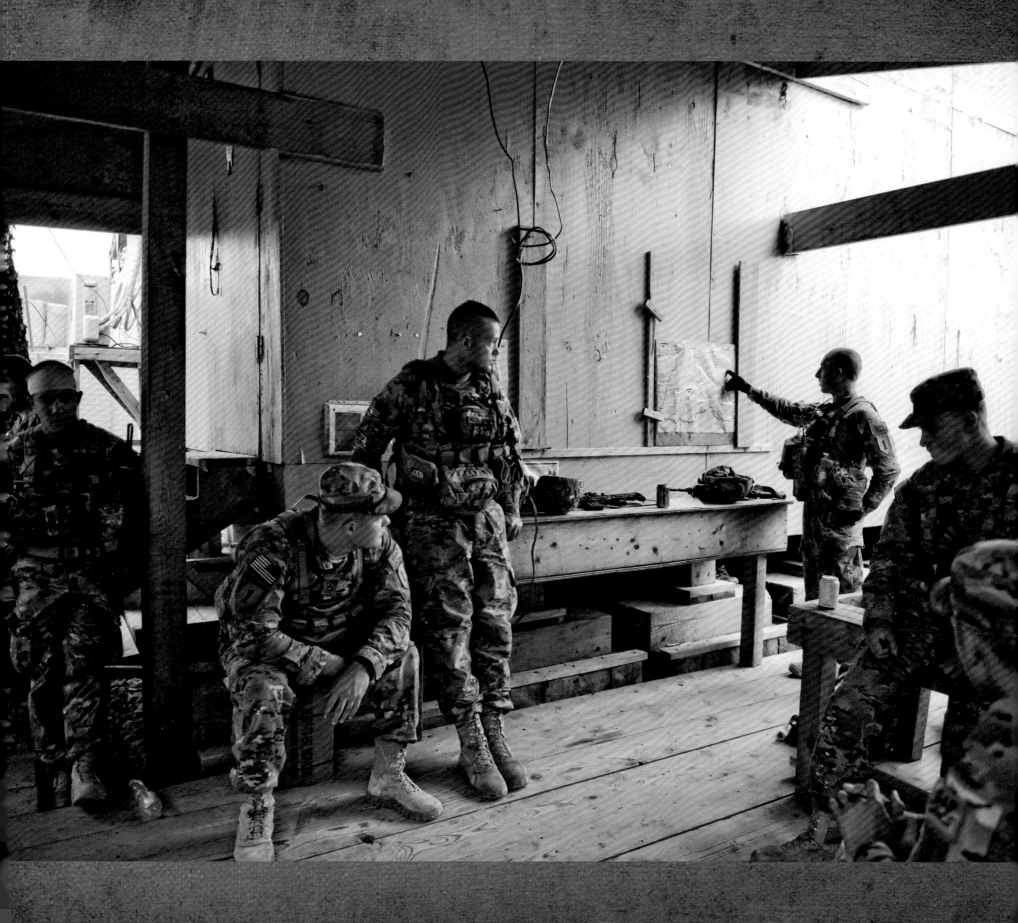

2

TEARS ON THE TARMAC

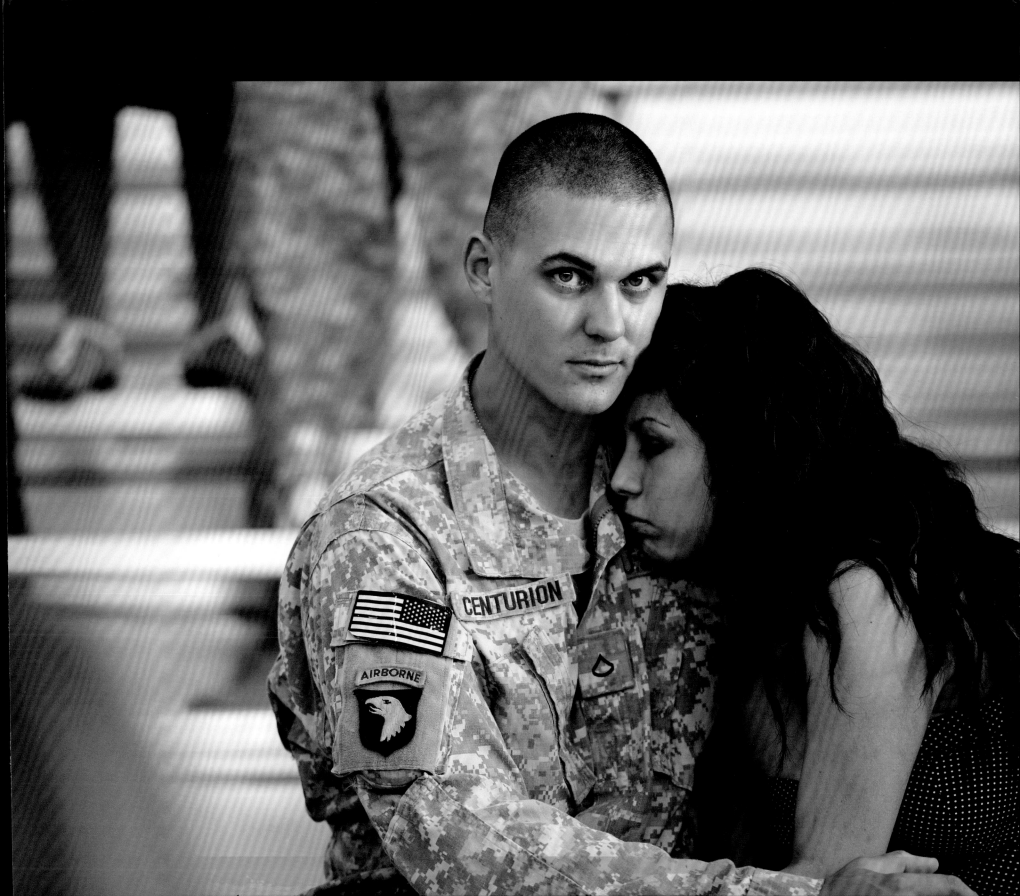

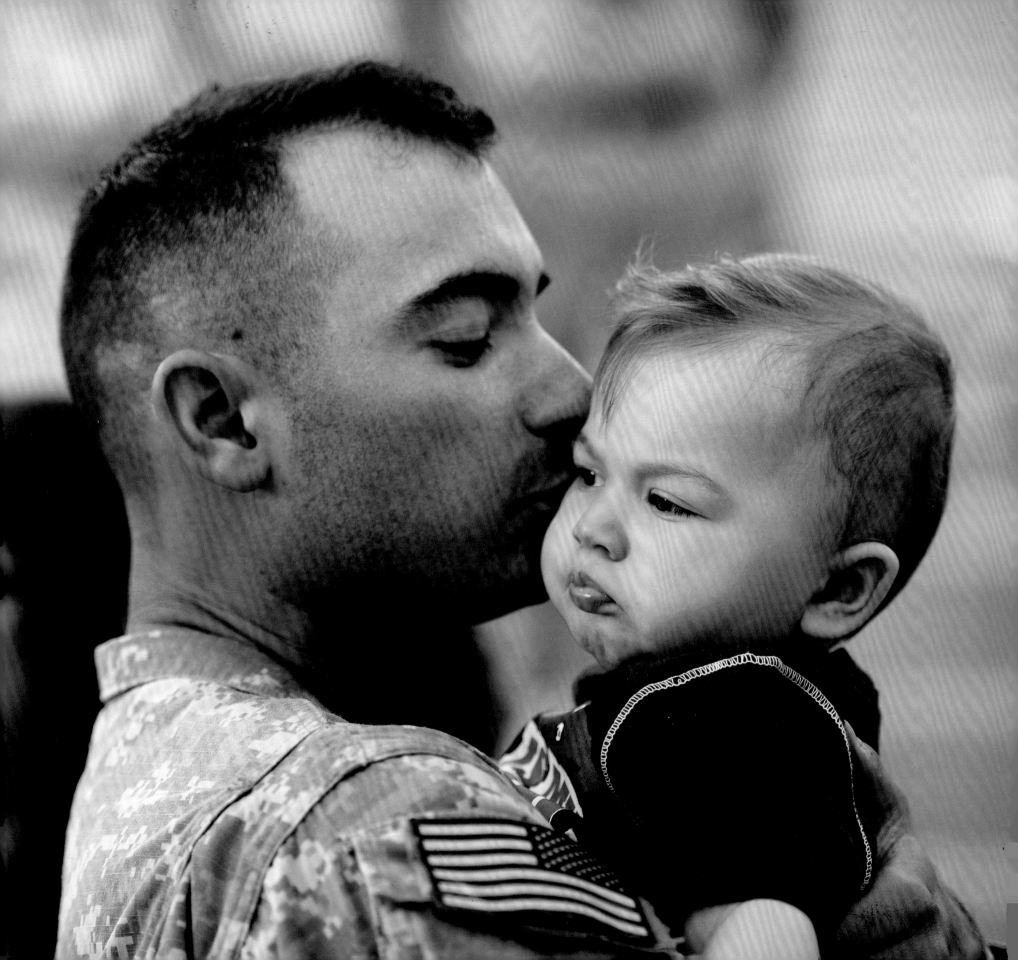

TEARS ON THE TARMAC

The hardest part of deploying is when it's time to roll out,
Families crying left and right while their kids scream and shout.
I kiss my wife and hug my kids and say I'll be home soon,
Tell your friends your daddy's in Afghanistan til June.
—STEPHEN HOBBS, "PRE-DEPLOYMENT"

War is a brutal business. But preparing yourself to leave your home and loved ones, your creature comforts and everyday pleasures, perhaps never to return from some foreign field, is an entirely unnatural event. A soldier trains for this day, prays for it, talks about it endlessly with his comrades-in-arms, and then suddenly the orders appear and it's real.

There are tons of gear to prepare, weapons to make ready, forms to fill out, medical checkups and vaccinations. And then, whether that soldier is a nineteen-year-old recruit or a combat-seasoned veteran, he or she comes face to face with that stark document—the last will and testament.

Who's going to get my dog and my pickup truck? I've heard I can have my remains turned into a sapphire pendant for my widow to wear. I can't picture my kids playing baseball without me, forever. Who's gonna want a chick with only one leg? What am I doing to my mom?

Everything you do, you know this may be the last time you do it, yet these are things you can't bring up, certainly not to your family or friends. People tell you secrets they never would have told you before because now they think you might die. Words you never expected to hear are whispered in corners at farewell parties. You cherish every moment, every breath, while trying to make damn sure nobody can see that storm inside. You tell yourself that in just six months, or nine, or thirteen, you'll be back. But you know that not everyone comes back alive. And still, above it all, your buddies are depending on you. Failing them is your greatest fear of all, so you lock that smile tight and carry on.

A predeployment soldier's ideals—duty, honor, country—war in his head with that longing to just forget the whole thing and go surfing. But that big fat bird's waiting somewhere on the tarmac, and the path to its steel cavern is a one-way street.

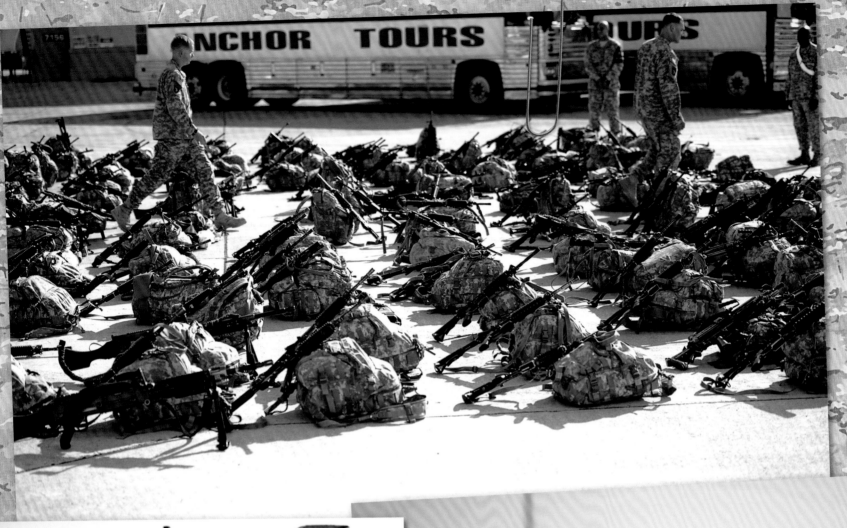

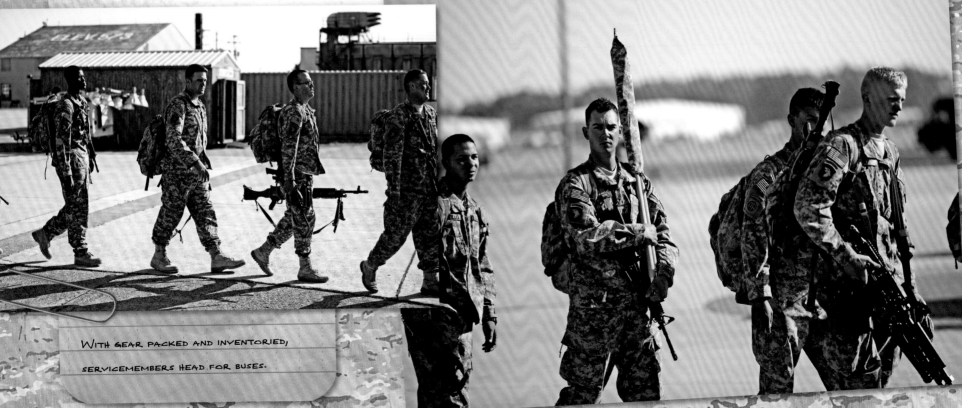

With gear packed and inventoried, servicemembers head for buses.

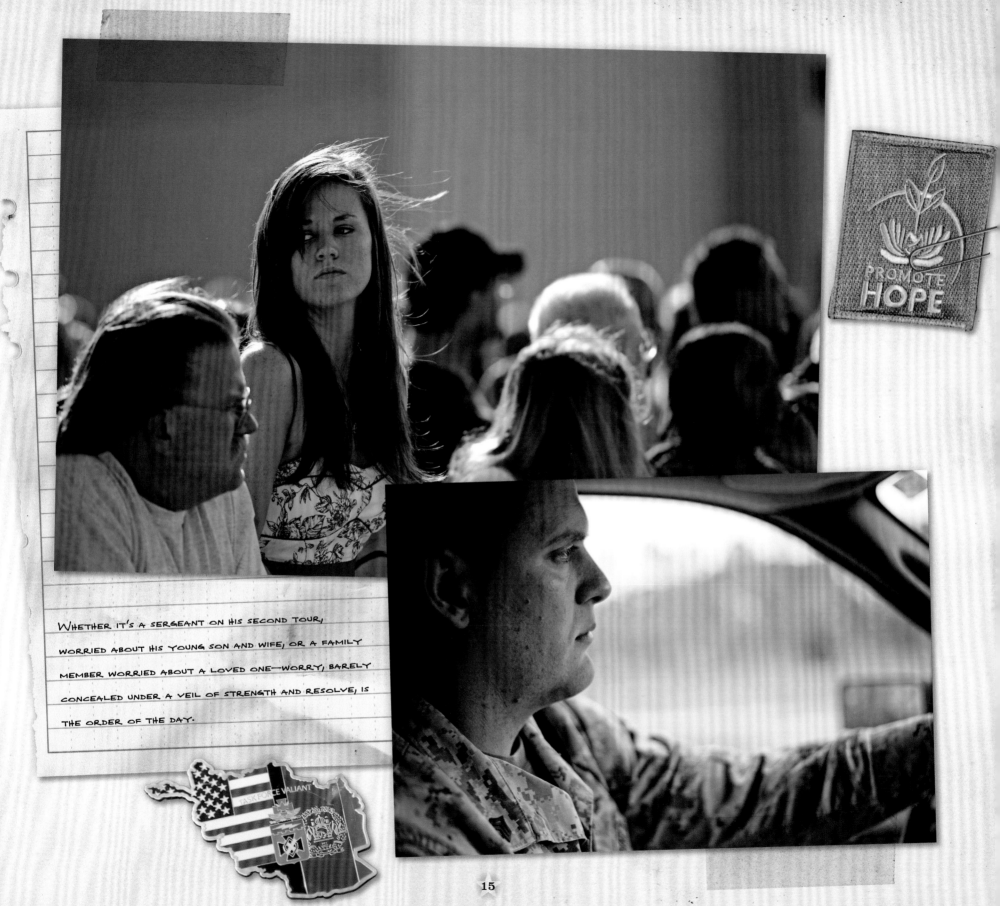

PROMOTE HOPE

Whether it's a sergeant on his second tour, worried about his young son and wife, or a family member worried about a loved one—worry, barely concealed under a veil of strength and resolve, is the order of the day.

TASK FORCE VALIANT

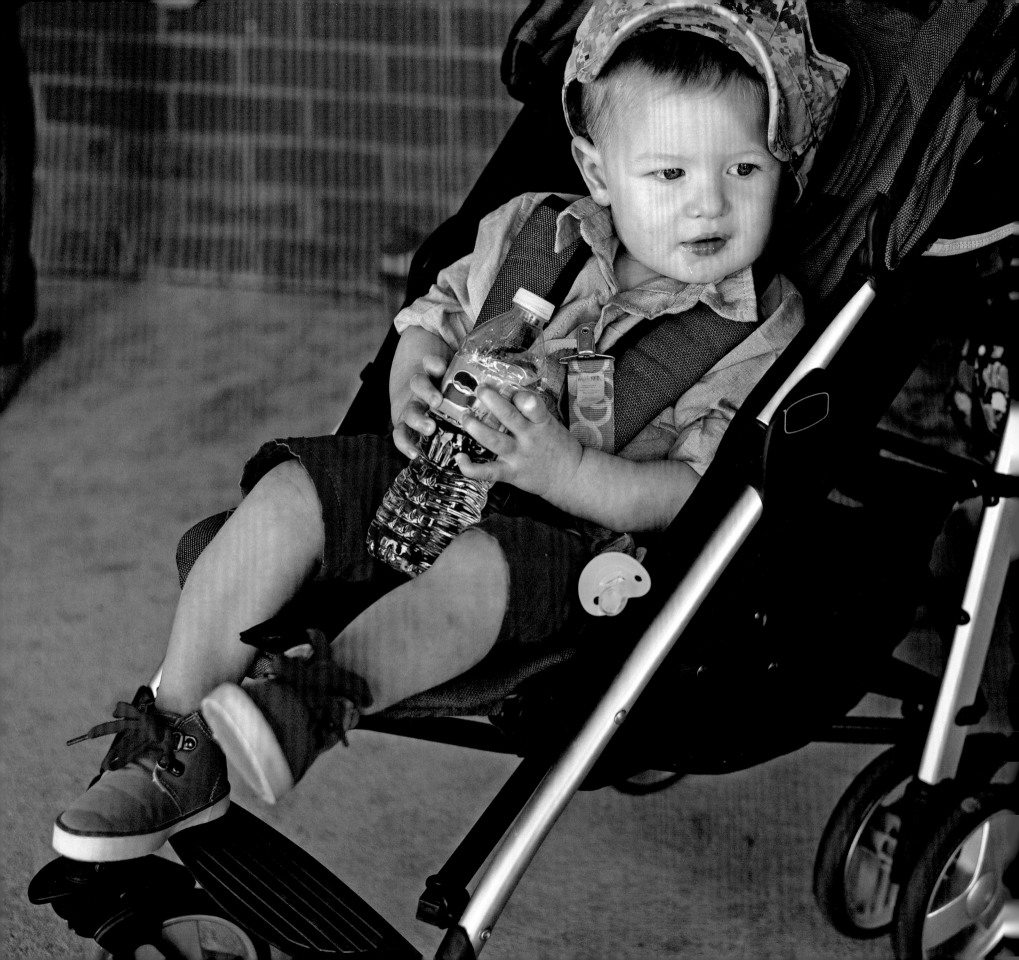

TANK XING

The servicemembers carry a three-day pack and a standard duffel bag. To an outsider, this might look like a weeklong trip. But these troops won't be back in this calendar year.

HELL'S BOX OFFICE

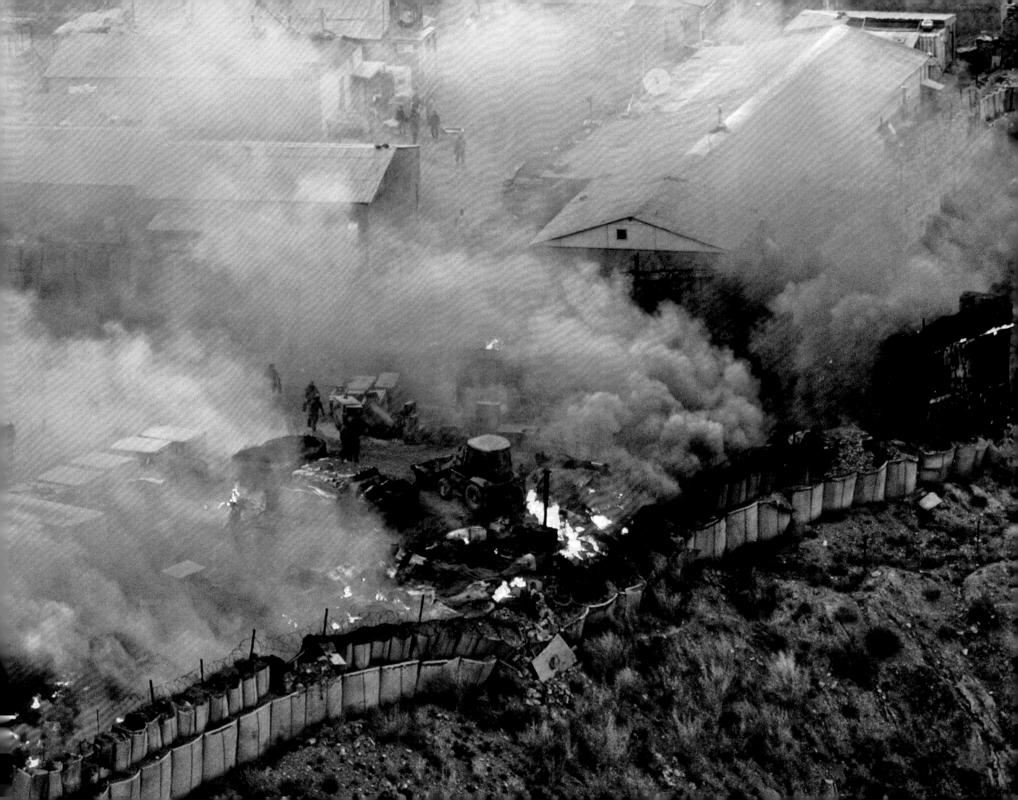

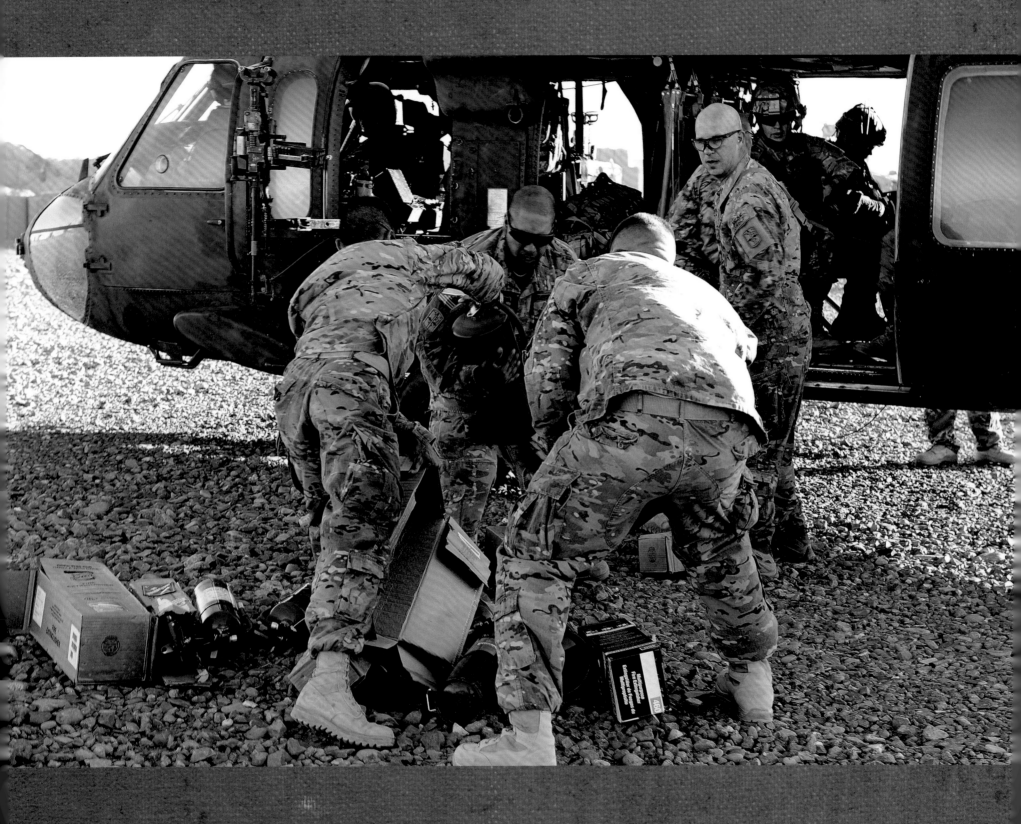

HELL'S BOX OFFICE

You step off that big bird for your first day in-country, and you quickly discover that you're Alice in Wonderland, but you're wearing a Kevlar skirt.

This isn't a mirror image of your own burgers-and-beer culture. The hammering rock music you and your buddies head-bang to is a sacrilege here. Those buxom pinup girls your granddaddies tacked up during World War II are no-go pornography here, so you guys have been warned to keep them on the down-low. If you're a female, wearing pants and hefting an M4 rifle makes you an instant freak in a land where girls are only beginning to be allowed to go to grammar school.

Your combat training has imbued you with the belief that a seventeen-year-old Afghan male is of fighting age and potentially a threat, but he's wearing flowers in his hair and eye makeup and strolling through the marketplace holding his best friend's hand, which doesn't mean anything at all. Meanwhile, that nine-year-old kid who looks so much like your little brother, and has an innocent grin to match, has a Russian grenade in his back pocket.

Then there's the landscape. It's like something out of a science fiction novel, the colder side of Mars. You've been given the impression that the whole of Afghanistan is composed of caves, endless places for the enemy to hide in and then pop out from and kill you. But what you see is dry, gray—enormous piles of boulders and stones and mountains and endless miles of dirt, clay huts, dust, and more dust.

Then you're suddenly on the bounce aboard a helicopter, and you land in an environment so lush, so full of rich green trees and rainbow flora, rushing, clear rivers and lakes and pine-covered peaks, that the only brown thing around is your own boots, and you wouldn't be surprised if Frodo Baggins popped out of a hut and said, "Welcome!"

You've just bought a ticket to the weirdest, deadliest show on Earth.

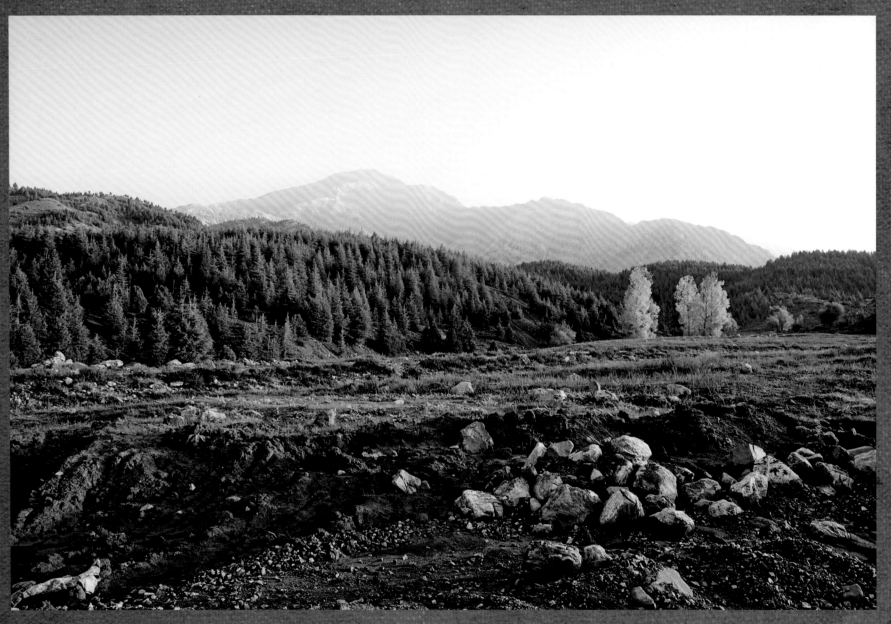

That clichéd description "a cruel beauty" might be overused, but damn, here it is.

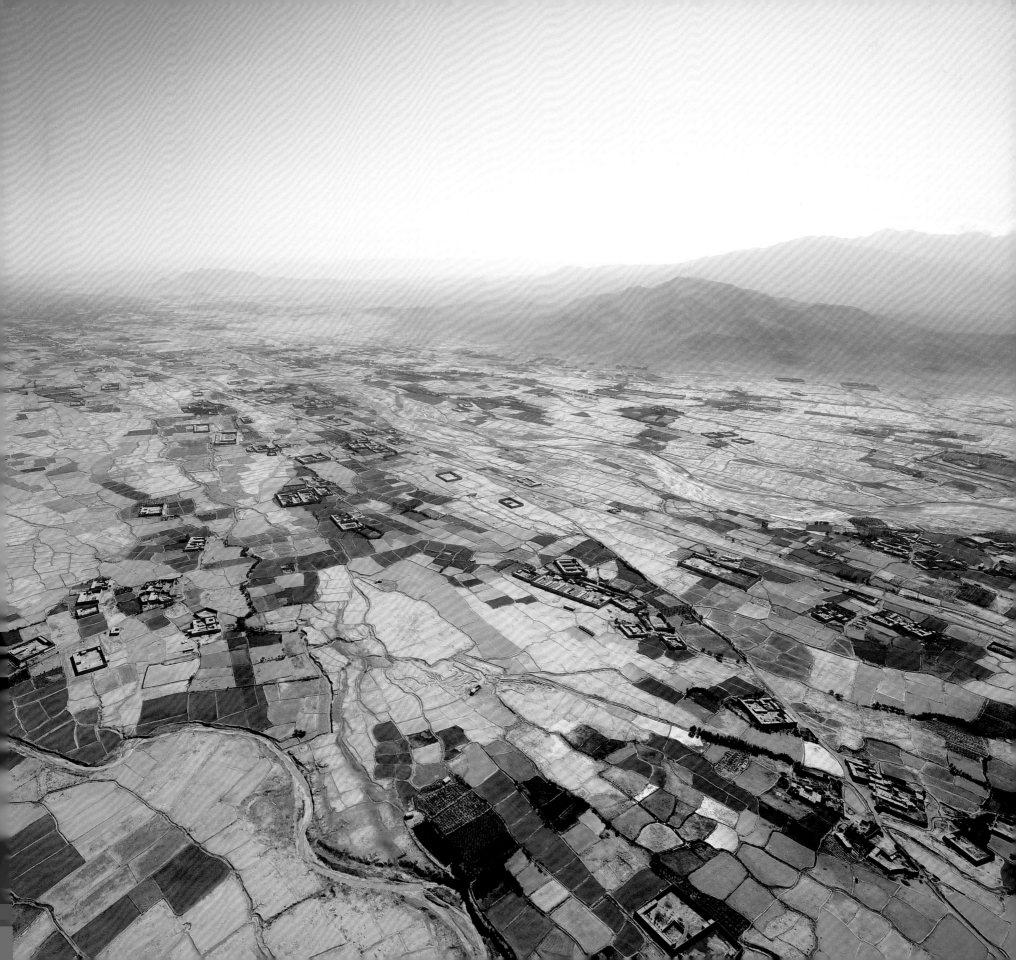

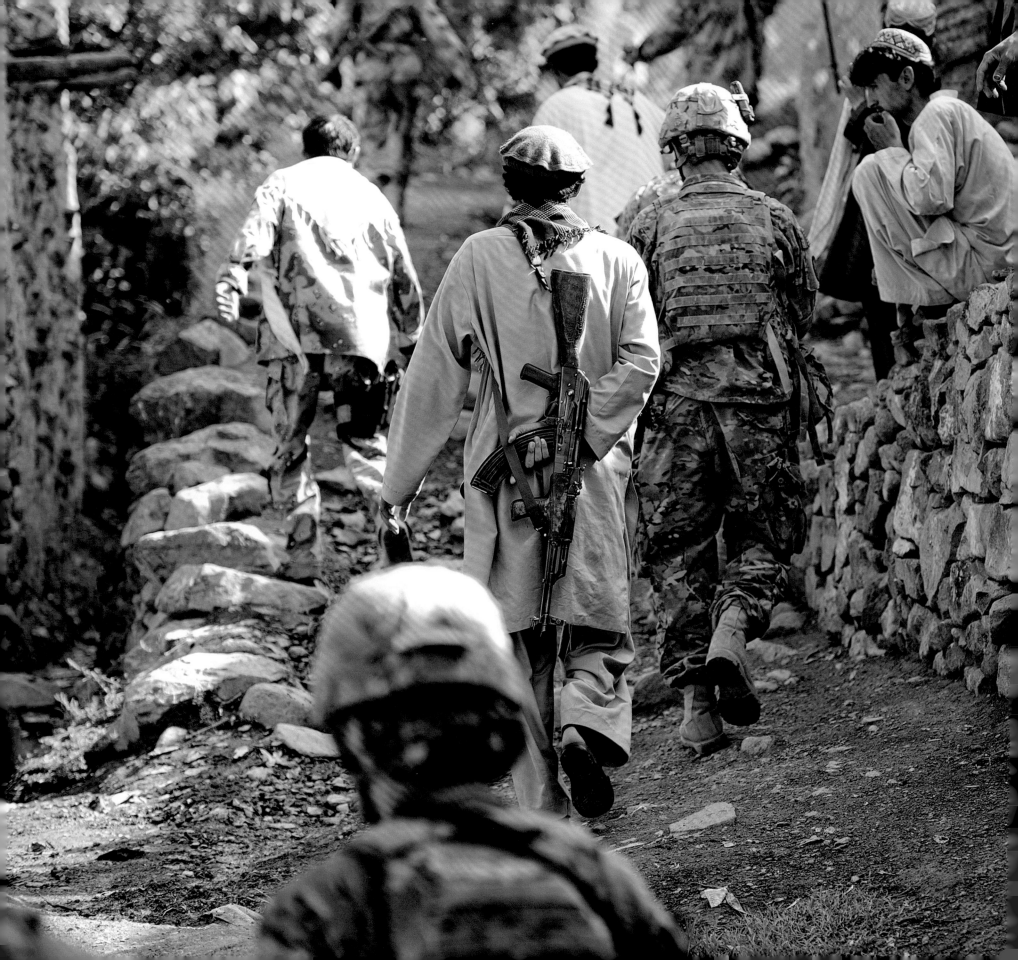

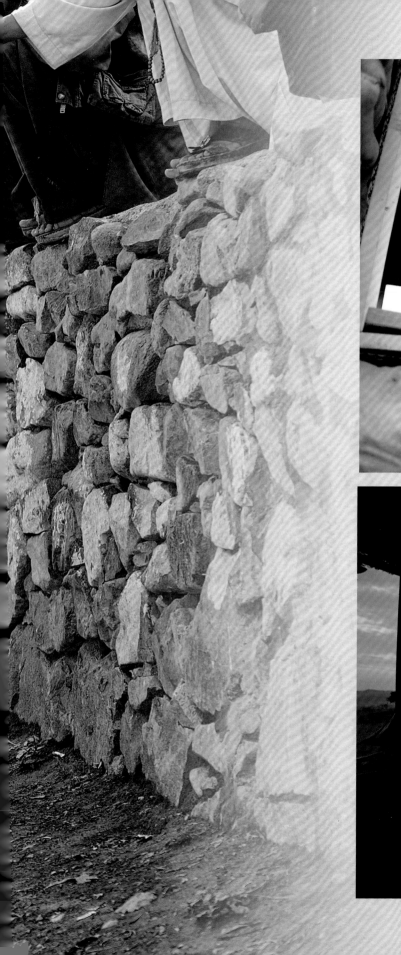

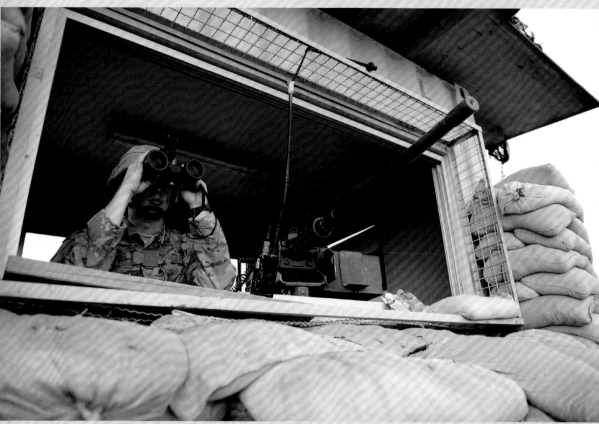

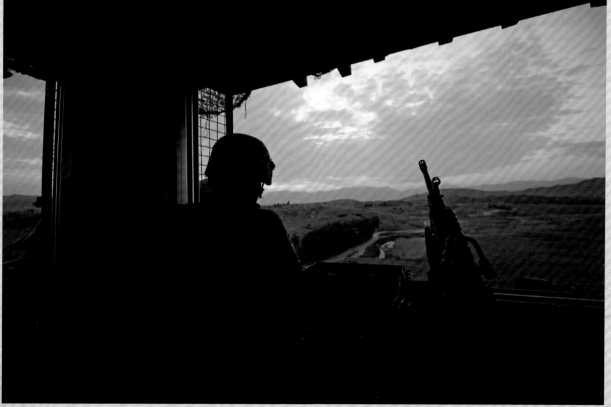

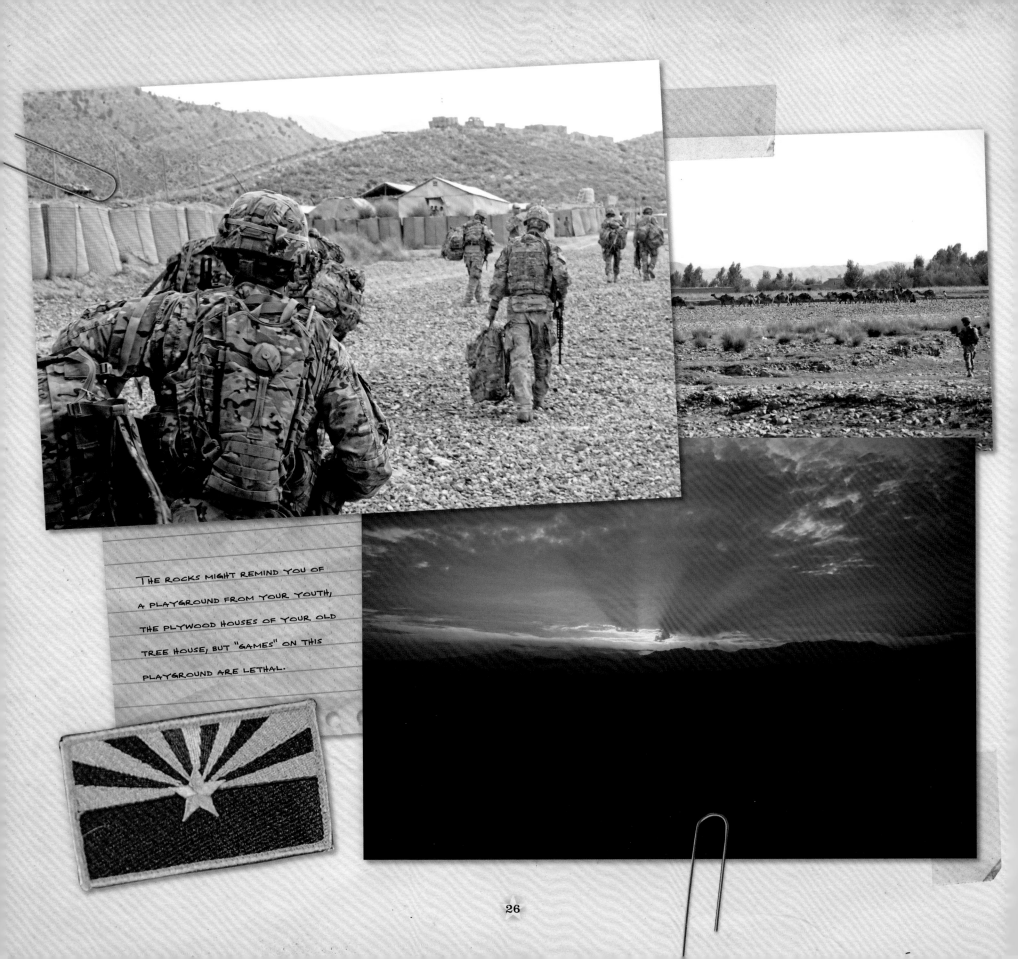

The rocks might remind you of a playground from your youth, the plywood houses of your old tree house, but "games" on this playground are lethal.

American servicemembers wear the "reversed" flag on their right shoulder. When viewed from the right, this is how a flag on a pole looks while it is blowing in the wind. The same flag appears on Air Force One's right side.

4

MISSION ESSENTIAL GEAR

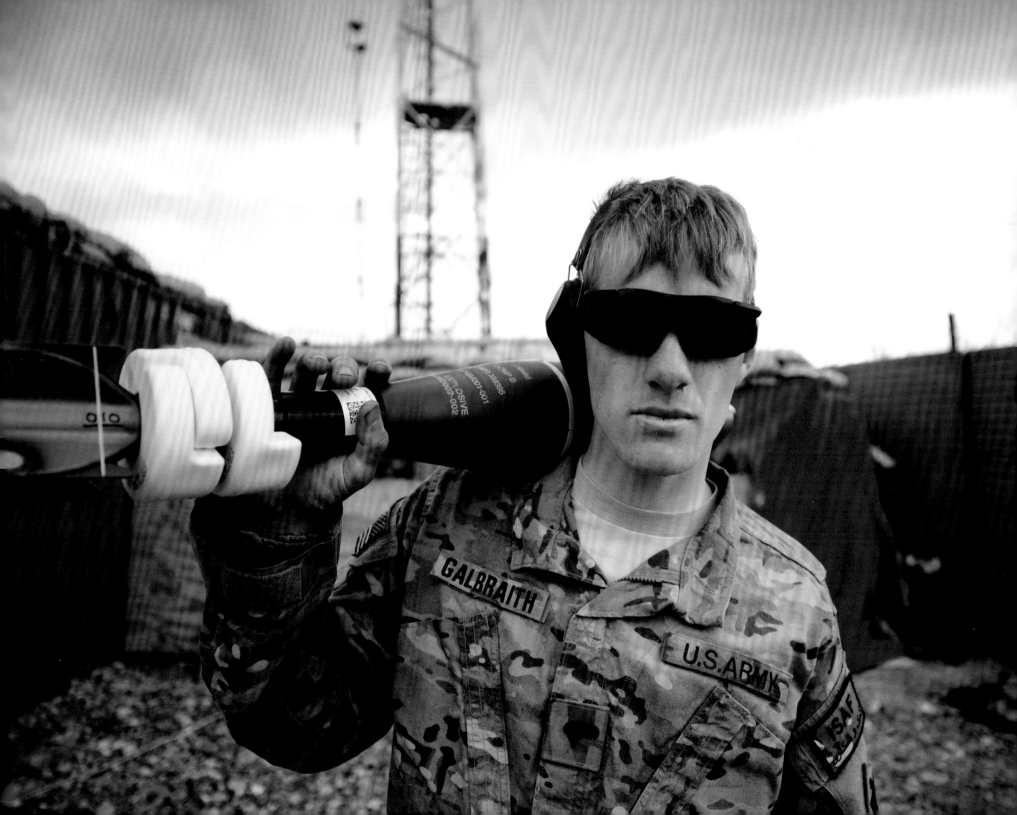

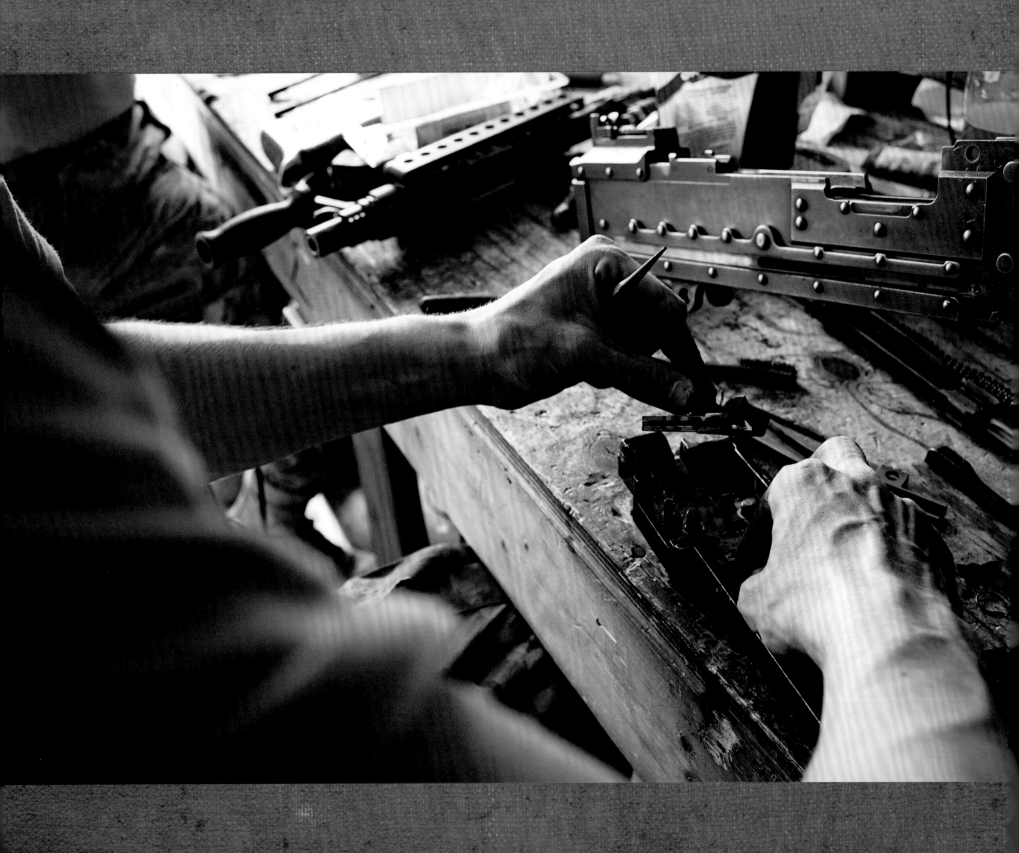

MISSION ESSENTIAL GEAR

"Take care of your shit and your shit will take care of you."

—JUST ABOUT EVERY DRILL INSTRUCTOR IN HISTORY . . .

Most civilians go to work each day wearing an appropriate set of clothing and carrying their tools of the trade. You've got some decent dress shoes and maybe a skirt and earrings or, perhaps, slacks, a button-down, and a clean shave. Your backpack or briefcase contains your job-related files, your iPad or laptop, notebooks, and pens and pencils, and the only thing clipped to your hip is your favorite smartphone. Maybe the total weight of all your office gear is ten pounds, and unless you're secretly a ninja or Jason Bourne, you're not going to kill anybody with that stuff.

Here, though, the things you wear and carry are the things that are going to save your life, and they weigh half again as much as you do. Your boots are thick and high; your uniform is coarse; a load-bearing vest filled front and back with ballistic armor sits on your rib cage like a fat boa constrictor.

Your pouches contain magazines with nearly 200 rounds of ammunition, hand grenades, illumination sticks, a GPS, a tourniquet, medical survival gear, a combat knife, and a two-way radio, and topping it all off is a Kevlar helmet strapped to your skull like a five-pound tortoise shell. In your grit-lined fingers is a military close-quarters battle rifle. It's a machine gun, and it's further weighed down with tactical flashlights, night and day sights, and maybe a grenade launcher.

You know where every single item is at all times. You keep them all in perfect working order, and not just for yourself. If you're killed in action, your best friend might have to use your stuff to save his own life.

Maybe a mere few months ago you were slogging through your last year of high school, carrying your backpack and your books and itching to get your graduation tassel. Maybe you barely remember the events of September 11, 2001 (after all, you were only in sixth grade). But now you're a soldier. This is your mission essential shit, and you're going to be carrying it for a long, long time.

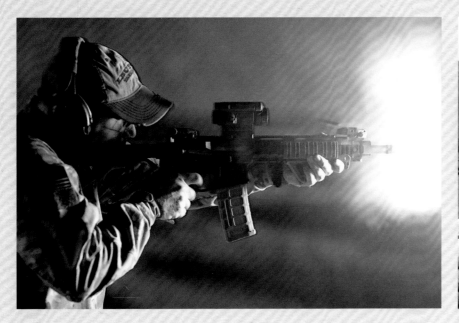

The M4 carbine is the primary weapon used by the modern US military. This is the descendant of the M16 and fires a 5.56 mm round.

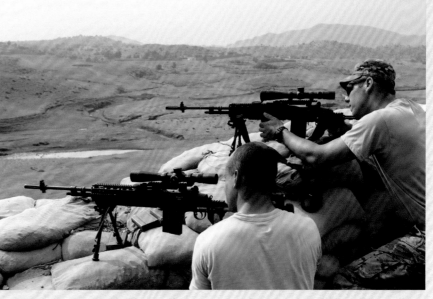

The M14 Enhanced Battle Rifle (EBR) is the descendant of the M14 rifle and fires a 7.62 mm round. This rifle's primary purpose is to provide the designated marksman with increased accuracy, knock-down power, and reach.

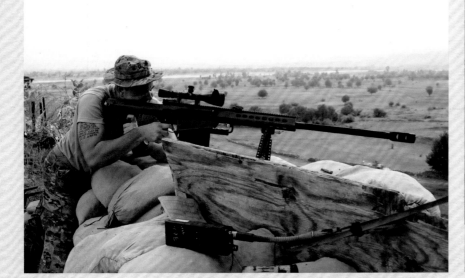

The Barrett M107 anti-materiel, anti-personnel Long Range Sniper Rifle (LRSR) fires a .50-caliber (12.7 mm) round. Also pictured is a Thales AN/PRC-148 MBITR radio, the primary personal radio in use by the military.

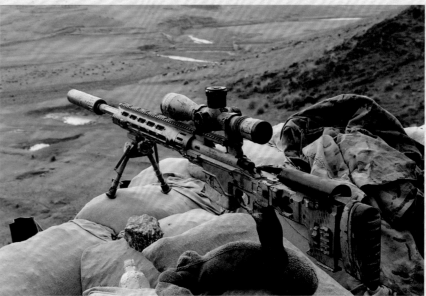

The XM2010 Enhanced Sniper Rifle fires a .300 Win Mag round. This model has a sound and flash suppressor to help conceal the sniper's location.

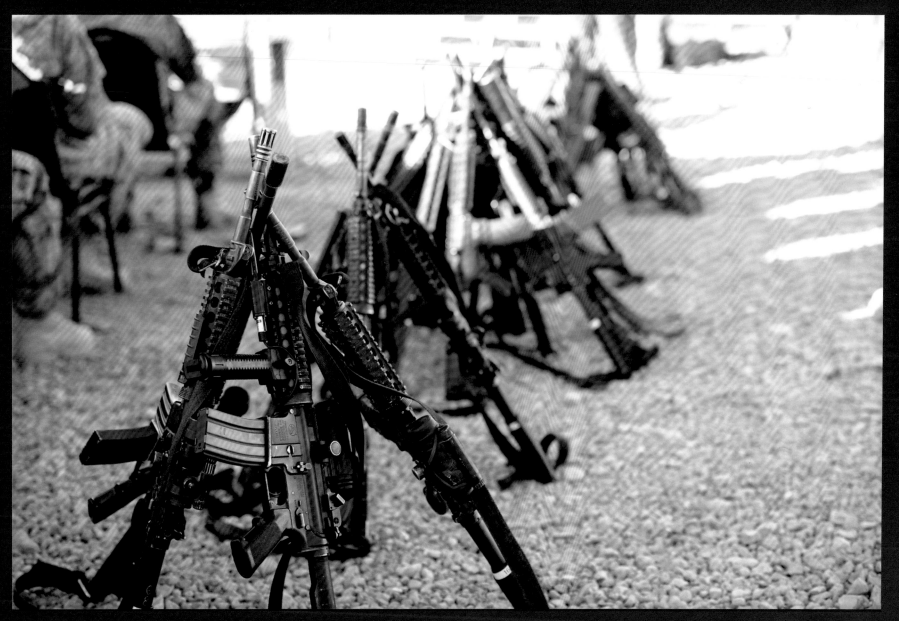

The requirement to carry your weapon with you at all times often leads to new and inventive ways of storing it.

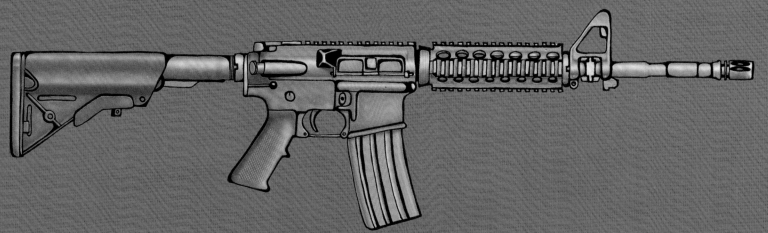

SOPMOD
Special Operations Peculiar Modification
ACCESSORY KIT

...SPECIAL

FLEXIBILITY WITH THEIR GEAR
SELECTION, FROM THIS OPS-
CORE FAST HELMET TO THIS
CAMOUFLAGED M203 TO THE PLATE
CARRIER OF THIS US AIR FORCE
PARARESCUE JUMPER.

AIRBORNE

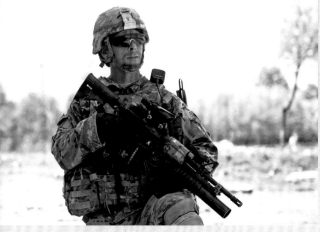

The M203 is a single-shot 40 mm grenade launcher that mounts under the barrel and foregrip of the M16 and M4.

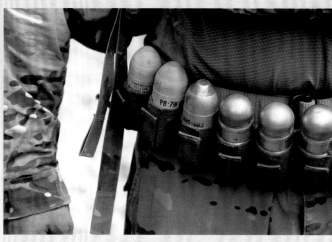

The M203 has multiple forms of 40 mm ammunition. Seen here are two M716 yellow smoke ground markers, one M715 green smoke ground marker, and three M433 high-explosive dual-purpose cartridges.

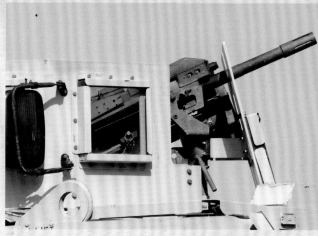

The MK19 is a belt-fed 40 mm fully automatic grenade launcher, capable of firing over forty rounds per minute.

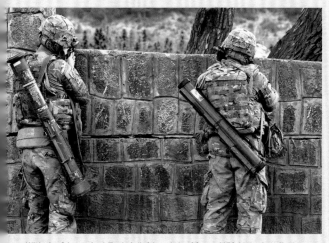

With the 84 mm Anti-Tank 4 (left) and the 66 mm M72 Light Anti-Tank Weapon (right), almost no target is indestructible.

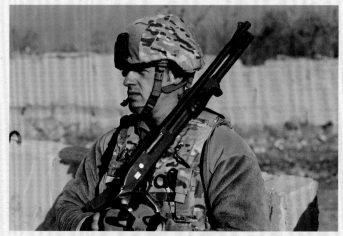

The Remington M870 MCS 12-gauge shotgun has multiple uses. This M870 was loaded with less-than-lethal crowd control rounds.

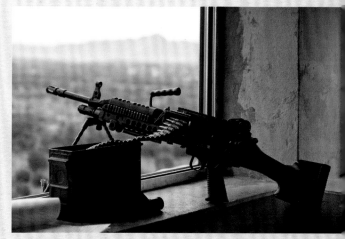

The MK48 is a belt-fed machine gun that fires a 7.62 mm round.

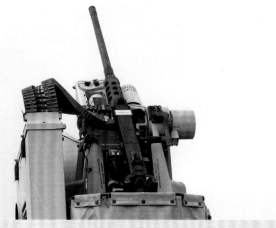

The M2HB is a belt-fed .50-caliber (12.7 mm) machine gun and is the flag-ship of ground vehicle turret weapons. This one is mounted in a remotely controlled turret system called the M153 CROWS.

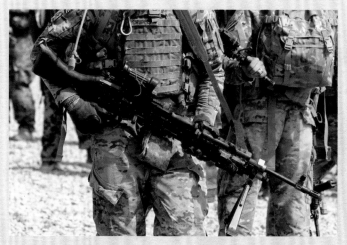

The M240B is a 7.62 mm belt-fed machine gun that is known for its reliable, heavy-hitting firepower and for being used by many NATO countries. The M240 is also commonly mounted on vehicles.

The M120/M121 mortar system is a 120 mm mortar that can hit its target from over four miles away. The M120 fires primarily four types of rounds: high-explosive, illumination, practice, and smoke.

IRON HORSES

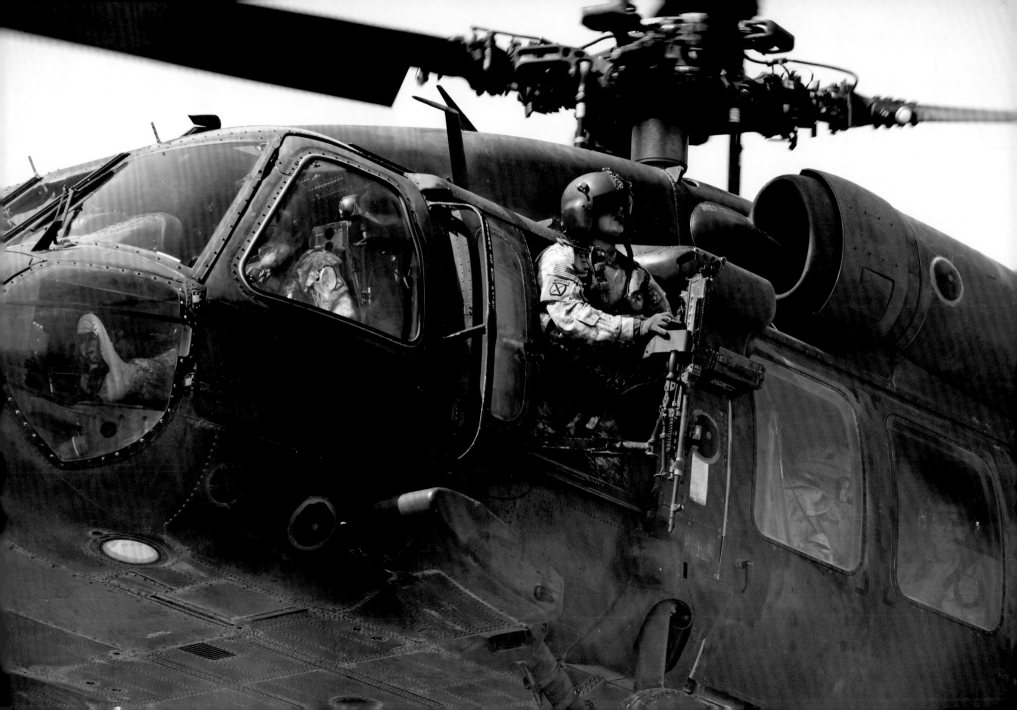

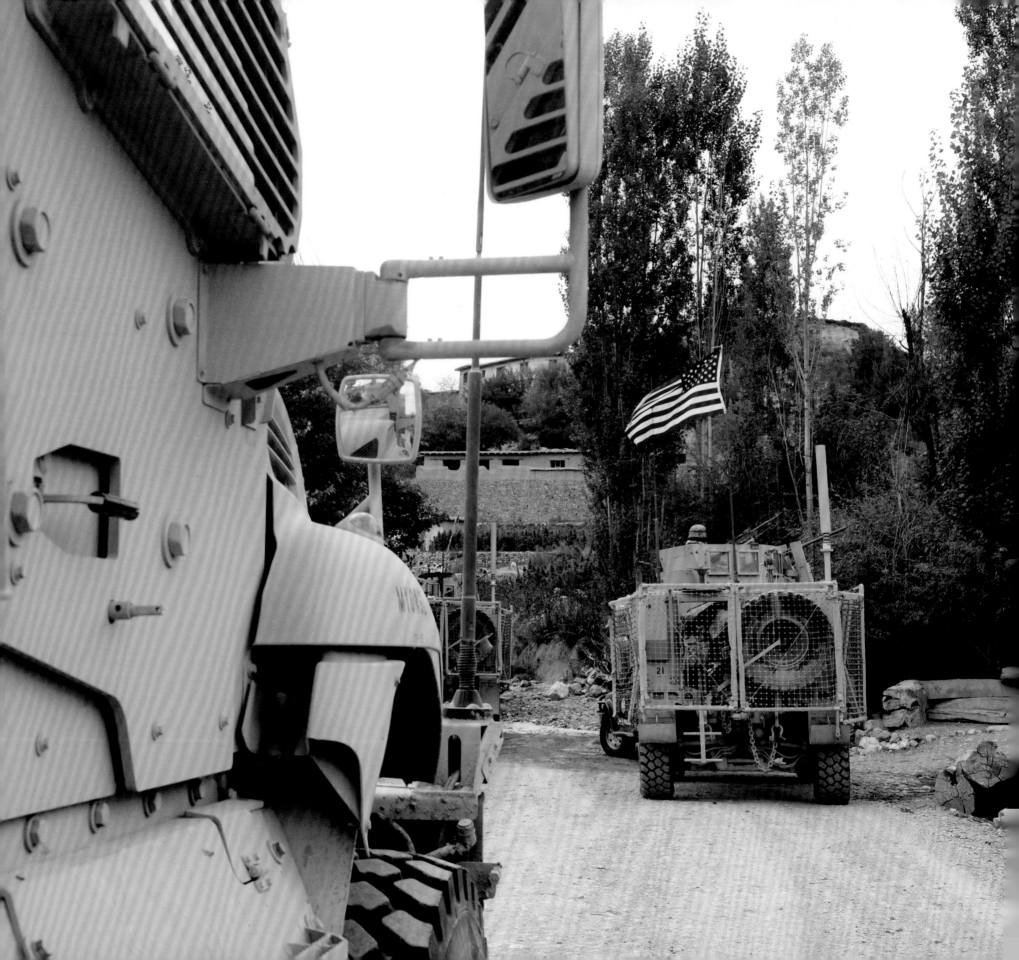

IRON HORSES

Back in the States, a soldier said good-bye to her baby-blue Mustang. It was more than a car; it was an extension of her, how she felt about the world, how she wanted the world to see her. She picked that color and the shape and the feel of it, the way she slid into it and wore it like a lamb-leather glove. It was all about being young and alive, about unbridled exhilaration. Every time she got behind the wheel, it was the first day of summer.

Now, in Afghanistan, all geared up, drenched in sweat, and waddling like an armadillo under sixty pounds of ceramic and steel, she hustles to her new ride, an MRAP. It's a mine-resistant, ambush-protected fourteen-ton monster bristling with antennas; dragonlike armor plates; a whining, motor-driven turret with a .50-caliber machine gun; three-inch-thick windows; a gaping maw with iron stairs for teeth; and an all-enveloping cage designed to detonate enemy rockets before they can kill her and everyone else inside.

She marvels at the size of it. The enormous rubber wheels almost tower above her head. It'll never be pretty, and it'll never go fast, but it's the only way to go anywhere and live to see another day.

If that's not scary enough, that comfy commercial airplane she once flew in to Disney World is now replaced by another metal phoenix. This one has wings of steel and propellers or spinning rotors that, if she's not super careful, will take her head off like a guillotine. This snorting, roaring sky dragon is even bigger than the MRAP, armored from its blunt nose to its knife-blade tail. It's got machine guns jutting from its gills, and when it even *thinks* it's in danger, it actually spews balls of fire. It doesn't matter if it's nighttime or daytime; it still roars across the country too fast and too low, filled with soldiers as fragile as eggshells, some barely able to keep their chow in their stomachs.

The whole purpose of these warhorses is to deliver her intact from one risky part of the country to an even more dangerous one, so she can survive the trip and face the next mortal danger—combat.

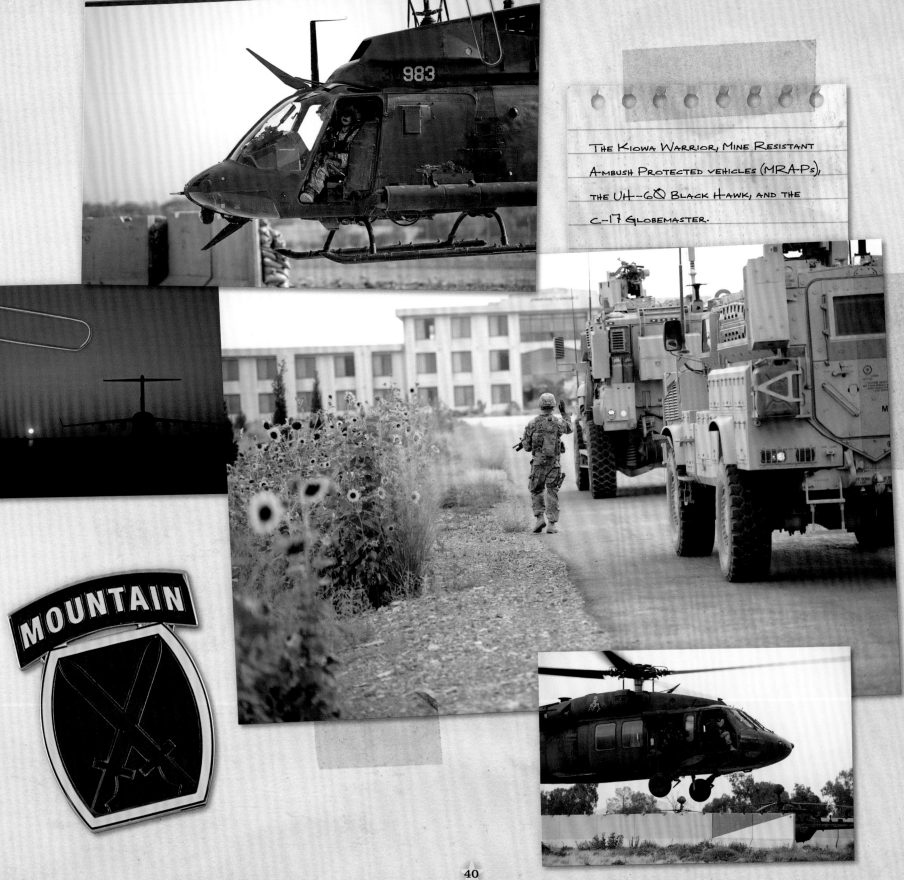

The Kiowa Warrior, Mine Resistant Ambush Protected vehicles (MRA-Ps), the UH-60 Black Hawk, and the C-17 Globemaster.

MOUNTAIN

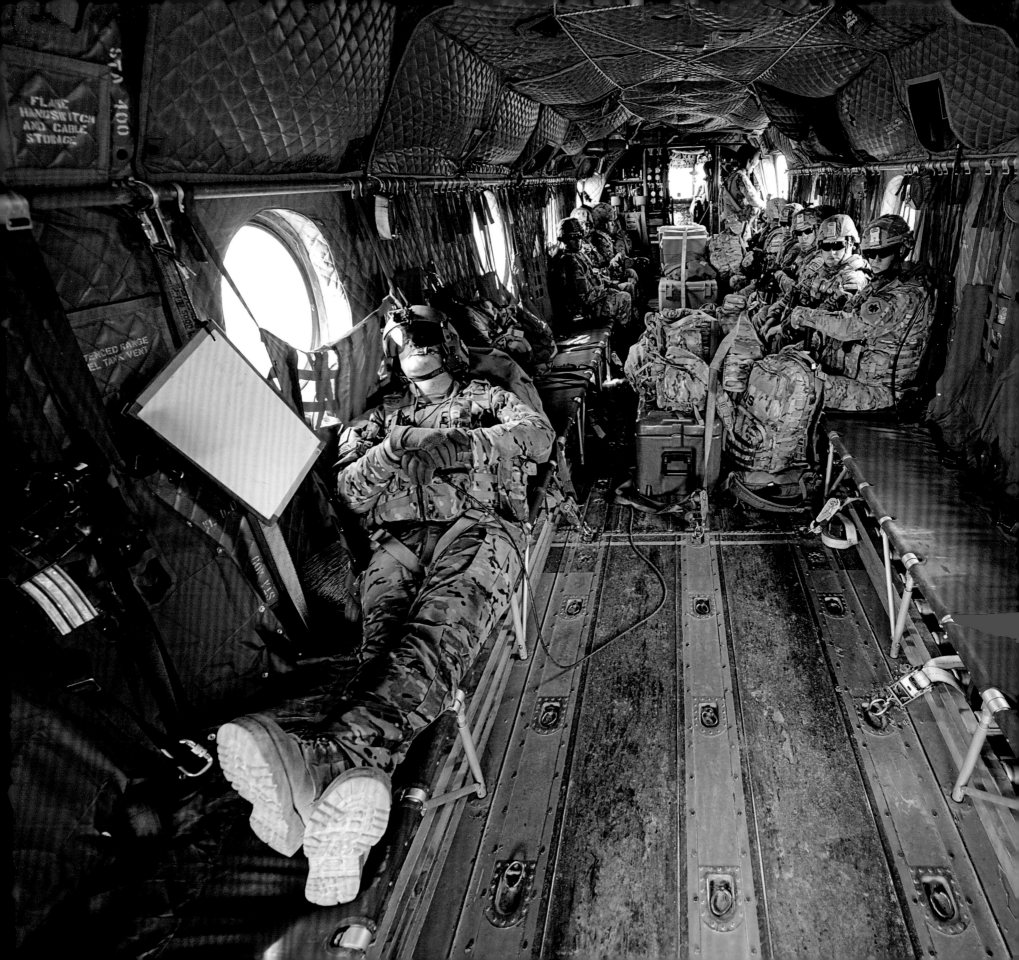

"Keeping Death in the Air" is the slogan of a particular aircraft maintenance unit (A-MU), but it speaks to the importance of the ground crew mission.

The M261 is a 19-tube launcher that fires the Hydra 70 2.8-inch (70 mm) aerial rocket.

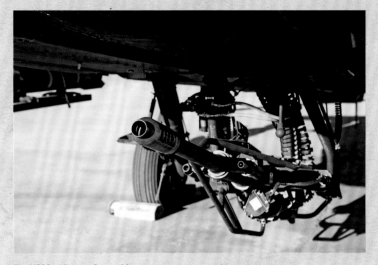
The M230 chain gun fires a 30 mm auto-cannon round.

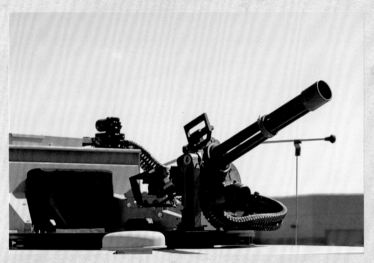
The M134 mini-gun fires 7.62 mm rounds at a rate of more than 60 per second.

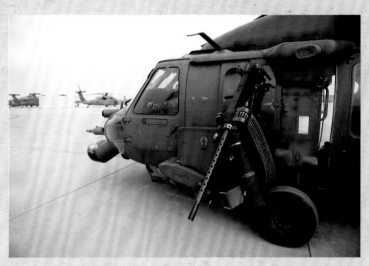
The GAU-18 is a .50-caliber (12.7 mm) machine gun.

The M61 Vulcan Gatling rotary cannon, mounted here on an F-16 fighter jet, fires 20 mm rounds at a rate of 100 per second.

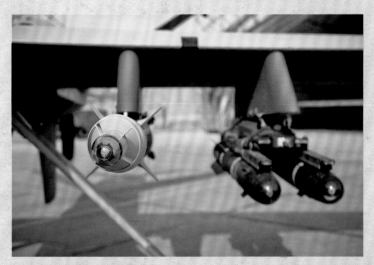
The GBU-12 Paveway II (left) is a 500-pound laser-guided bomb, shown next to the AGM-114 Hellfire, a 100-pound air-to-surface missile.

All weather, all the time. The war
doesn't stop because of the rain.

The combination TADS/IHADSS systems (the "eyeball" on the front of the Apache and the pilot's heads-up display) gives the crew unprecedented knowledge of their surroundings.

Though absent from this particular Apache helicopter, some have a round, pucklike disk mounted on top of the rotor. This "puck" is an AN/APG-78 radar and designates that Apache model as an AH-64D Longbow.

The Apache uses two T700 General Electric engines.

A helicopter's tail rotor works as a counterbalance against the torque that the main rotor engine puts on the aircraft.

"DO be a backseat driver." The Apache has a copilot gunner in the front seat, and the pilot sits in the backseat.

Some Apaches have an internal auxiliary fuel system—the "Combo Pak"—installed. This gives them an additional 45 minutes of flight time, as well as 300 rounds of 30 mm ammo.

The Apache has many radio and data antennas placed throughout the aircraft, and it even has a headphone jack in the tip of the wing so that crew chiefs can speak directly to the crew.

Some helicopters in the military have wheels, like this one, and some have skids, like the Kiowa. Pilots tease each other with comments like "Tricycles are for toddlers" or "Skids are for kids."

The AH-64 Apache, currently made by Boeing, is a four-bladed, heavily armed attack helicopter. The first prototype, the Hughes 77/AH-64A, took flight on September 30, 1975, and was accepted into the army in late 1981. Traditionally, the US Army names all of its helicopter models after Native American tribes. The Apache helicopter was developed after cancellation of the short-lived AH-56 Cheyenne.

The CH-47F uses two Honeywell T-55 engines, producing 4,868 horsepower.

The Chinook uses a three-bladed rotor system. The blades are made of fiberglass. The rotor blades spin at 225 miles per hour.

The Chinook has seating for a staggering forty-four people! And that doesn't include the two pilots.

07-08746

UNITED STATES ARMY

The Chinook has a large loading ramp at the back of the aircraft.

The CH-47F has six wheels. The landing gear is fixed, and if needed the Chinook can be fitted with landing skis for touchdown in snow.

The Chinook has two door gunners.

The Chinook can fly at speeds of more than 175 miles per hour while carrying over 21,000 pounds. The Chinook performs great at high altitudes, where smaller aircraft have problems, and can operate efficiently and effectively well above 10,000 feet.

Mine Resistant Ambush Protected (MRAP) vehicles are armored combat vehicles designed to withstand mines, improvised explosive device (IED) attacks, and ambushes. This bad boy weighs anywhere from 27,500 to 31,000 pounds, depending on the loadout!

This grid is called a Q-NET. This lightweight netting is designed to "catch" a rocket-propelled grenade, stopping it from hitting the vehicle.

The M-ATV uses a 7.2-liter inline-6 Caterpillar C7 turbodiesel with 370 base horsepower.

This "up-armored" turret provides a bulletproof box for a gunner to work from. This turret is replaceable with a CROWS remote-controlled turret that can permit the gunner to work from within the M-ATV.

The M-ATV has 3-foot, 10-inch tires with a solid rubber ring inside that allows the tires to work even if they are shot and deflate.

The strength of the MRAP comes from its V-shaped bottom. This V shape deflects the energy of an IED or land mine sideways rather than directly up into the vehicle.

The Oshkosh M-ATV has four doors and carries five people. There are MRAPs made by other companies that can carry up to twelve people.

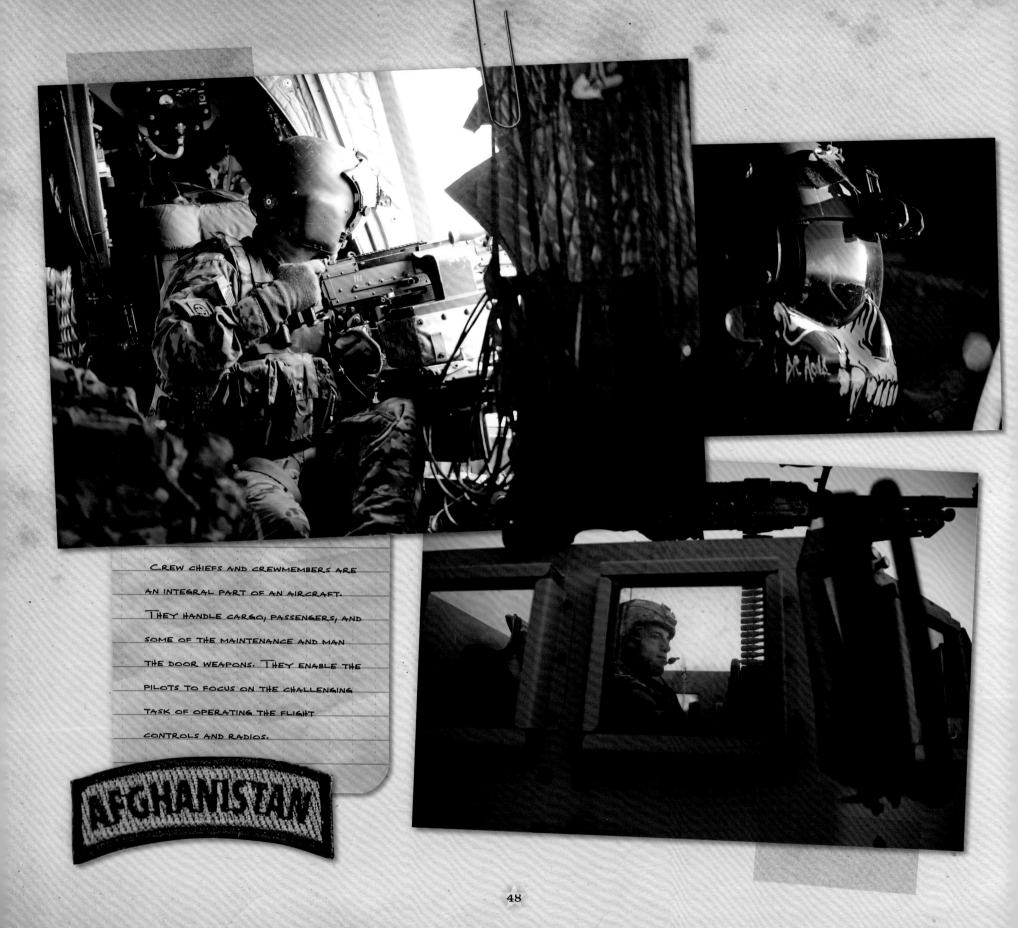

CREW CHIEFS AND CREWMEMBERS ARE
AN INTEGRAL PART OF AN AIRCRAFT.
THEY HANDLE CARGO, PASSENGERS, AND
SOME OF THE MAINTENANCE AND MAN
THE DOOR WEAPONS. THEY ENABLE THE
PILOTS TO FOCUS ON THE CHALLENGING
TASK OF OPERATING THE FLIGHT
CONTROLS AND RADIOS.

AFGHANISTAN

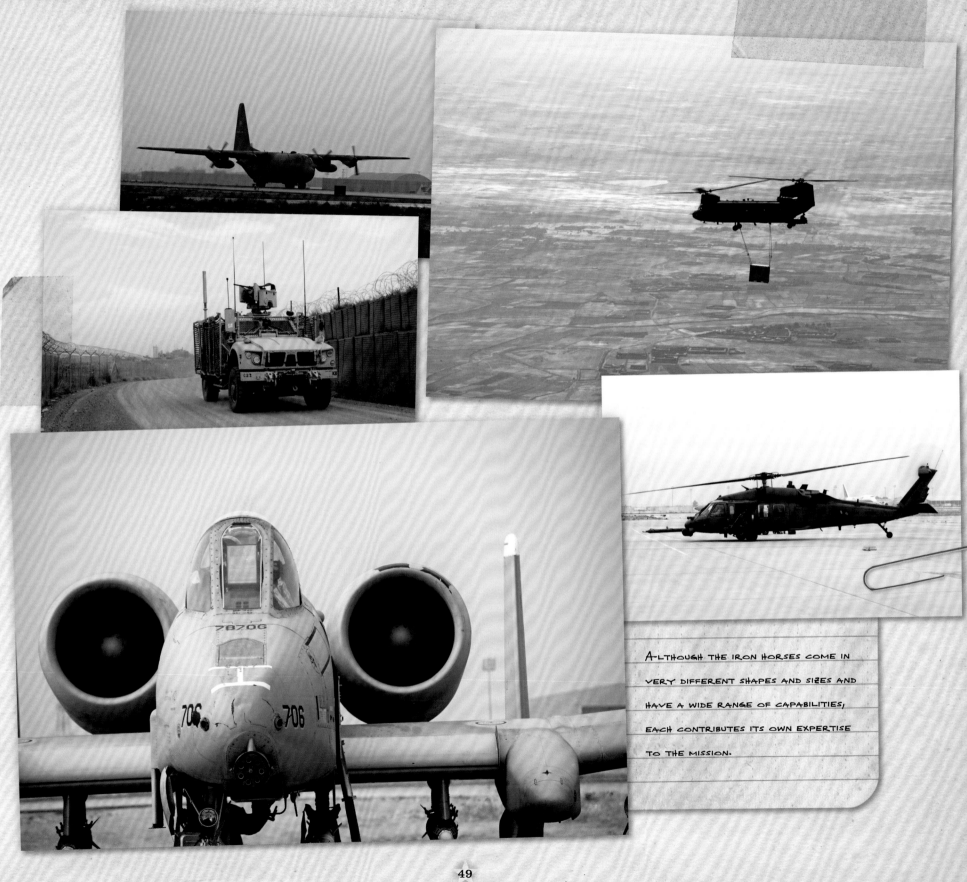

ALTHOUGH THE IRON HORSES COME IN VERY DIFFERENT SHAPES AND SIZES AND HAVE A WIDE RANGE OF CAPABILITIES, EACH CONTRIBUTES ITS OWN EXPERTISE TO THE MISSION.

6

HOOCHES, HESCOS, AND HAZARDS

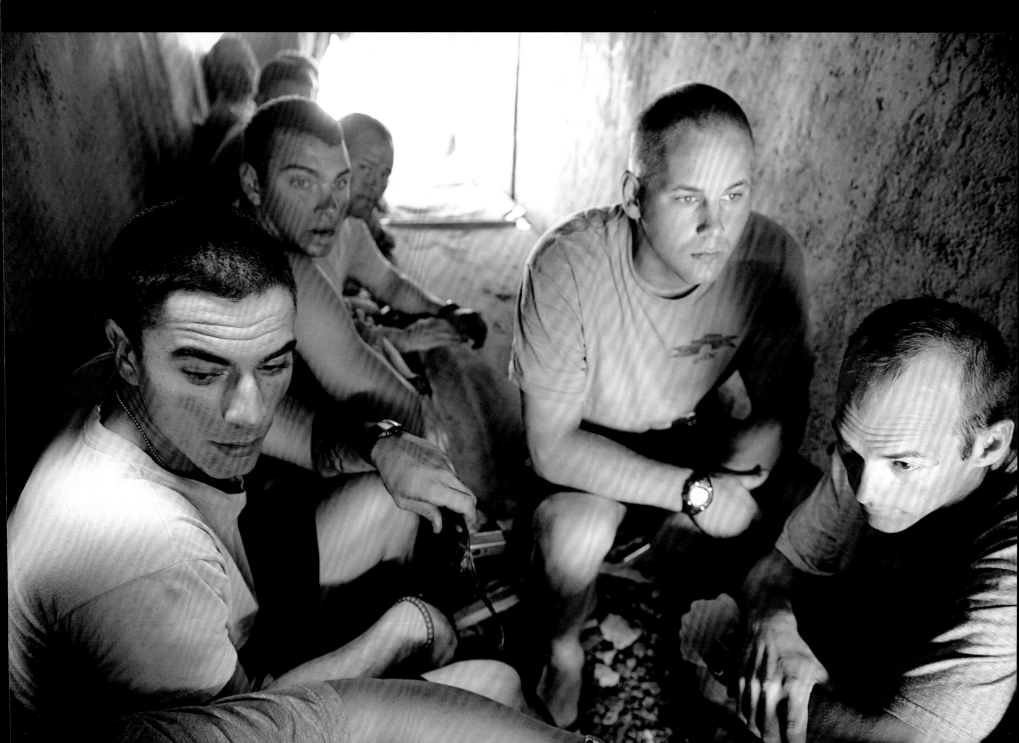

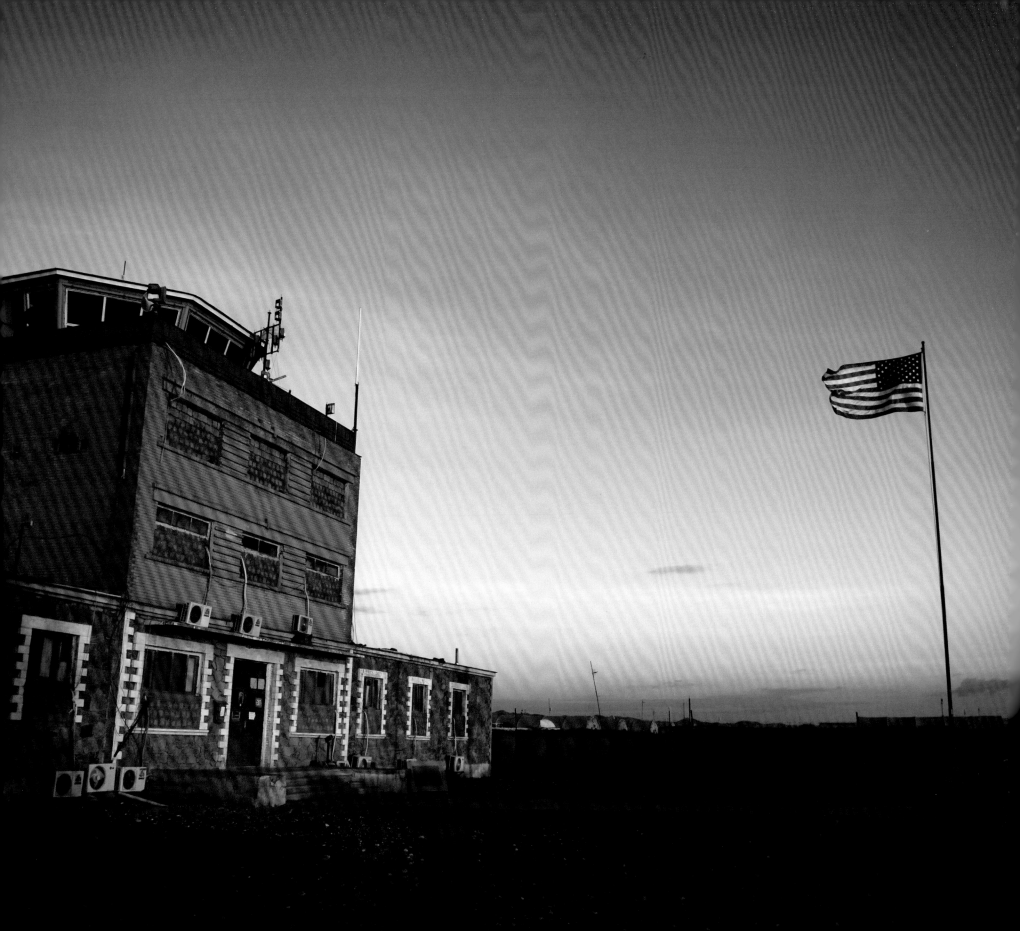

HOOCHES, HESCOS, AND HAZARDS

Say the word *home*, and everyone you know instantly experiences a flash of images, memories, and sensations. There's that beautiful old house on a tree-lined hill or that baked-brick apartment building in the city. You can smell your mom's cooking in the family kitchen and the smoke from the fireplace. You can hear the happy bark of your dog and the laughter of your kids playing some video game. In winter your bed's a plush, warm cocoon, and in summer there's a pool or a sprinkler where you find relief from the heat. But out here at the war, it's amazing what the word *home* can mean.

For the past two days and nights, you've been outside the wire, your legs aching from hauling your combat gear, your eyes and ears like overworked radar, waiting for that first gunshot. You're unshaved, unwashed, living in a slick membrane of your own slime. And at night, for those brief hours when it's not your turn to guard your buddies, you sleep on a pile of rocks, curled up in a fetal shiver. But at last it's time to go back, to a place that normally wouldn't be fit for a homeless guy from the ghetto.

That combat outpost has a name. It's the name of a soldier who was killed on that spot long before you got there, and whatever it is, after the last two nights it sounds like the Hilton. It's encircled by rings of razor wire and battlements of HESCO barriers—big wire-girded boxes filled with dirt to stop bullets and shrapnel. Then there's your "suite," a general-purpose tent, and inside that is your own personal hooch. It's a plywood box about the size of a prison cell. You've got your rickety wooden table for your laptop, a metal folding chair, a "kitchen counter" you made from some scrap wood and a few nails, and a cheap electric broiler that makes "meals, ready to eat" taste almost like food. Pictures of your wife and your cat are stapled to a splintery wall, next to the smashed Humvee mirror you stuck there with speed tape. There's just enough room to sit, breathe, and climb the wooden ladder to slip into your bunk, because the rest of the space is crammed with your guns, radios, body armor, grenades, LAW rockets, and ammo.

Looking up, you see nothing but a canvas roof. It'll keep out the rain but not the mortars or rockets, and a fire set off by a Taliban assault will turn the joint into an inferno. If something bad happens, you'll grab your gear and scramble outside to a concrete bunker or hit the wire to try to hold them off. This place is home now, and you're going to learn to love it.

Life here feels 30° off of normal. Sure, there is a Wal-Mart here; it's next to the Radio Shack. But these are local copies as authentic and real as the pirated videos they sell.

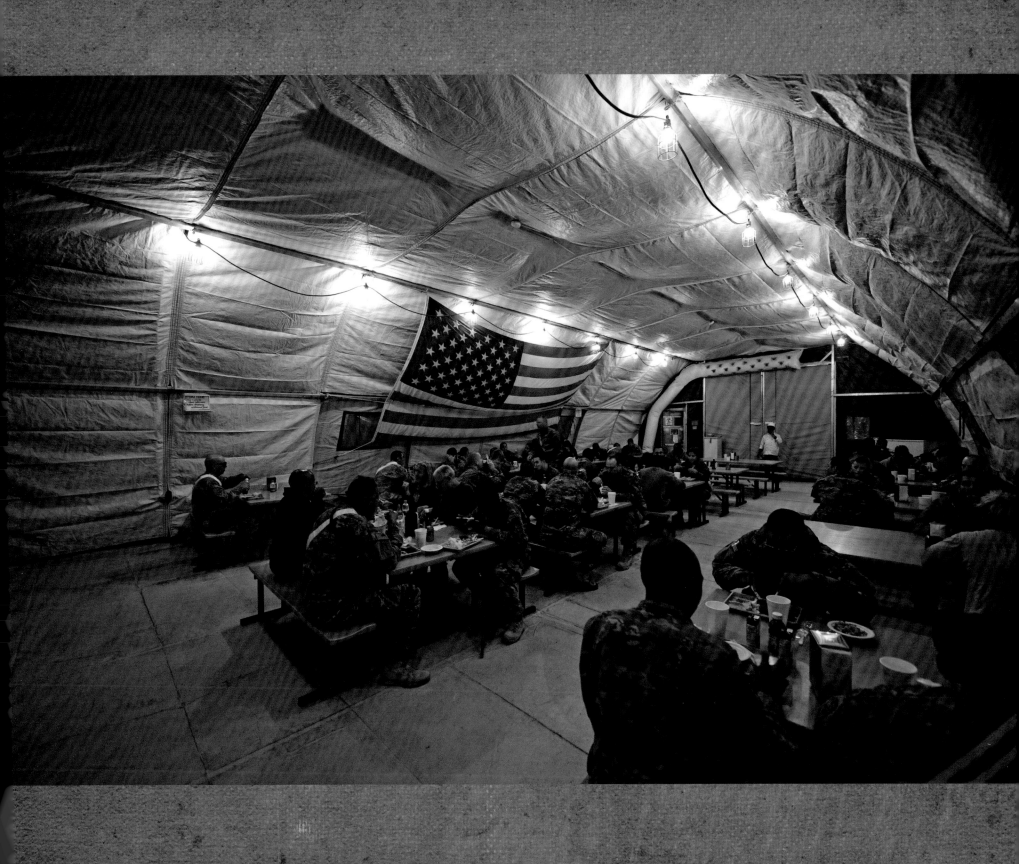

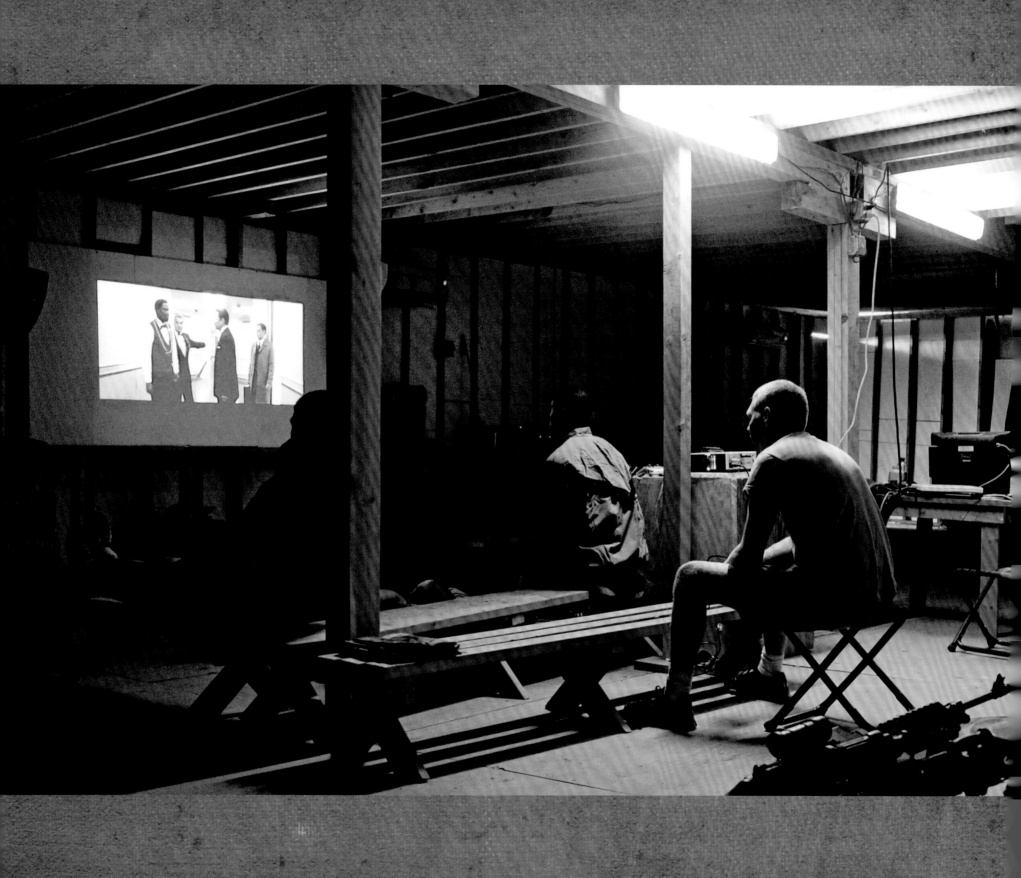

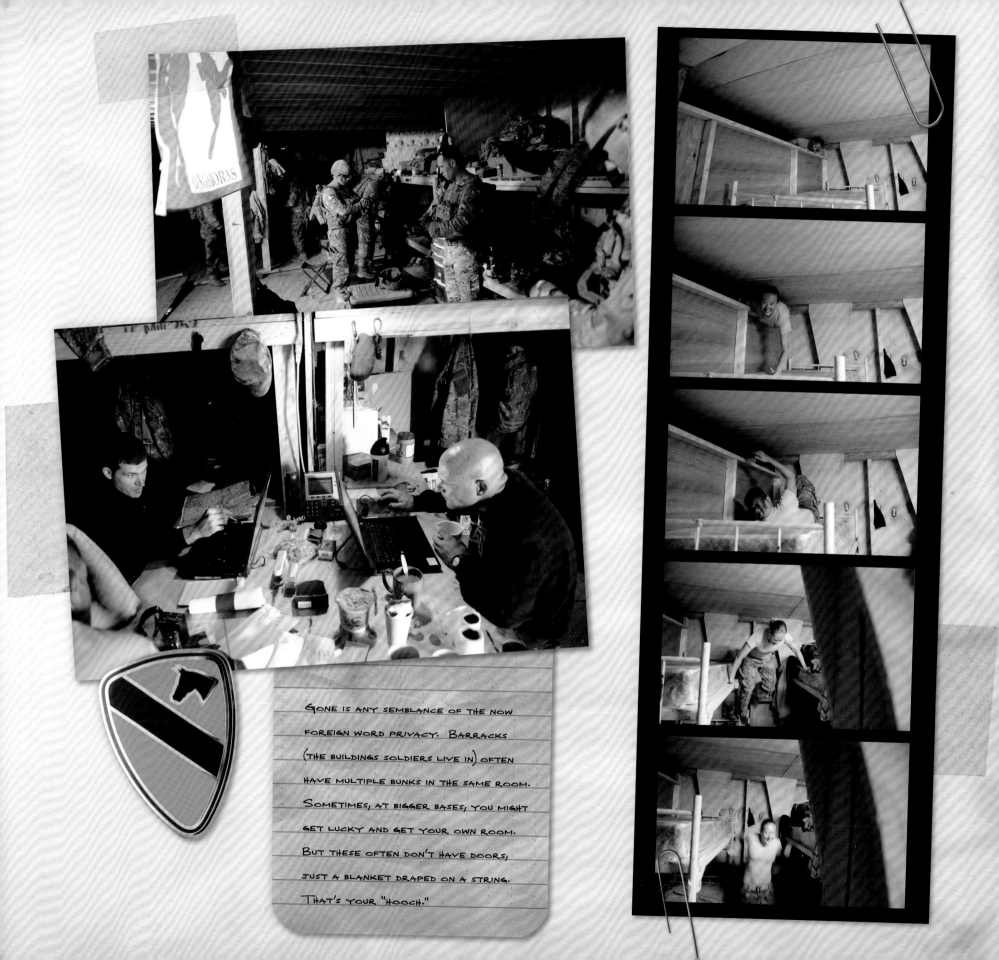

GONE IS ANY SEMBLANCE OF THE NOW
FOREIGN WORD PRIVACY. BARRACKS
(THE BUILDINGS SOLDIERS LIVE IN) OFTEN
HAVE MULTIPLE BUNKS IN THE SAME ROOM.
SOMETIMES, AT BIGGER BASES, YOU MIGHT
GET LUCKY AND GET YOUR OWN ROOM.
BUT THESE OFTEN DON'T HAVE DOORS,
JUST A BLANKET DRAPED ON A STRING.
THAT'S YOUR "HOOCH."

BOOM. It's a sound you hear regularly. A few times a day. But this one is different. It's close, and the warning that usually blares over the loudspeaker whenever there are incoming mortars or rockets didn't go off. RA-T TA-T TA-T! Gunfire. Right on the base perimeter. An officer bursts into the gym and shouts, "The base is being overrun! Arm yourselves!" Now, without your armor, without your platoon, you have to work with those around you to respond to one of the worst things here—a surprise attack. Even your home is not safe.

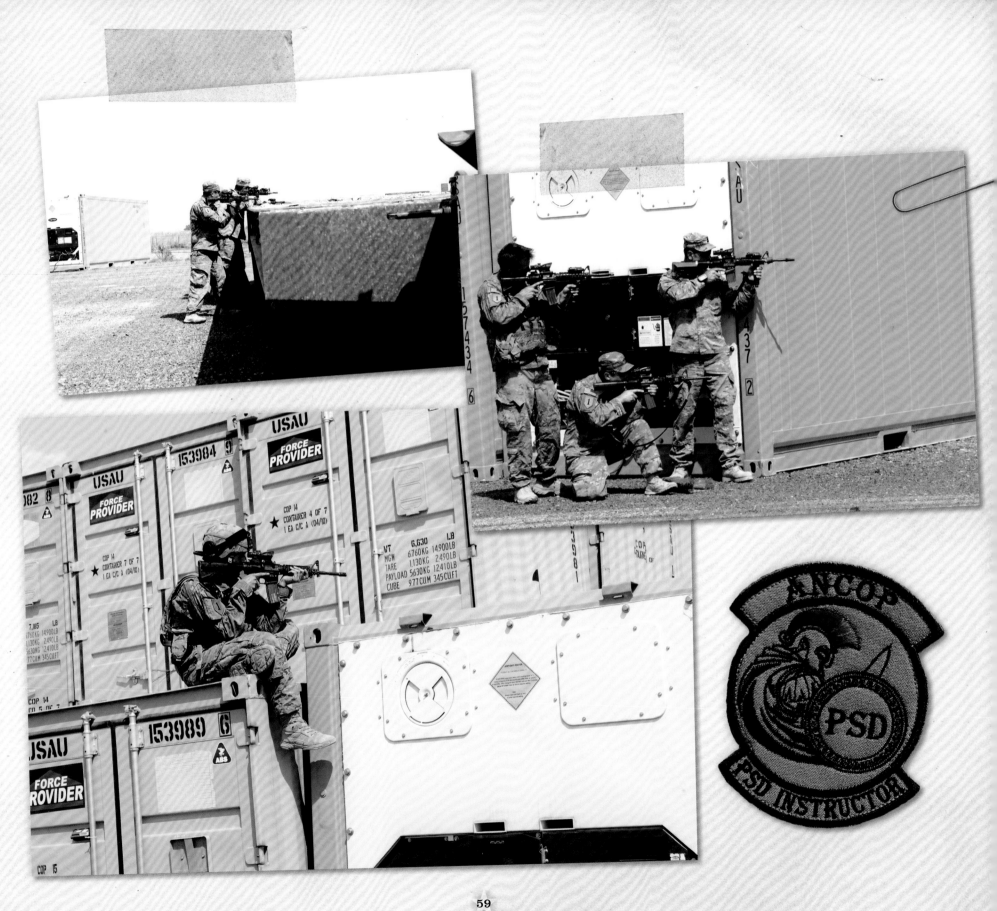

7

OUTSIDE THE WIRE

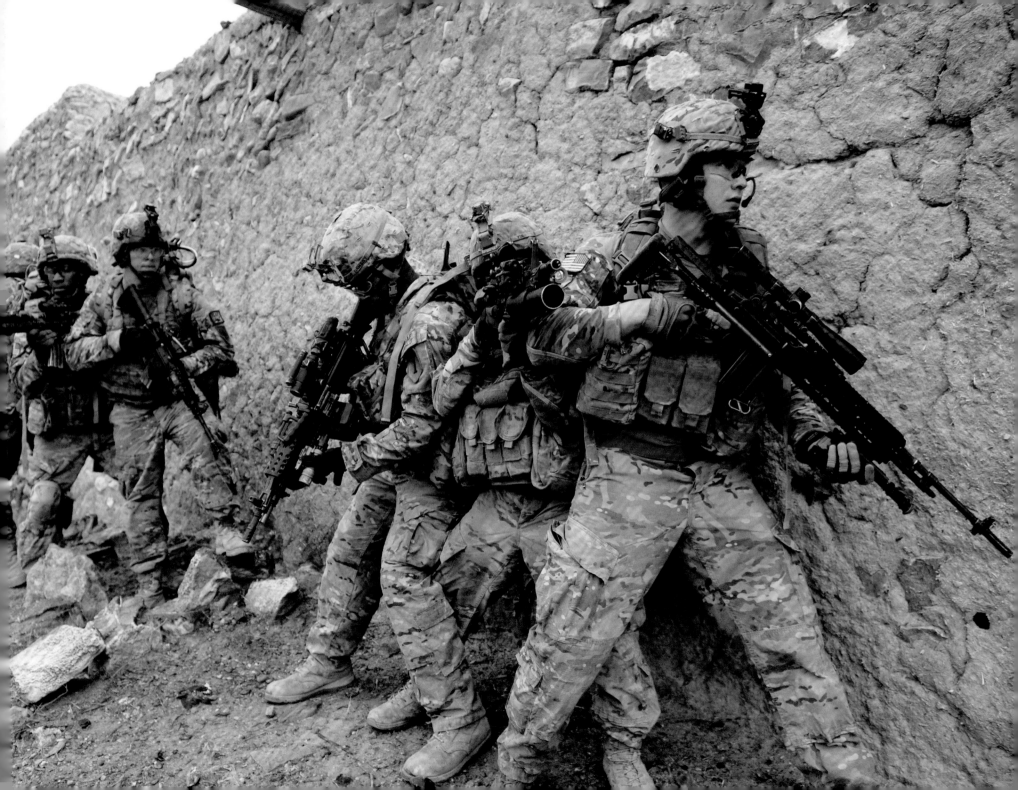

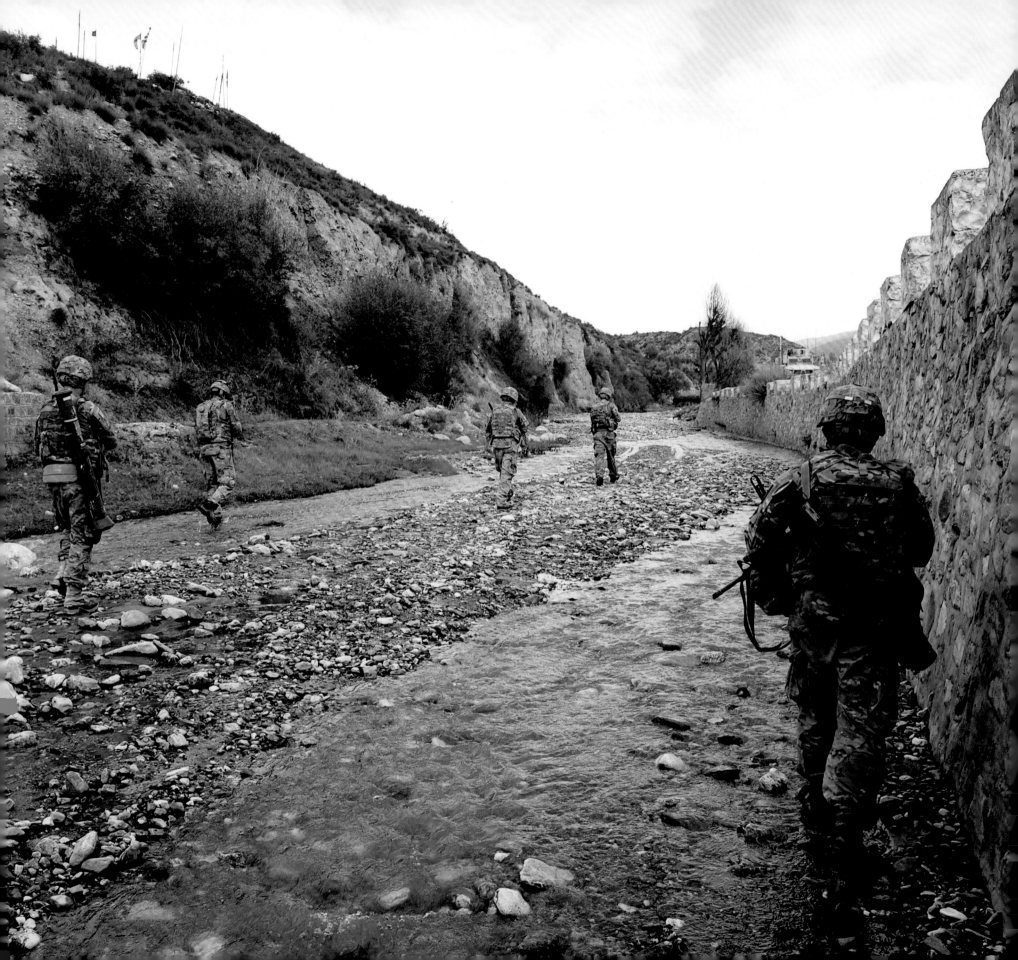

OUTSIDE THE WIRE

It doesn't matter if it's your very first combat patrol or your last. You are an alien visitor from another planet, encased in a space suit of heavy armor. You're armed with weapons the inhabitants of this world can barely imagine, communicating with your fellow "astronauts" via magical devices and nourished by self-contained substances you bring with you. You can't speak the language of these creatures, and they can't speak yours. The only thing you have in common is that you breathe the same air.

You leave the combat outpost, the mothership, crammed knee-to-knee inside your MRAP, which you hope will protect you from the fury of an improvised explosive device, at least until you disembark. Your mission is a "presence patrol." It's a show of force yet also an outstretched hand, intended to convince the inhabitants that you and your country can bring something to this land that's been missing. Freedom. Democracy. Hope. Change. Stability.

When at last you reach the point where it's time to continue on foot, it seems to take forever for you and your buddies to unfold yourselves from that rolling, broiling sardine can. A gaggle of locals watch as you shake off the cramps and resettle your gear like a rain-soaked dog. On the outside, you're a formidable creature of war. You are trained. You are the best. You are confident. But now you're carrying another burden: your fear.

To the Afghan villagers, the circus has just come to town. They emerge from their mud huts and market stalls, staring, whispering, pointing. Old men with gray beards tinged with henna eye you as if they've seen these "alien landings" before and are hardly impressed. Women in face coverings maintain a modest distance while schoolchildren dart, rush you, and then split like laughing schools of fish. A soldier raises his phone to photograph a woman in a blue burka, and the locals become angry, hostile. But just as quickly, the villagers spot one of *your* female warriors, and she becomes the object of stares, exclamations, and exploring hands. The same soldier who was challenged for nearly defiling an Afghan woman is now being begged to take group photographs with this alien female.

The enemy is everywhere, yet nowhere. You know their names—Al-Qaeda, Haqqani, Taliban—but they wear nothing to identify themselves, until that moment when an AK-47 or a pistol or a grenade pops out of a dark robe. You, on the other hand, are wearing your target on your sleeve. It's an American flag.

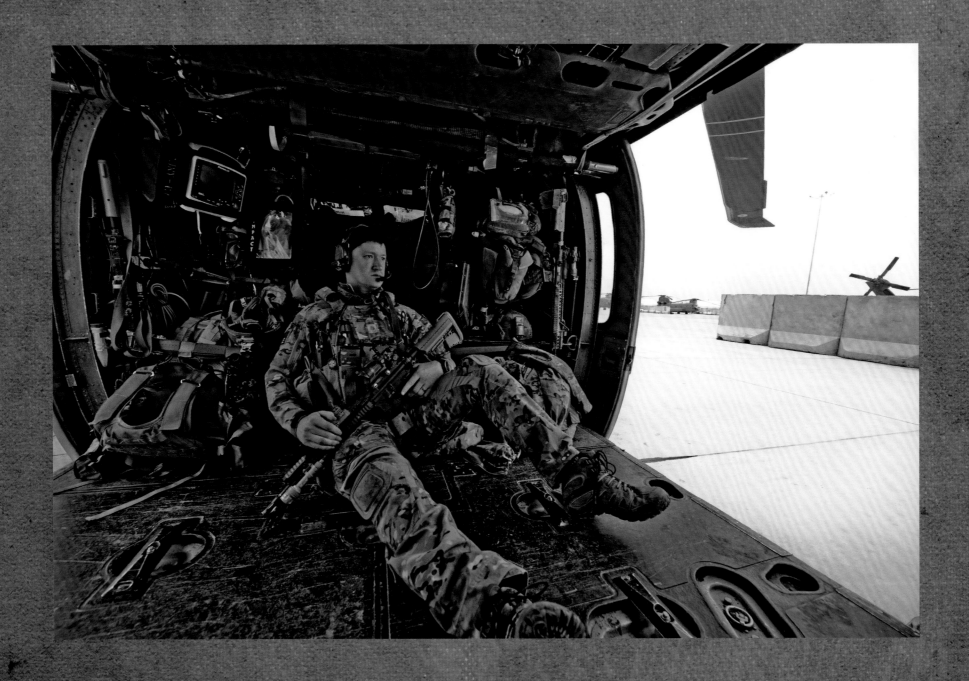

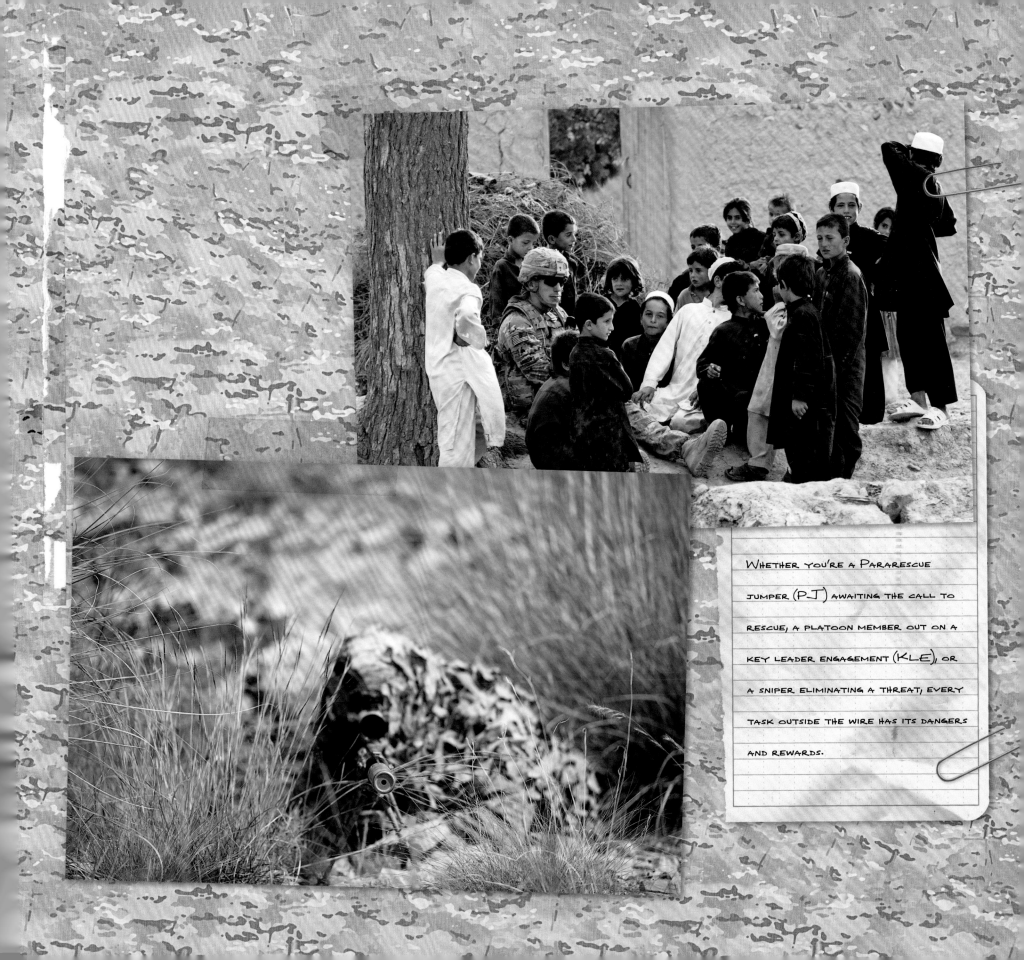

Whether you're a Pararescue Jumper (PJ) awaiting the call to rescue, a platoon member out on a key leader engagement (KLE), or a sniper eliminating a threat, every task outside the wire has its dangers and rewards.

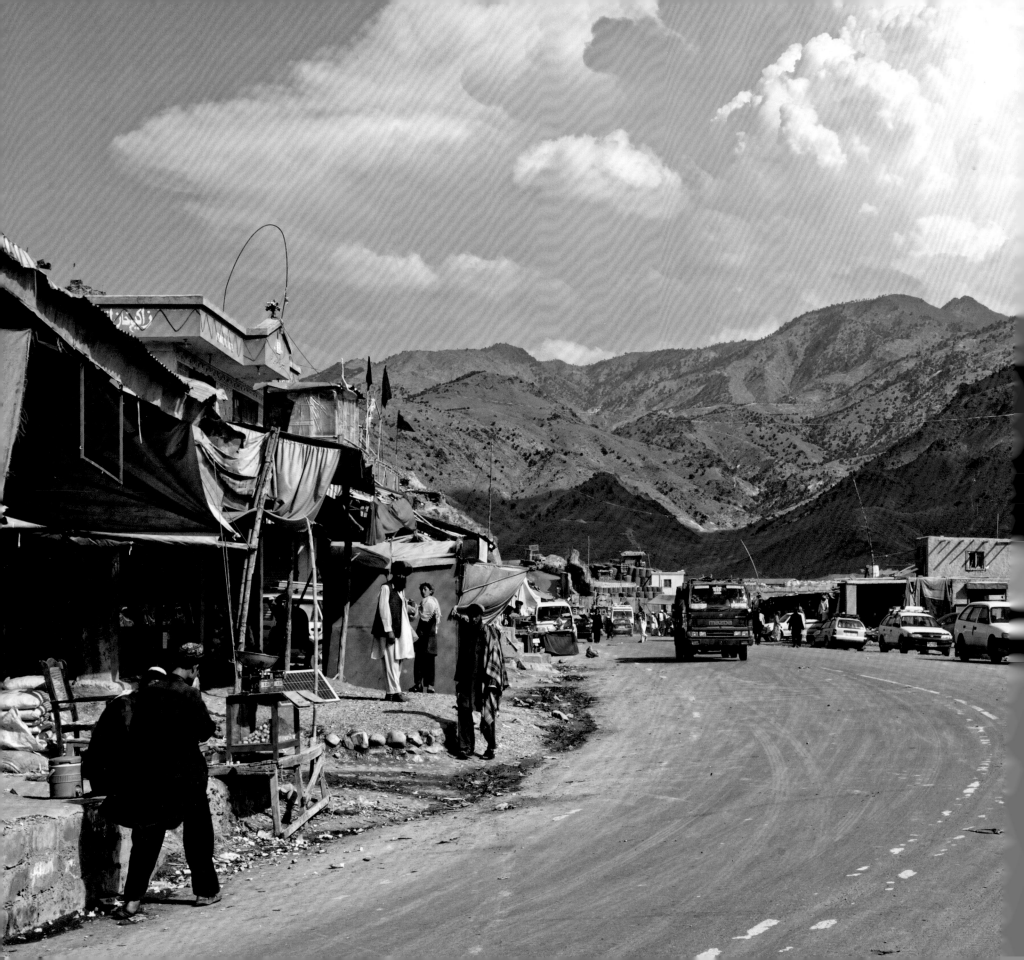

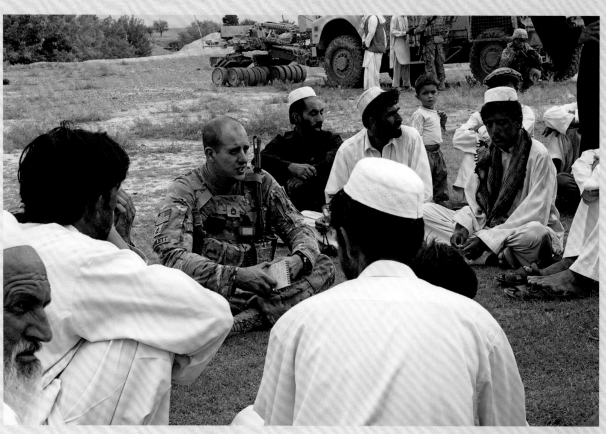

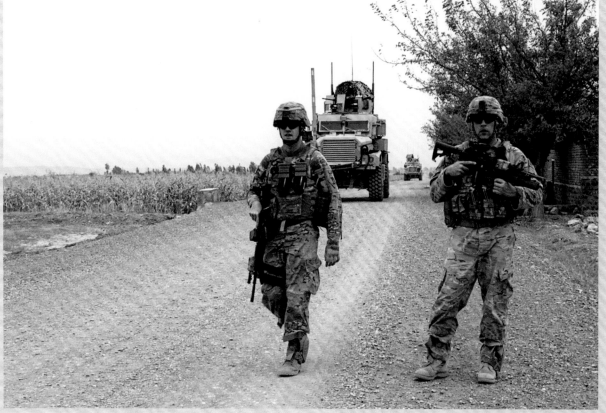

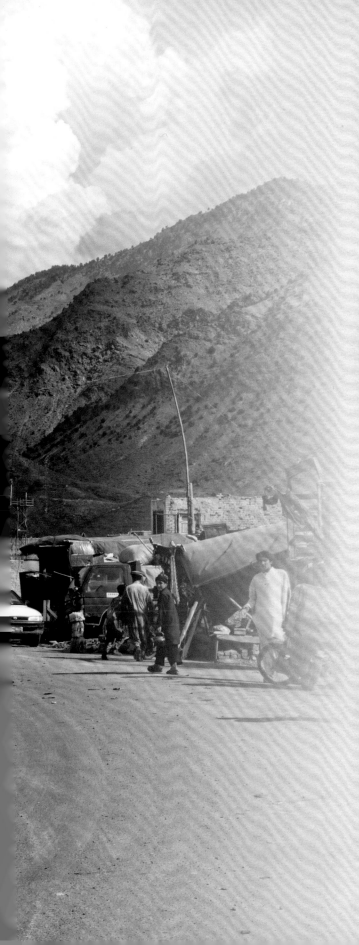

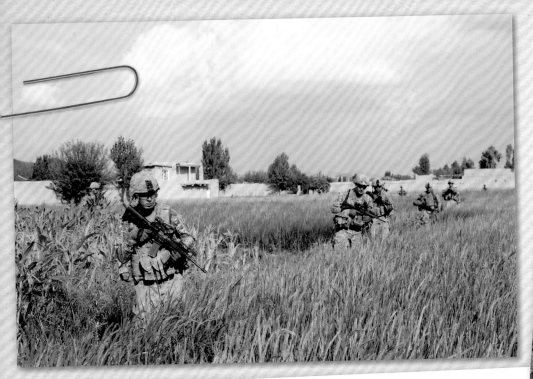

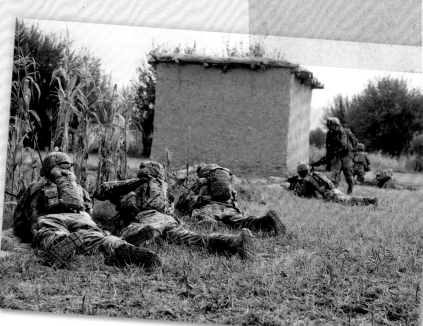

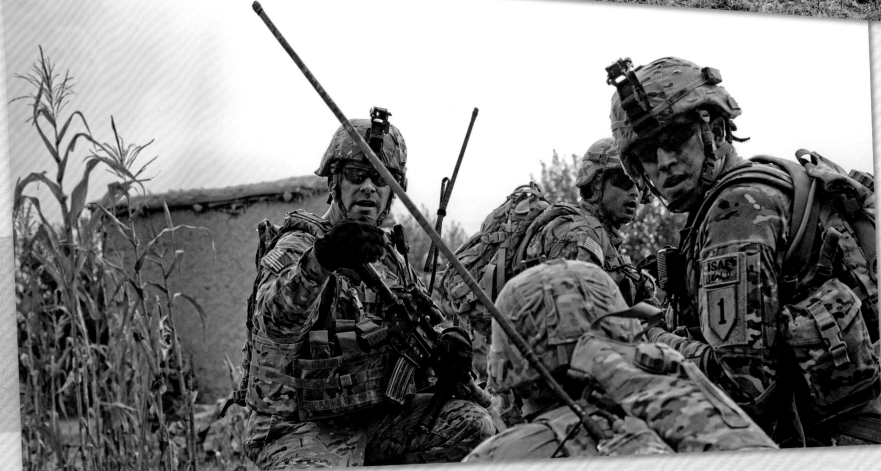

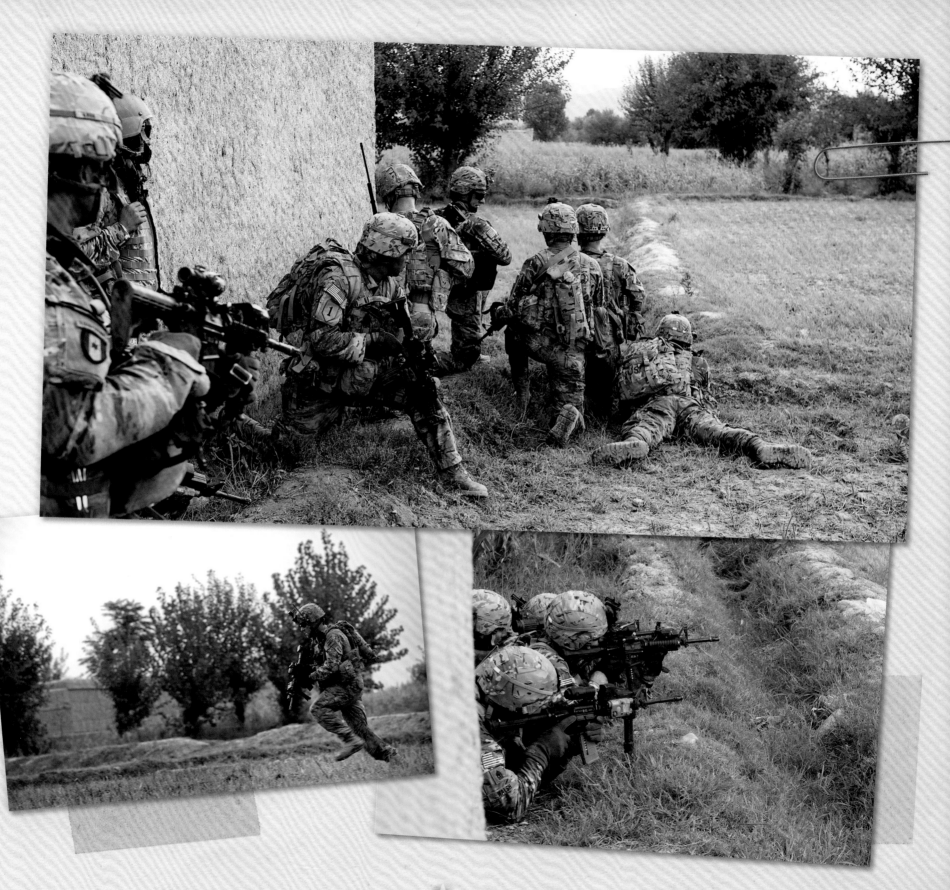

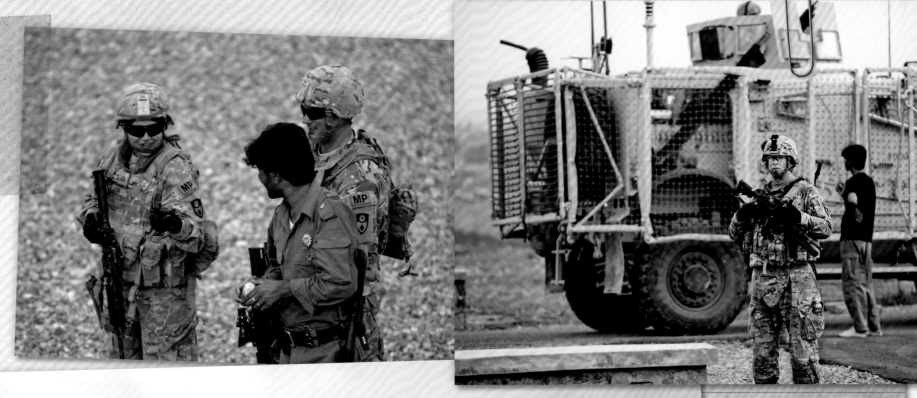

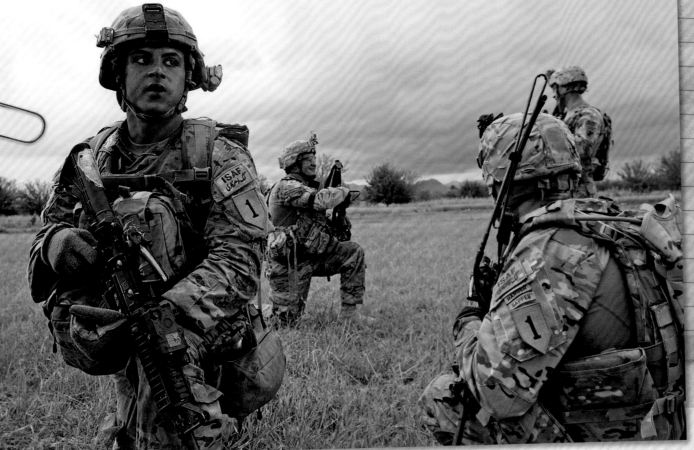

When you step outside the relative safety of your base, your teammates are all you have. You have their back, and they have yours. The bond between you is unlike any other bond. Your life depends on them. You may have your differences back in the barracks, but out here, you are united.

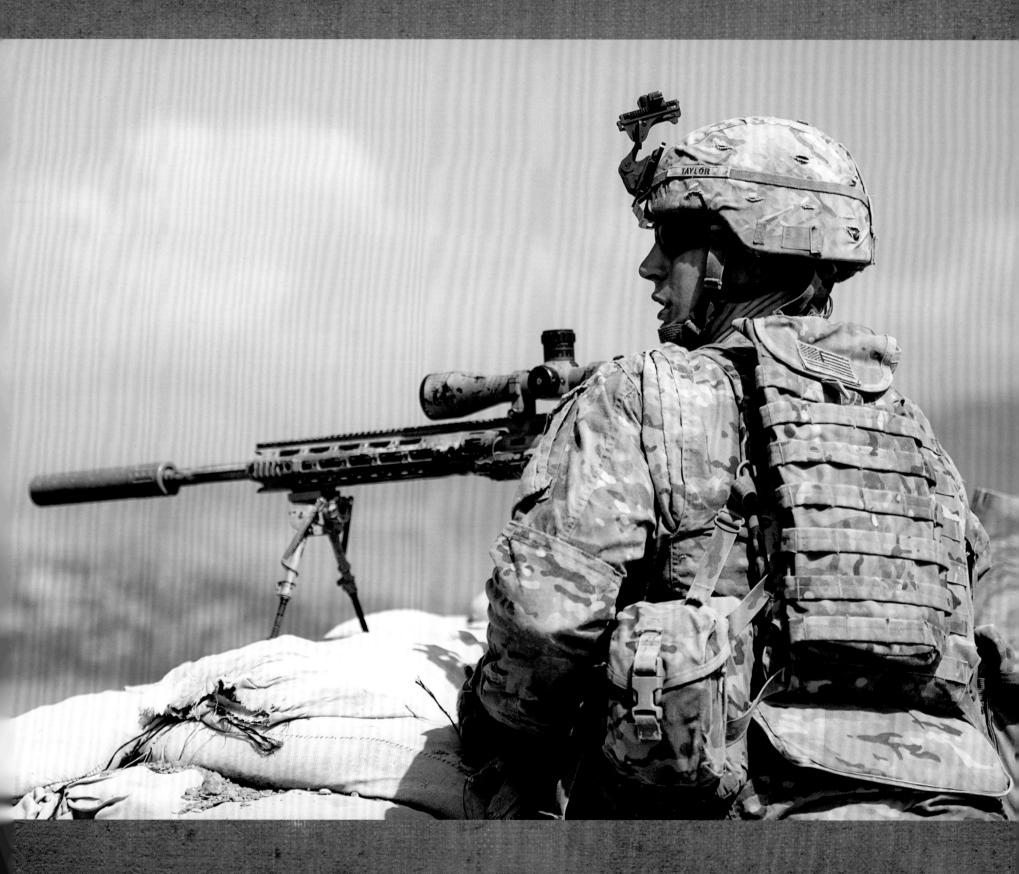

Most days in Afghanistan are the same as the day before. You get a briefing, leave the base, head to meet and interact with the locals, find out what they need from you, give them supplies that they asked for last time, and it's back to base. But on some occasions, the mission calls for some more kinetic activity.

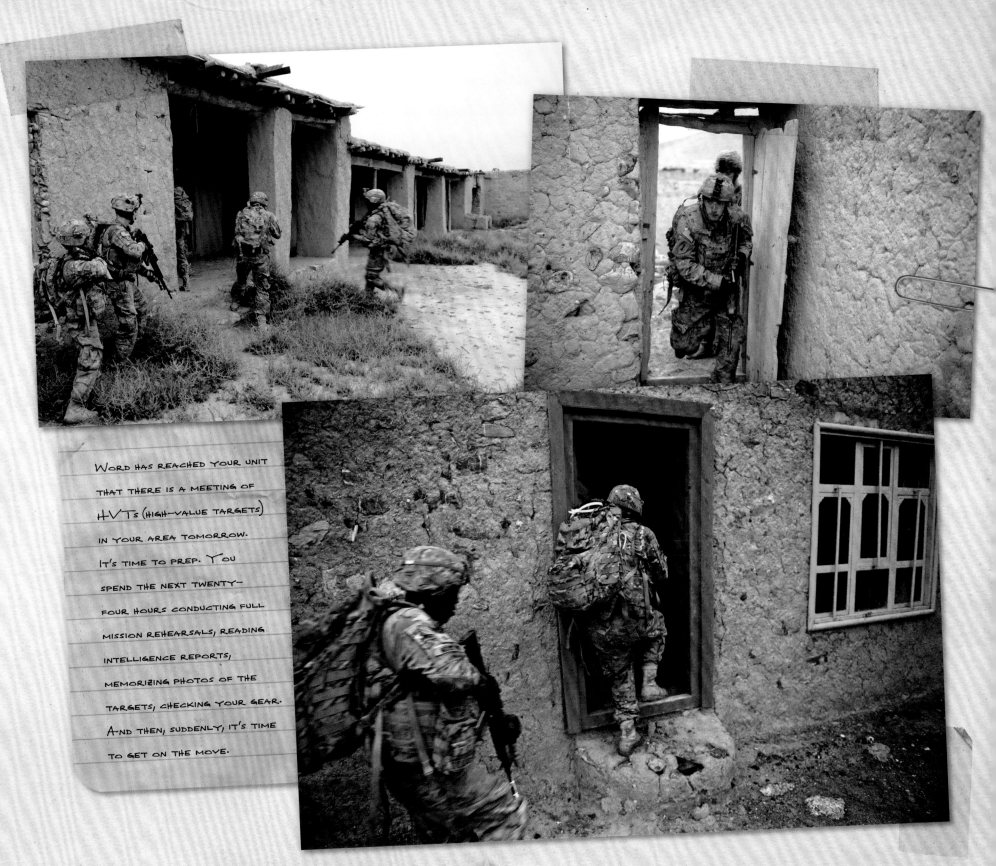

Word has reached your unit that there is a meeting of HVTs (high-value targets) in your area tomorrow. It's time to prep. You spend the next twenty-four hours conducting full mission rehearsals, reading intelligence reports, memorizing photos of the targets, checking your gear. And then, suddenly, it's time to get on the move.

8

UNDER THE COVER
OF DARKNESS

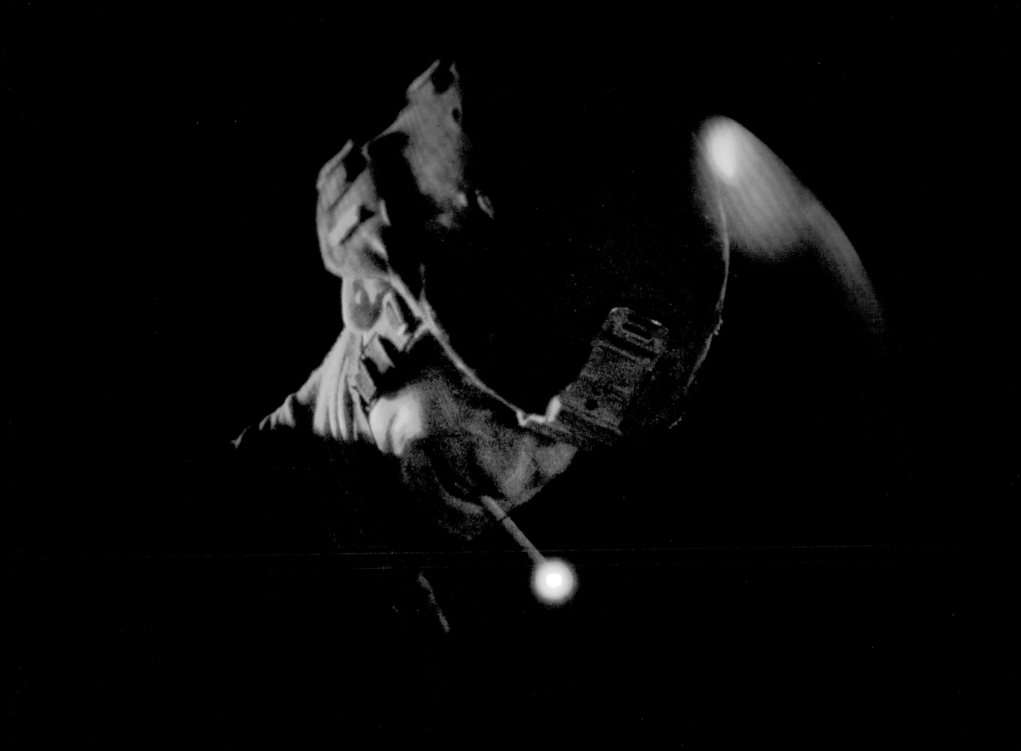

UNDER THE COVER OF DARKNESS

The night in Afghanistan is nothing like the night back at home. American towns, even long after the witching hour, reveal sparkles of illumination from flickering televisions, streetlights, vehicles, and distant neon. But an Afghan village, once the sun has set, is cloaked in a cape of blackness penetrated only by a rare spark of electricity. Its thickness is almost palpable, and it causes the kind of visceral reaction that rises up from the belly along with the most primal fear of the unknown. There is no sight, only sound: the ghostly whipping of clothes on a line, the snarl of a wild dog. Literally, you can't see your own outstretched hand in front of your face. You might find that kind of darkness in America, but only inside a dense forest on a remote mountaintop, with the stars obscured by a carpet of thunderclouds.

Yet the American warrior is something of a demon. With the flip of a combat glove, he pulls his night observation device down over his eyes, and that utter blackness is turned into a sparkling green glow, revealing every secret danger. Yes, it's tunnel vision, and it demands the constant, neck-straining sweep of his helmeted head from side to side, like a hawk searching for prey. But there's nothing else like it, and it gives him the ultimate power in the land. The enemy doesn't possess this capability, and he knows it. The American soldier's night vision is a technological miracle that makes him the ruler of all he sees. And whether he's an infantryman, an attack helicopter pilot, or a weapons officer utilizing an unmanned aerial vehicle, he sees everything.

And just imagine it from the other side. You are a lethal Taliban warrior, with all the skills and experience of a Bedouin tracker, and you know every tree, every rock, and every dry wadi in your land. Still, no matter how skilled you are, no matter how perfect your vision, your eyes are naked and no more powerful than those of a wolf. You are faced with American warriors festooned with ballistic armor and the most advanced weapons, and their eyes are mechanical, magical glowing green tubes that can spot you long before you even hear their footsteps. There is no contest. You can be felled by an enemy you'll never see. You may be the Lord of the Land by daylight, but the Americans own the night, and that's when they like to fight.

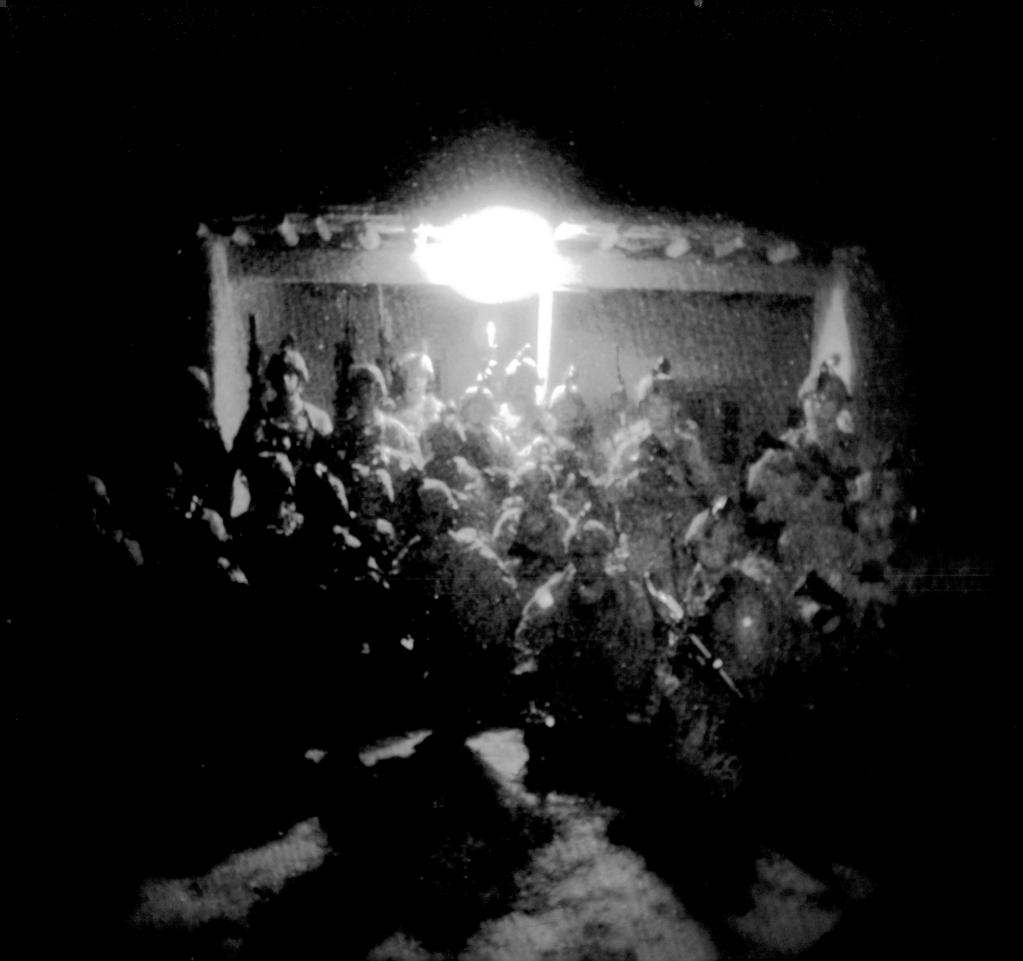

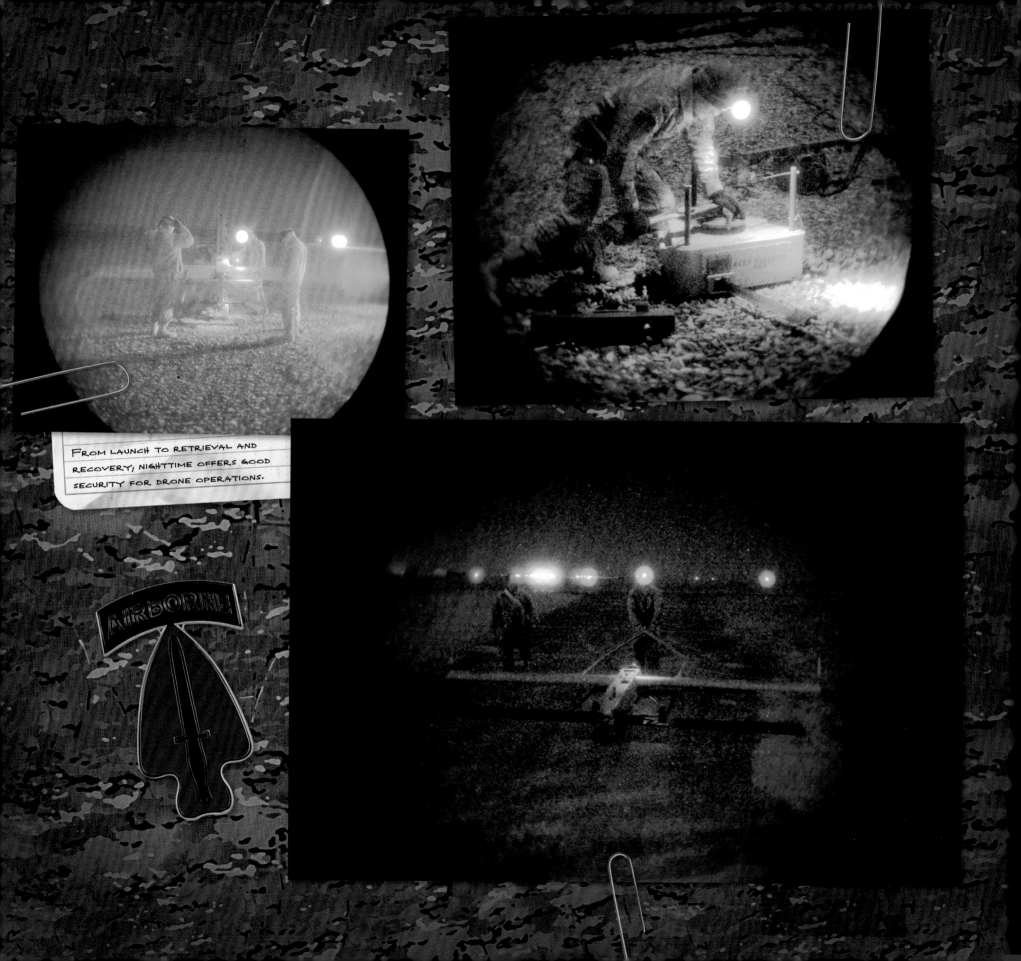

From launch to retrieval and recovery, nighttime offers good security for drone operations.

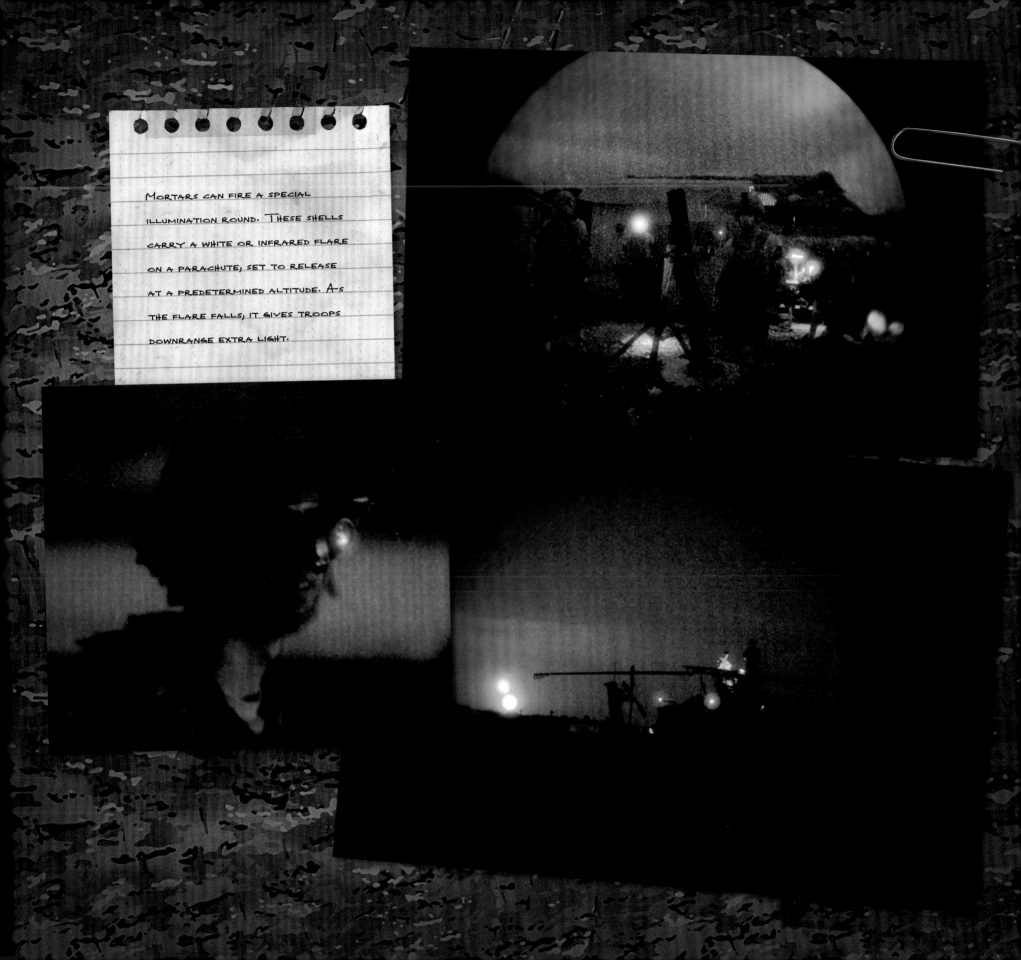

MORTARS CAN FIRE A SPECIAL ILLUMINATION ROUND. THESE SHELLS CARRY A WHITE OR INFRARED FLARE ON A PARACHUTE, SET TO RELEASE AT A PREDETERMINED ALTITUDE. AS THE FLARE FALLS, IT GIVES TROOPS DOWNRANGE EXTRA LIGHT.

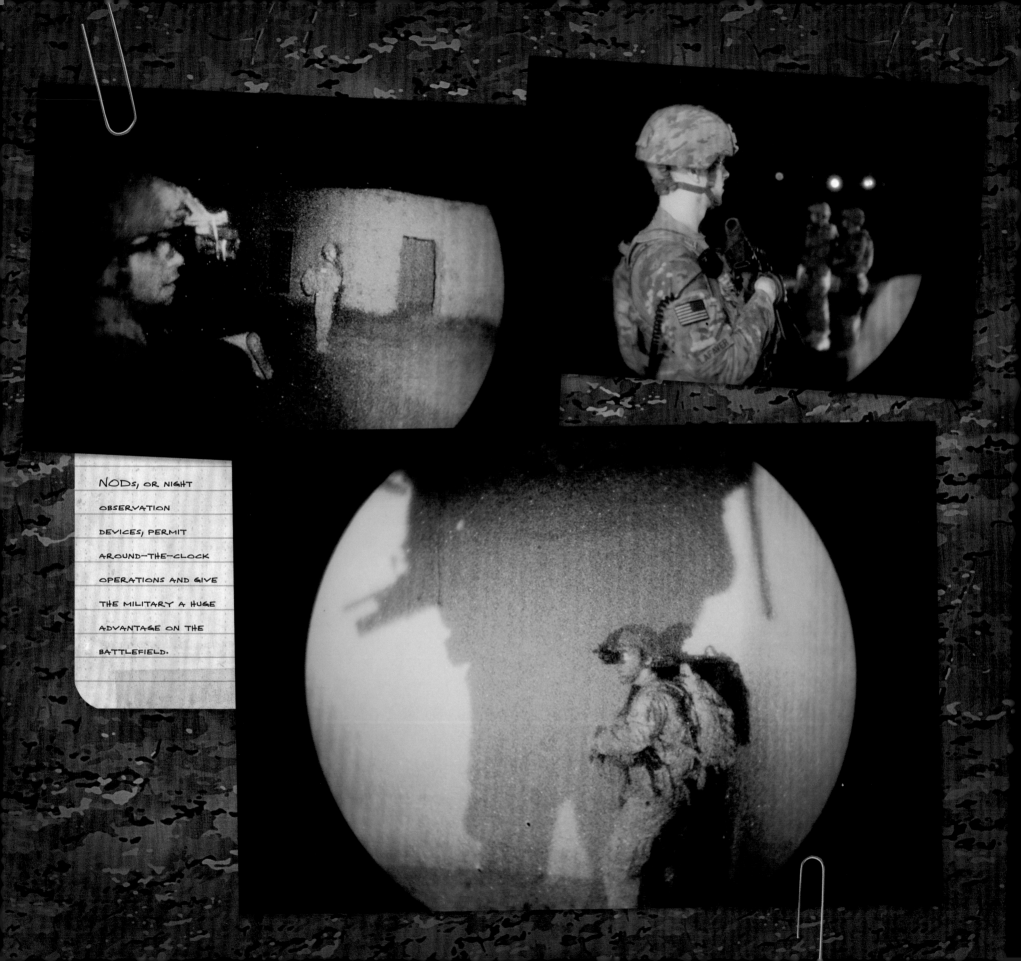

NODs, or night observation devices, permit around-the-clock operations and give the military a huge advantage on the battlefield.

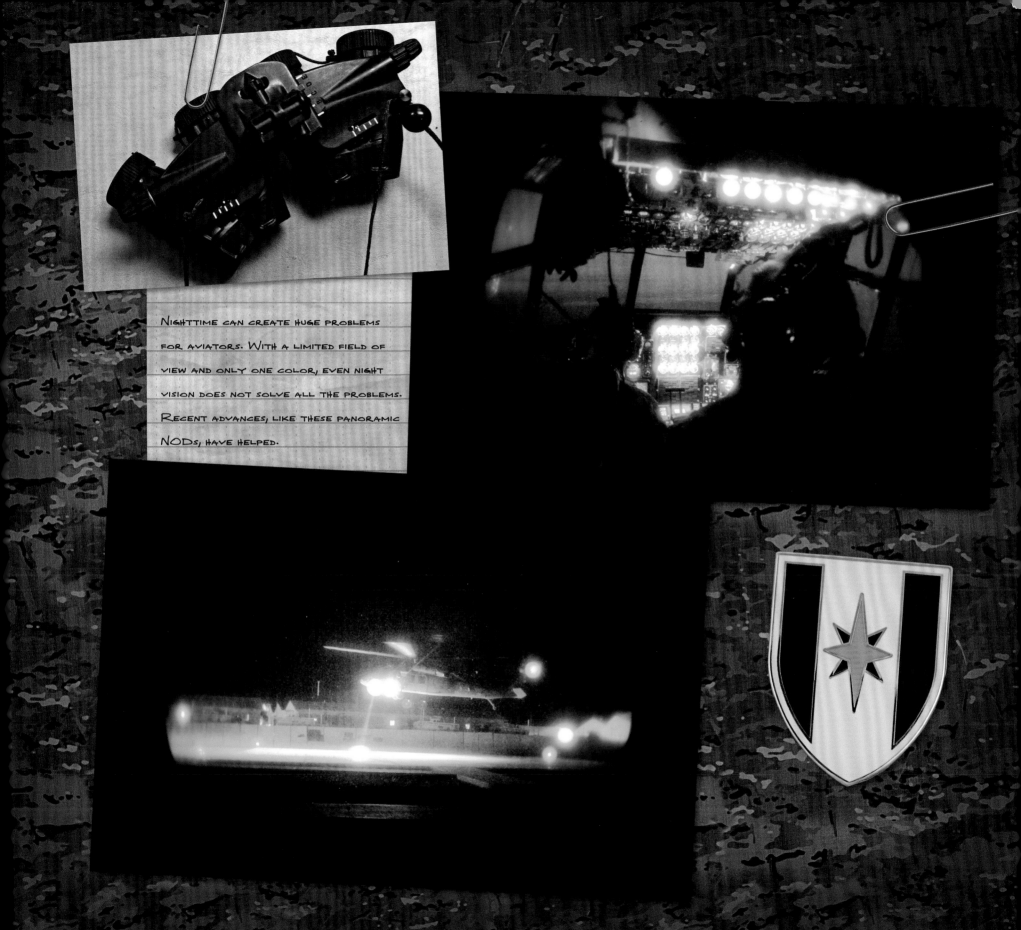

Nighttime can create huge problems for aviators. With a limited field of view and only one color, even night vision does not solve all the problems. Recent advances, like these panoramic NODs, have helped.

9

ت رج م ان

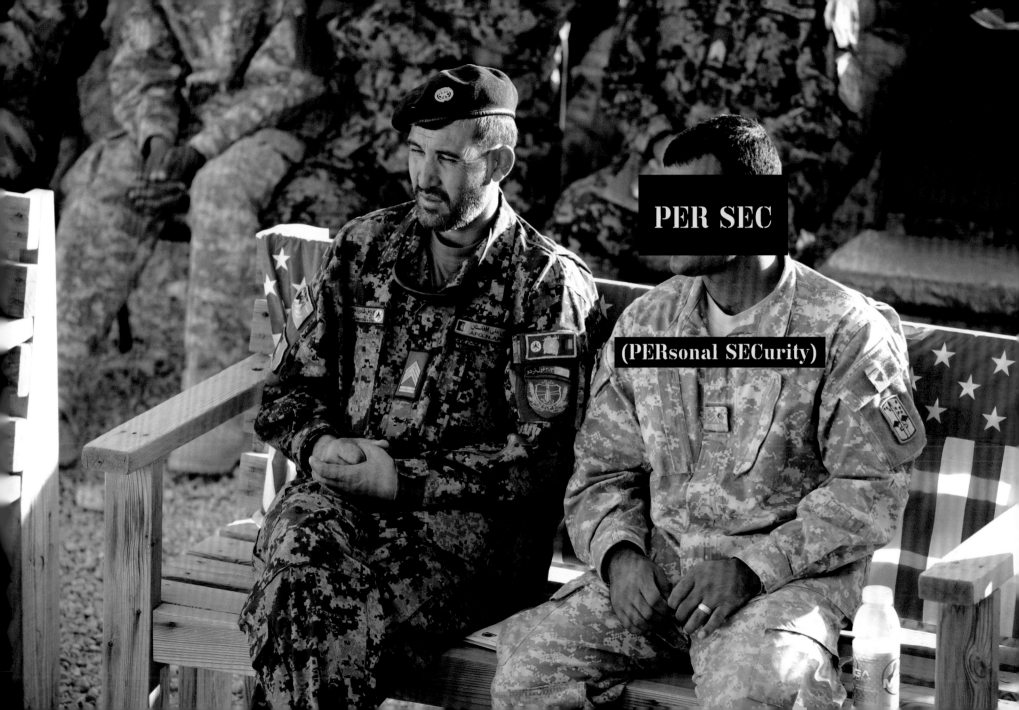

PER SEC

(PERsonal SECurity)

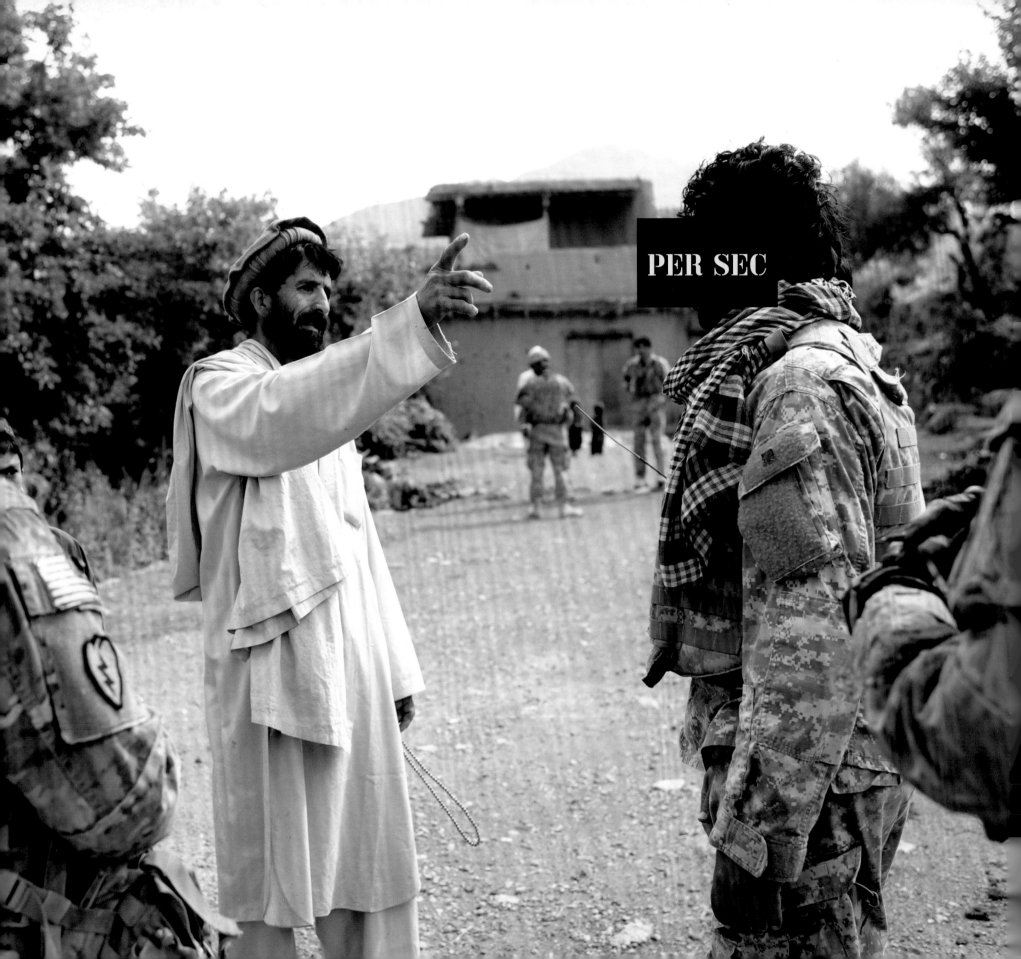
PER SEC

ترجمان

One of the bravest men on your combat patrol is a young guy who calls himself Mike, but that's not his real name. He wears body armor, but his only weapons are his language skills and his quick-thinking brain. Outside the combat outpost, his face is always covered by the ubiquitous *shemagh*, a checker-patterned scarf that reveals only his eyes. The home he hails from is far away, and no member of his family knows what he's doing out here in bad-guy country. His parents and siblings think he's working at some administrative job, and they don't ask why the wages he sends back are so generous. Mike's not an American. He's an Afghan. He is a translator, an interpreter, commonly called a "terp."

To many Afghans, Mike is a traitor. But to the Americans he works for, he's a hero, a lifeline, the integral link between the liberators and the oppressed. When Mike's American commander has a thought, Mike has to translate the intent precisely into Dari or Pashto while coloring the words to fit the cultural norms. He is a technical asset, but he's also a priest, a social worker, and a negotiator. Somewhere in his past Mike studied English, maybe in the States, and couldn't help but be steeped in American culture. He has an iPod and secretly listens to "Give Me Everything" by Pitbull on his headphones.

Mike is like Batman, always on hand to save the day. But if his identity is revealed, the consequences won't be some comic book drama. Many of his terp friends have been murdered, some by members of their own tribes, some captured by the Taliban and beheaded, their heads left on pikes as a warning. One day while out on patrol, he helps arrange getting the US commanders into a *shura*, a meeting of respected village elders, to discuss what supplies the village needs from the International Security Assistance Force (ISAF). Mike's heart rate is up because in this case, keeping his face covered would be a grave insult. His *shemagh* comes down, and he serves as aide-de-camp for both parties. But soon enough the *shura* expands into a council feast, with many Afghan participants, none of whom it can be said with certainty are not Taliban or Al-Qaeda. Mike uses all his skills to pave the way for this budding relationship, but his brain is split in two. One half is focused on ensuring the meeting's success. The other half is thinking he's a dead man.

There are no medals for Mike. If he dies, there will be no funeral with honors.

He'll be buried in a shroud of shame.

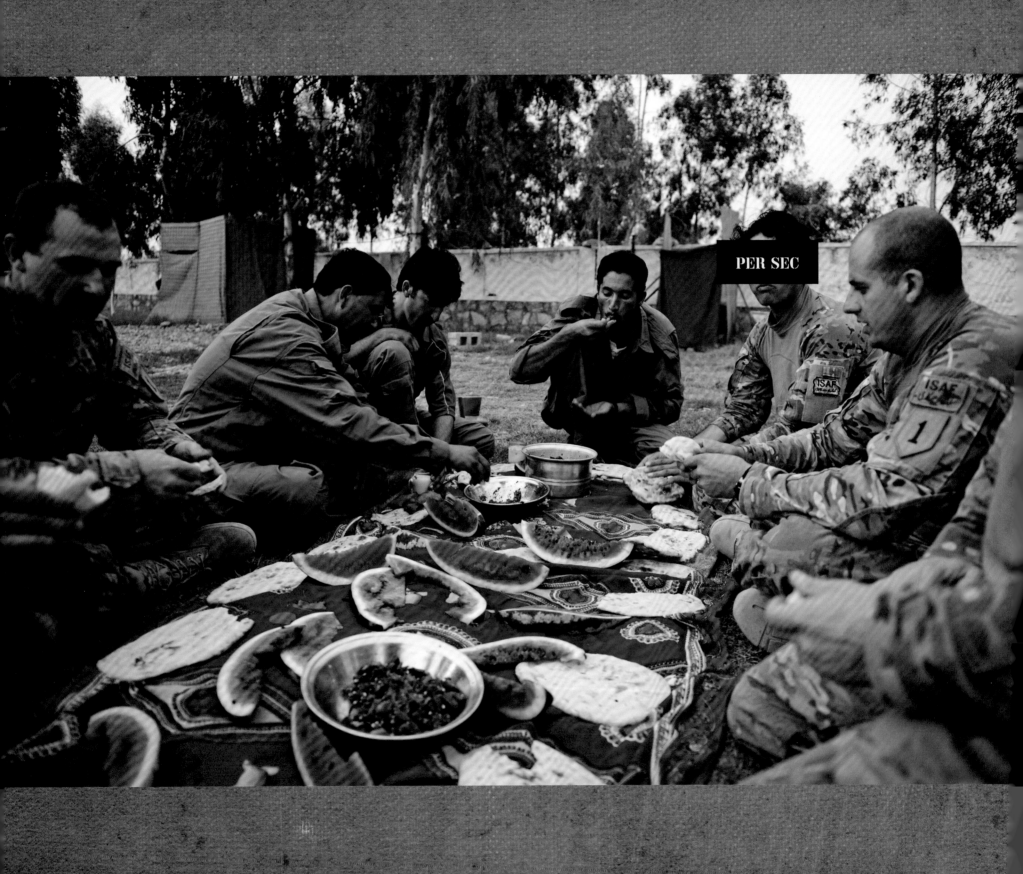

DARI WEAPONS

pistol *tufangcha*	تفنگچه	
rifle *tufang*	تفنگ	
grenade *bum-e dastee*	بمب	
bomb *bum*	بمب دستی	

DARI WEAPONS

landmine *main-e zaminee*	ماین زمینی
knife *kaard*	کارد
RPG *aarpeejee*	ار پی جی
ammunition *muhimaat*	مهمات
bullets *marmee*	مرمي
explosives *mawaad-e infilaaqeeyah*	مواد انفلاقیه
tank *taank*	تانك
armored vehicle *motar-e zarih daar*	موتر زره دار

PASHTO WEAPONS

pistol *tamaanchah*	تمانچه
rifle *ṯupak*	توپک
grenade *laasee bum*	لاسي بم.
bomb *bum*	بم

PASHTO WEAPONS

landmine *de zmakay mine*	د ځمکی ماین
knife *chaaku / chaareh*	چاقو\ چاړه
RPG *aar-pee-jee*	آر ـپي ـجي
ammunition *muhimmaat*	مهمات
bullets *golay / kaartus*	گولی ، کارتوس
explosives *chaawdedunkee mowaad*	چاودیدونکي مواد.
tank *taank*	ټانک
armored vehicle *zirih daara moṯar*	زره داره موټر

...te First Class ...dzaabet awal	خورد ضابط اول
Corporal ferqa mesher	فرقه مشر
Sergeant delgai mesher	دلگي مشر
Staff Sergeant / **Sergeant First Class** maawene delgai mesher	معاون دلگی مشر
Master Sergeant / **First Sergeant Warrant Officer** loy delgai mesher	لوی دلکی مشر
Second Lieutenant dwaham breedman	دوهم بریدمن
First Lieutenant lumrai breedman	لمری بریدمن
Captain turan	تورن

Major jagran	جگرن
Lieutenant Colonel dagarman	دگرمن
Colonel dagarwaal	دگروال
Brigadier General breed general	برید جنرال
Major General dagar general	دگر جنرال
Lieutenant General turan general	تورن جنرال
General general	جنرال
General of the Air Force generale qowaye hawaayee	جنرال قوه هوایی

Private First Class lumrai khurd zaabit	لومړی خورد ضابط
Corporal ferqa mesher	فرقه مشر
Sergeant dalgay mesher	دلگی مشر
Staff Sergeant / **Sergeant First Class** drasteez dalgay mesher	درستیزدلگی مشر
Master Sergeant / **First Sergeant Warrant Officer** lowy dalgay mesher	لوی دلگی مشر
Second Lieutenant dwaham breedman	دوهم بریدمن
First Lieutenant lumray breedman	لومړی بریدمن
Captain jagran	جگرن

Major turan	تورن
Lieutenant Colonel breed dagarwaal	برید دگروال
Colonel karnail / dagarwaal	کرنیل\ دگروال
Brigadier General dagar genraal	دگر جنرال
Major General turran genraal	تورن جنرال
Lieutenant General breed genraal	برید جنرال
General genraal	جنرال
General of the **Air Force** de hawaayee qowaawo genraal	د هوایی قواو جنرال

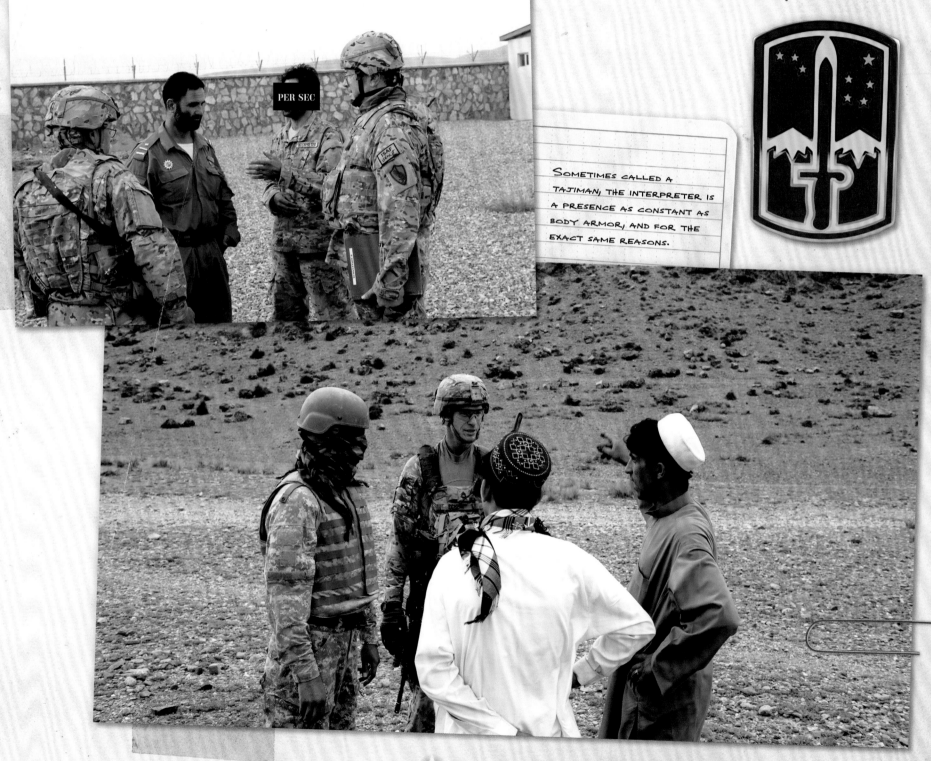

PER SEC

SOMETIMES CALLED A
TAJIMAN, THE INTERPRETER IS
A PRESENCE AS CONSTANT AS
BODY ARMOR, AND FOR THE
EXACT SAME REASONS.

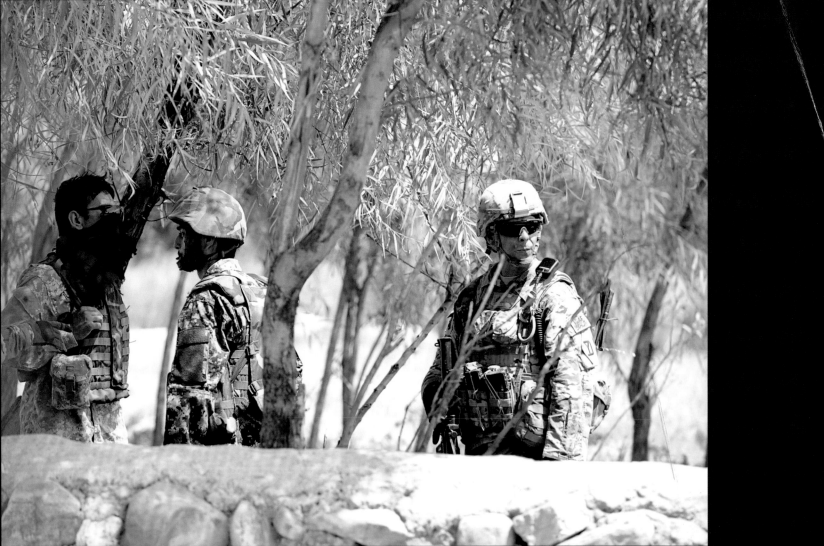

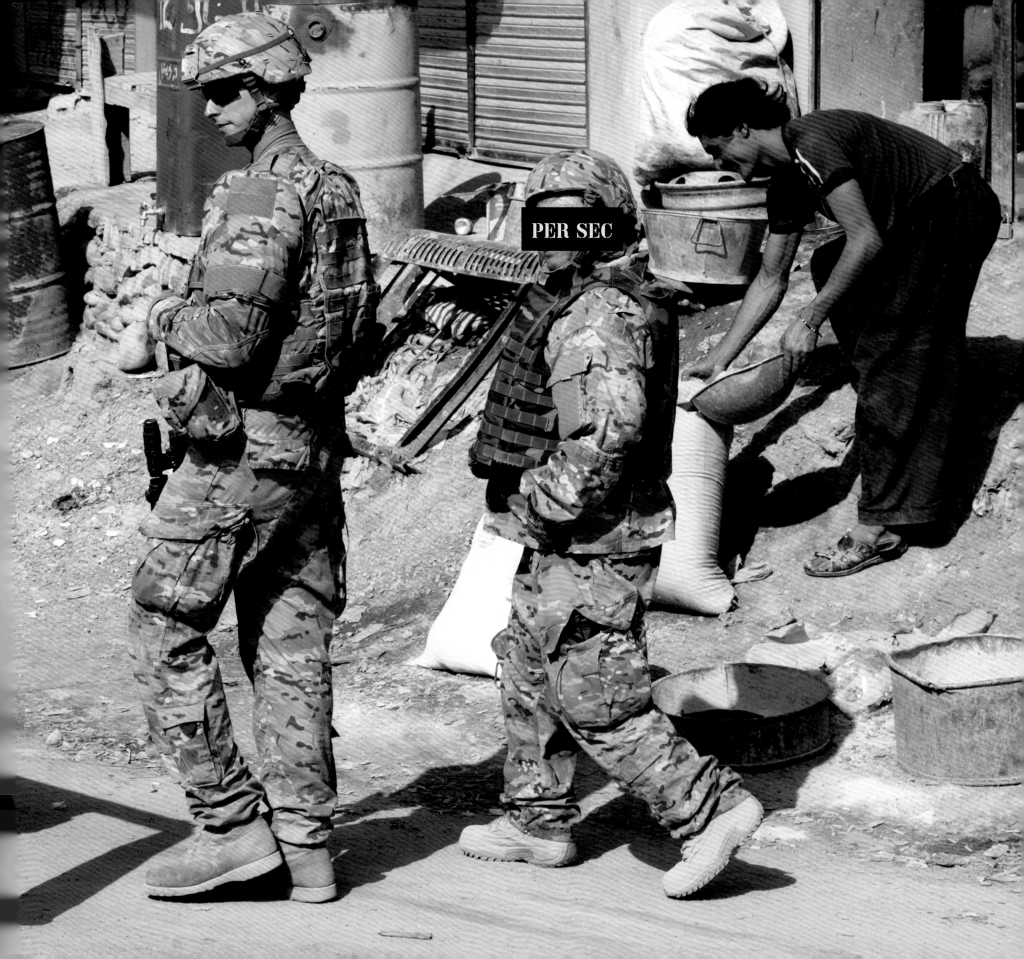

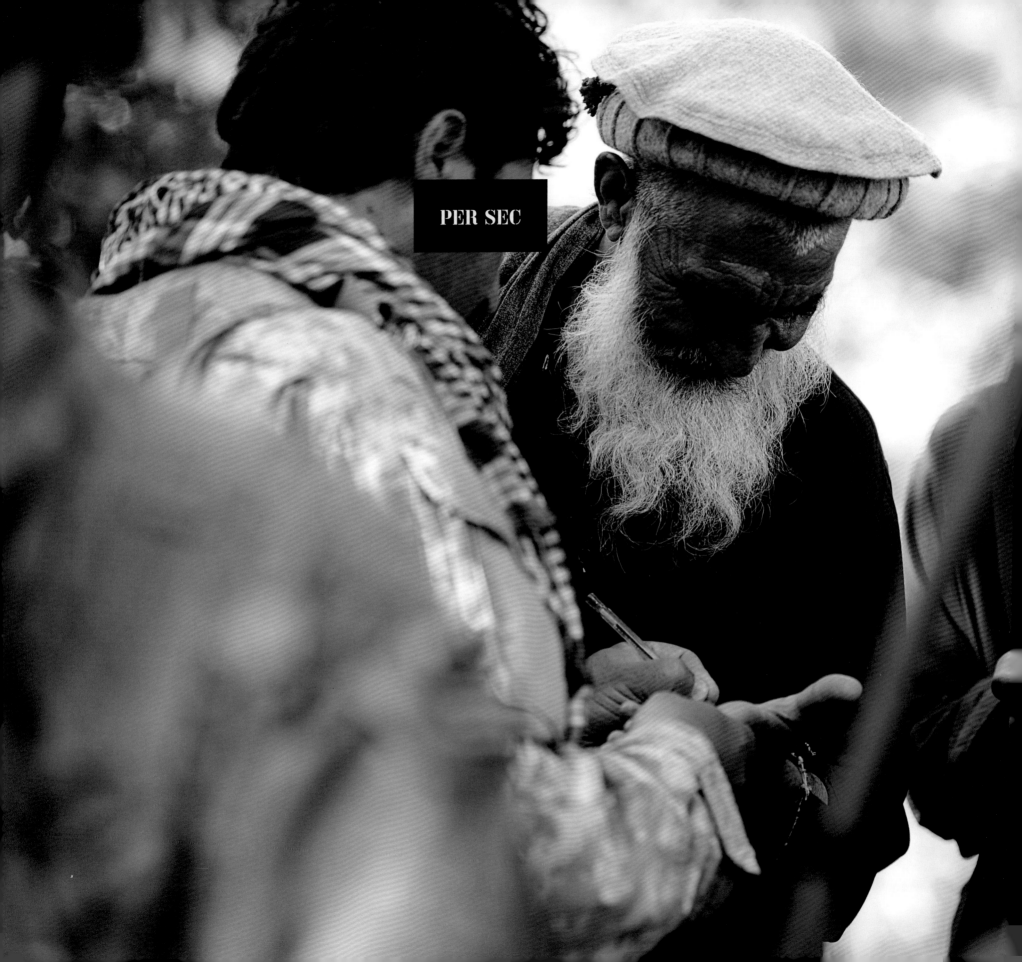

PER SEC

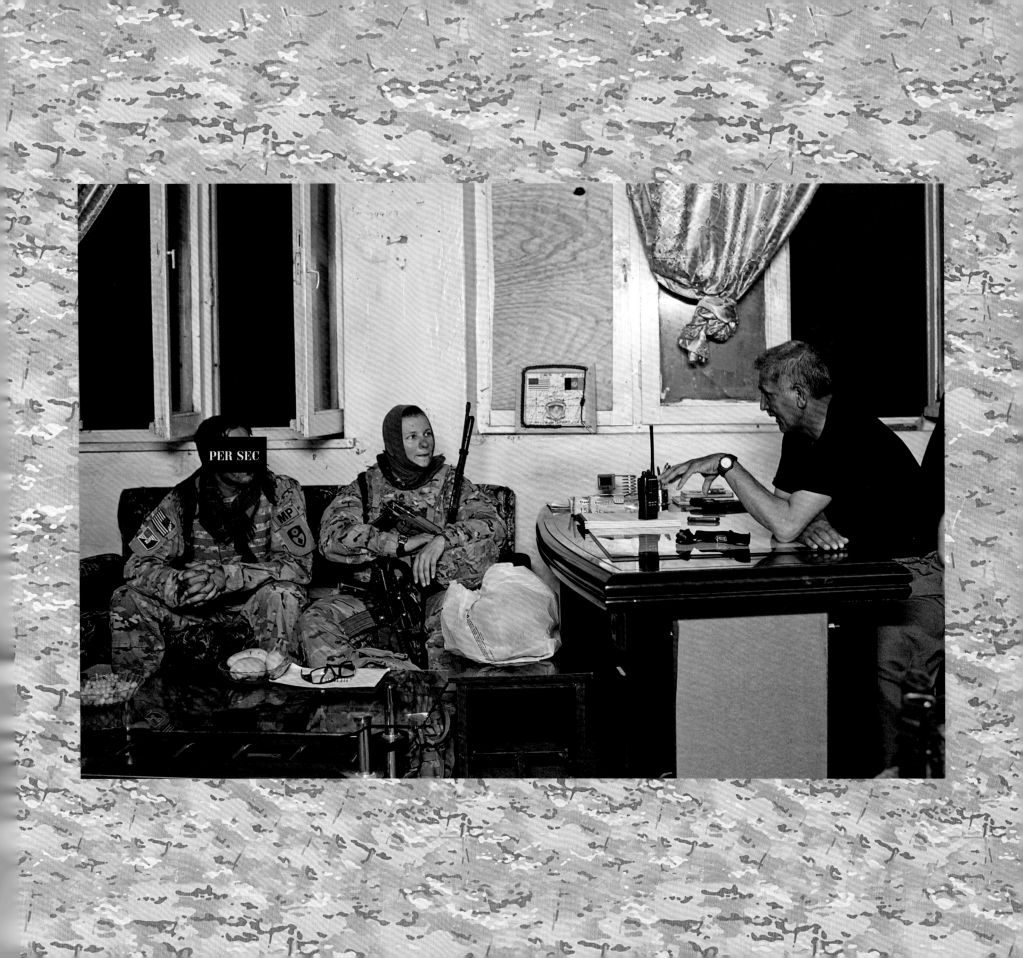

HEARTS AND MINDS

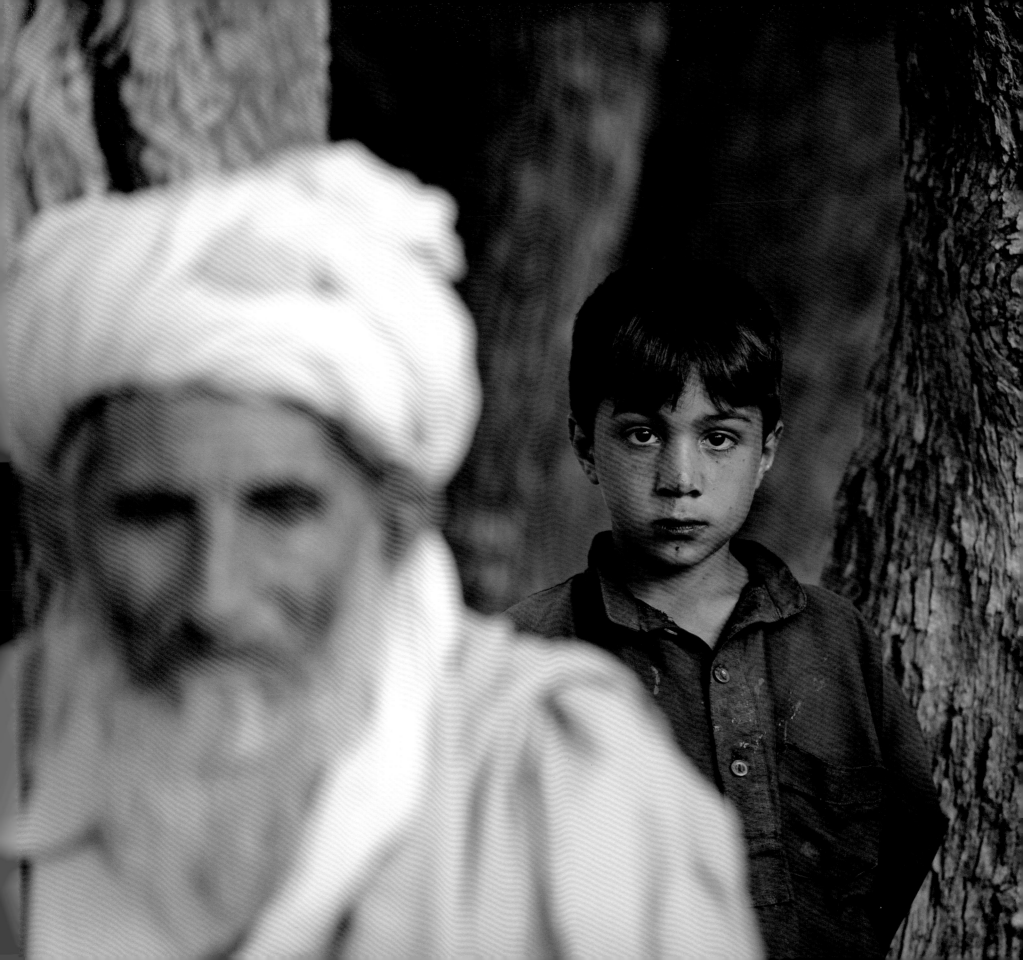

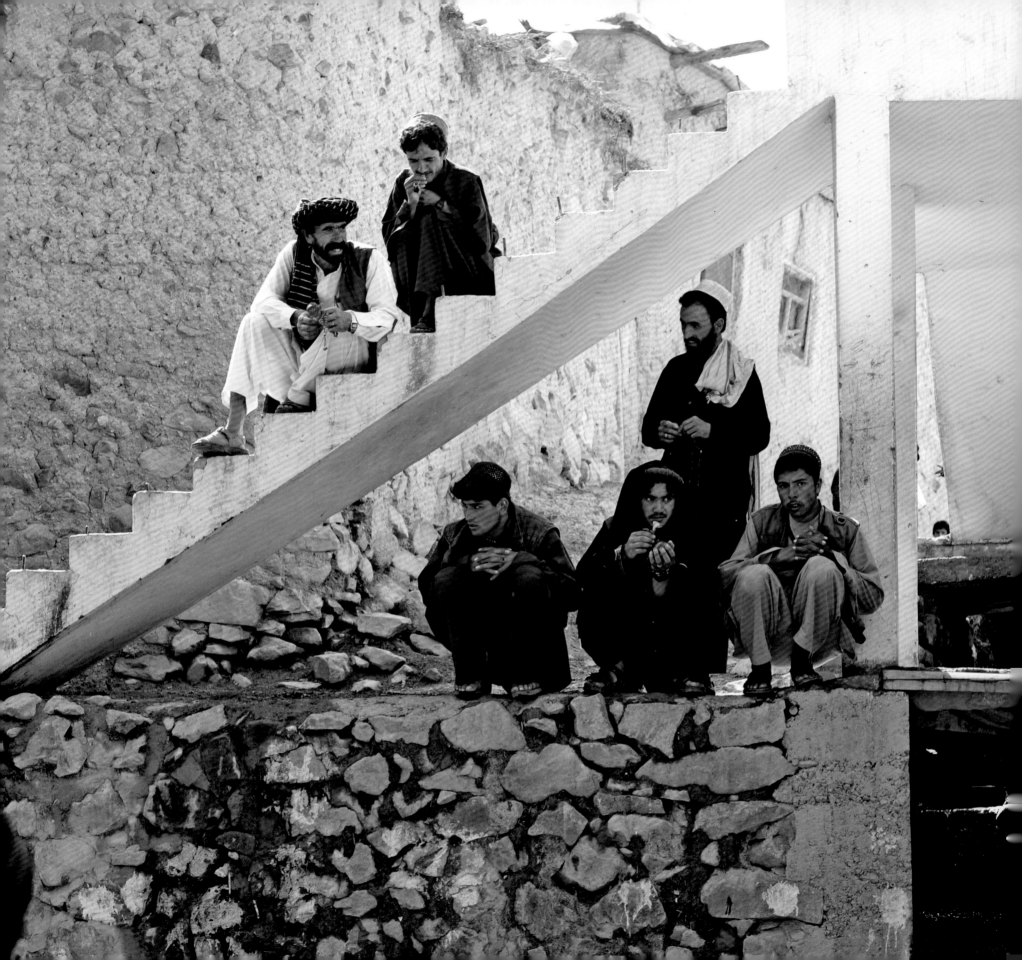

HEARTS AND MINDS

It's a tactical concept that used to belong solely to special forces. Small groups of men, highly skilled in small unit tactics, field medicine, weapons, psychological operations, and languages, and bathed in the social and cultural traditions of their area of operations, would infiltrate the enclaves of the enemy and turn the local population's loyalties around. The idea was to seize the advantage by winning the hearts and minds of the people, thereby denying the enemy footholds and safe havens. You had to be a hard-core, highly experienced Green Beret to pull it off. Now, everybody's expected to do it.

As a young American soldier, you've been taught to kill the enemy rather than teach him the finer points of democracy. But now you find yourself building schools and delivering water, grain, and goats. You show up like a freshly hatched superhero, ready to fix all the problems, be the savior, make a difference in Afghanistan. You're going to throw yourself into it (even if it's mostly to forget how far away you are from your family). Your commander, a twenty-something captain, is regarded by the seventy-year-old village elder as a rich baron with endless coffers of treasure. The captain wants intel on where the local Taliban, Al-Qaeda, and Haqqani warriors might be hiding out, so he has to barter with goodies, from ball-point pens (extremely popular) to cows (who's got a spare cow here?). You and your buddies show up in a classroom to demonstrate your presence and support. The Afghan kids are being taught math and English. They're carrying book bags donated by the US Agency for International Development. You're all carrying machine guns. You grin and shake their little hands and want them to trust you, but the day before this, you arrested one of their favorite teachers for emplacing an IED.

All over the world, children are open to kindness, their smiles easily encouraged with a handshake or a small gift. These Afghan kids are no different. However, their older brothers eye you with hatred and your gear with envy. And their grandfathers are stunningly unmoved by yet another military parade of conquerors. They've seen it all before . . . British, Italians, Russians, and now you. You can't win their hearts and minds. Soon enough, you too will be gone.

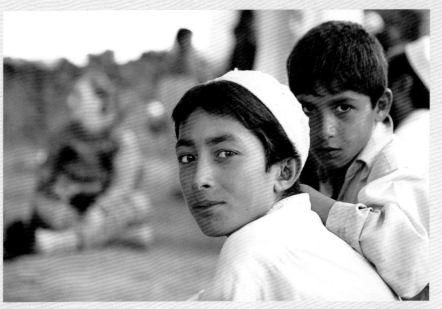

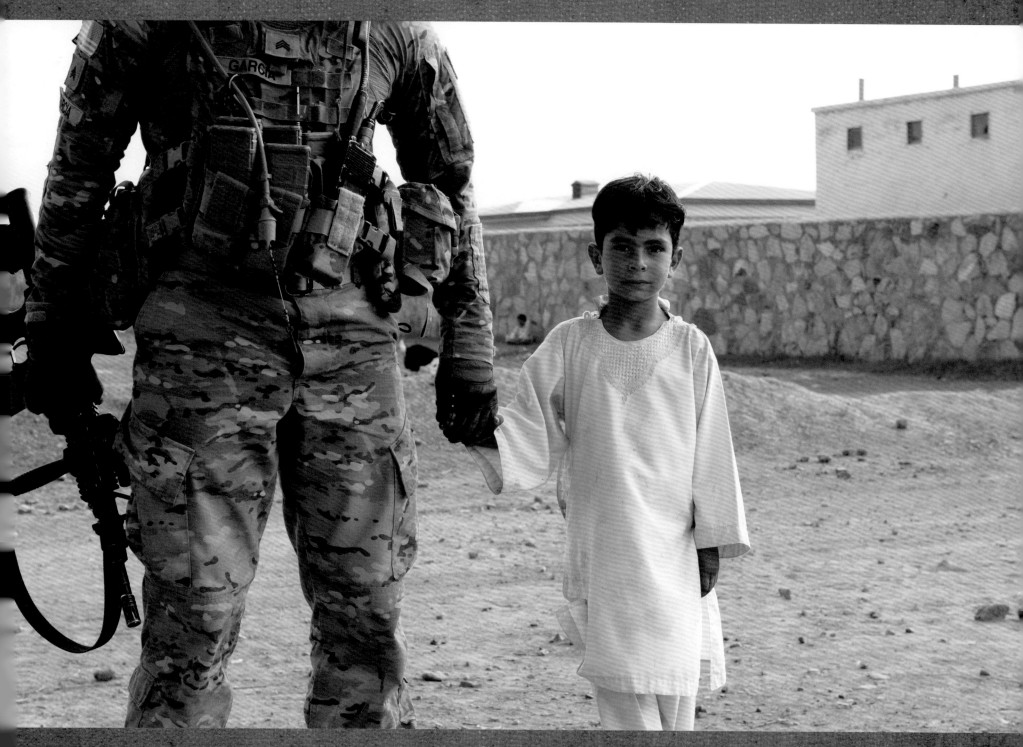

The young children here are innocent, curious, and forgiving, much the same as those back home.

The pakol, or Chitrali topi, is a hat as common and prolific as a baseball cap.

Key leader engagements (KLEs) are a daily occurrence in Afghanistan. These meetings start small, between one or two elders and US troops, and quickly grow to be quite the local attraction.

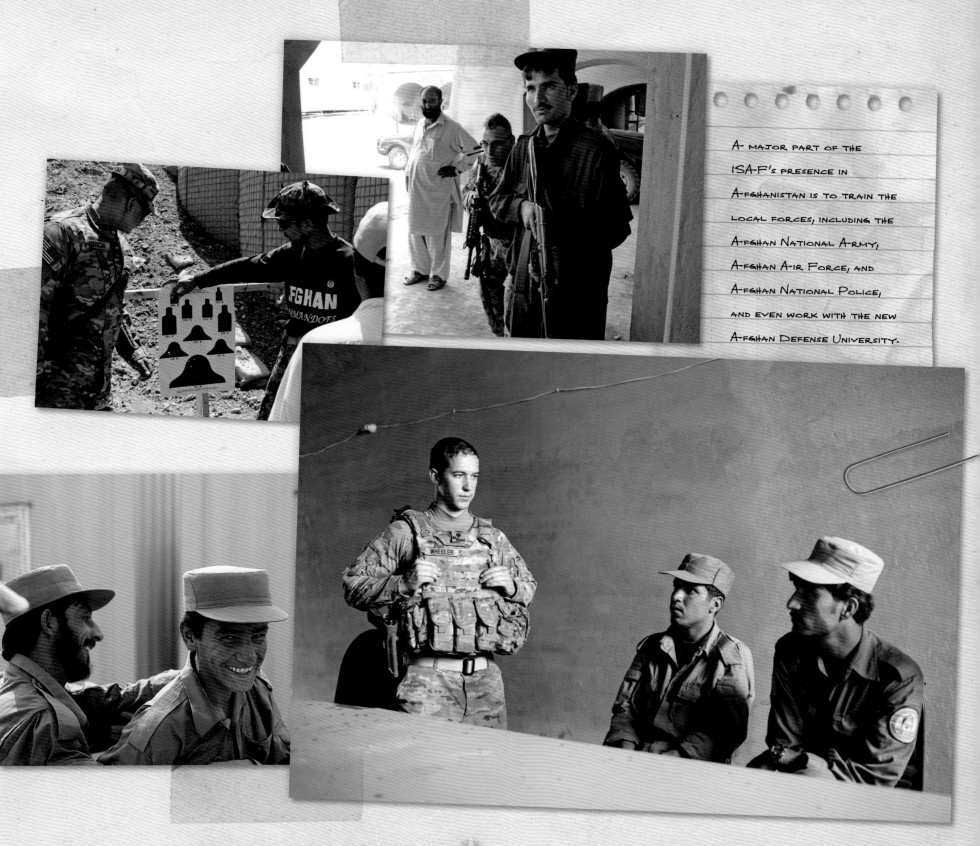

A major part of the ISAF's presence in Afghanistan is to train the local forces, including the Afghan National Army, Afghan Air Force, and Afghan National Police, and even work with the new Afghan Defense University.

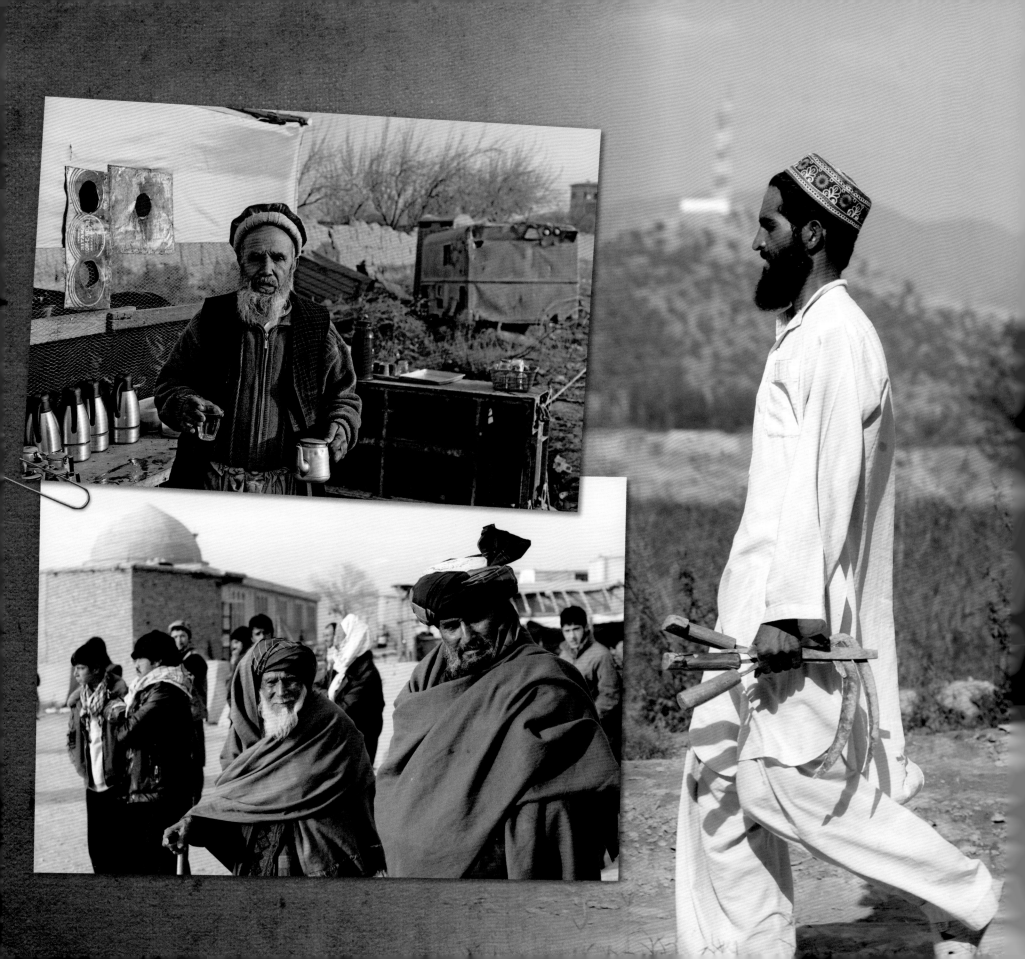

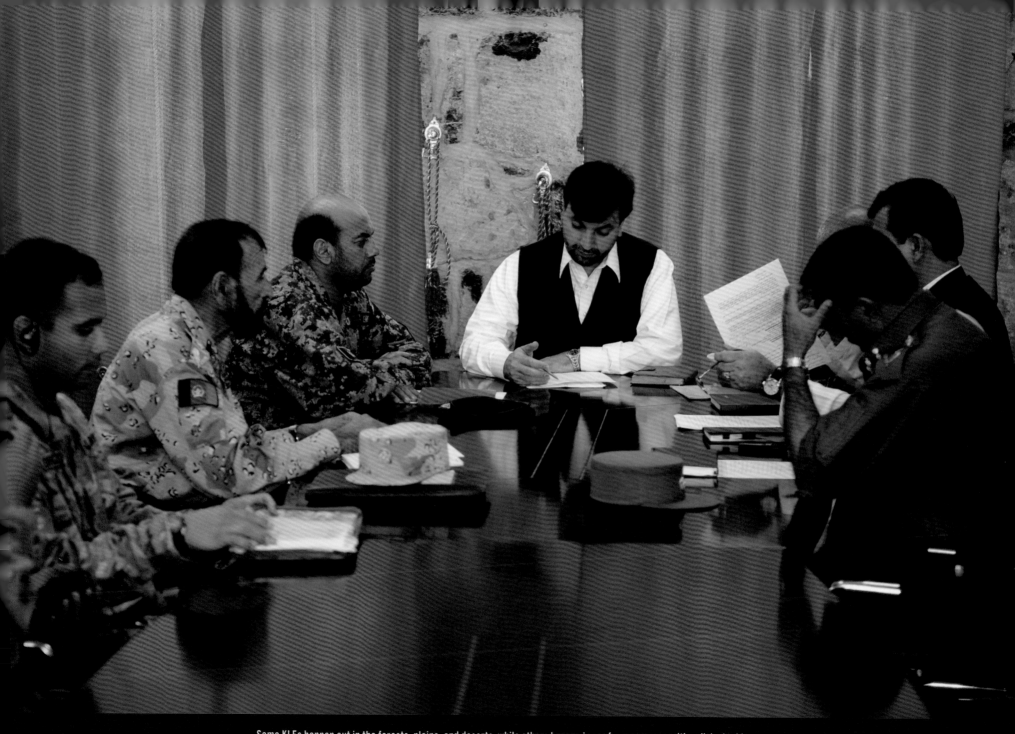

Some KLEs happen out in the forests, plains, and deserts, while others happen in conference rooms with polished tables.

11

DUSTOFF TO DOCTOR

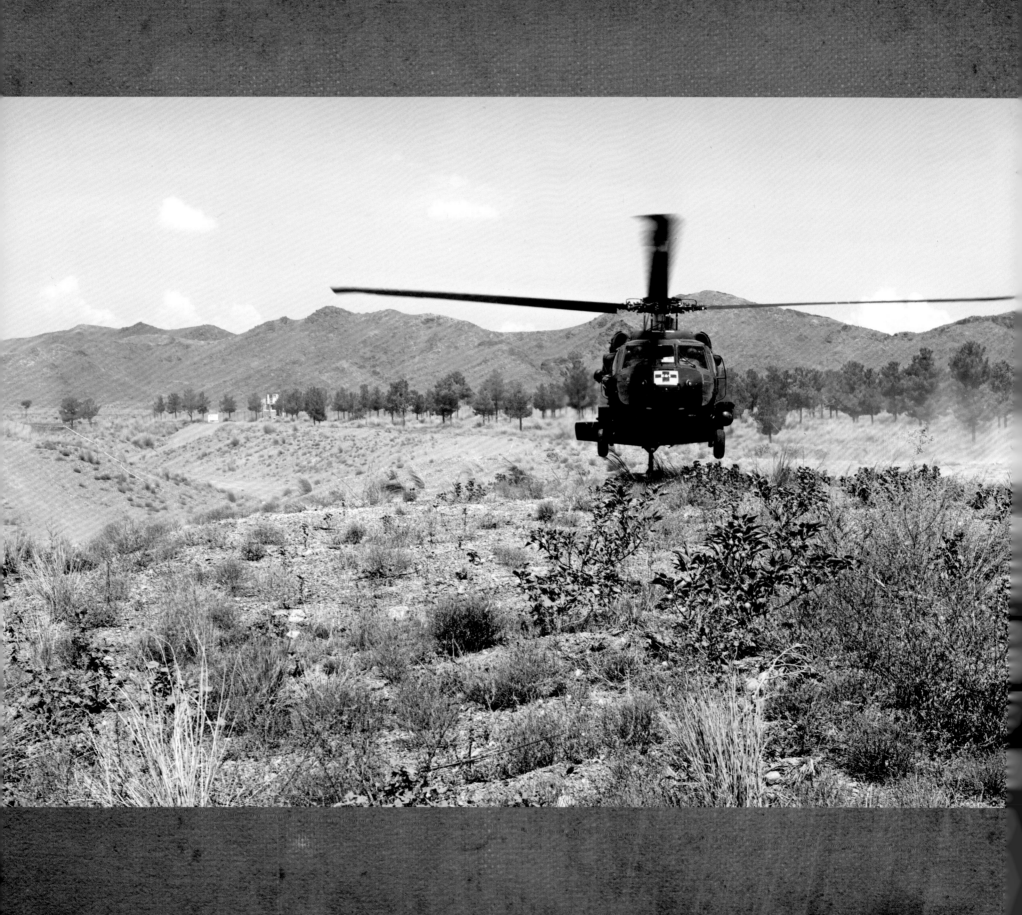

DUSTOFF TO DOCTOR

Definition: Dustoff (*noun*) 1. Military slang for casualty evacuation (CASEVAC) by helicopter.

The IFAK. The individual first aid kit. You pack it, you check the contents, and then you attach it somewhere on your gear where you can't actually see it. You don't need to be reminded that at any moment you might take a bullet or a whipping splinter of shrapnel or be suddenly lying there without a limb and bleeding out. It's the elephant in the room, the thing nobody ever talks about, never far from your mind. When you're out on patrol, right there in front of you is your buddy's IFAK, attached to the back of his combat gear. If something happens to him, you're going to use whatever's in his kit to save his life. If something happens to you, your buddy's going to use yours. You pack that thing carefully.

When it happens, it's a shock of sound followed by a wave of deafness. Your capillaries contract, pulling the blood from your extremities and your brain, till you shake it off and return to reality. Where are we? What happened? The explosion didn't hit you; it hit your buddy, and he's down, with a piece of him missing. The unit medic's already on his way, but you jump in too, because you're all trained in the basics. Your buddy needs a tourniquet above the knee, but his tourniquet was in the lower left pocket of his uniform trousers, and all that's gone. You reach for one of your tourniquets; the Velcro closure is slick with blood. Somebody's already called in a CASEVAC helo. You're supposed to write the time of when you applied the tourniquet somewhere on the casualty, but no one's got a marker. You dip a fingertip into your friend's blood, look at your watch, and smear the time on his forehead.

Then you all wait, lying there in a protective circle, weapons outboard, while agitated Afghans stream toward you and are waved off by your nervous comrades with crazy eyes. You can hear your buddy screaming, but you look only at your sector until, at last, you hear the sound of that blessed machine. Swirling dust, a litter kicked open, a crew chief with a Darth Vader helmet guiding the litter into the iron bird. Then it's gone, and you are all lesser men.

It is life or death? You won't know for hours, maybe days. You stand up and move out again. Back to the war. No one has any words of wisdom, but someone mutters, "FIDO." Fuck it, drive on.

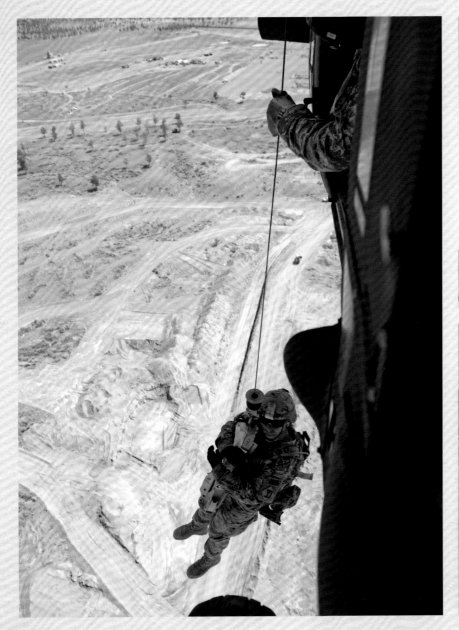

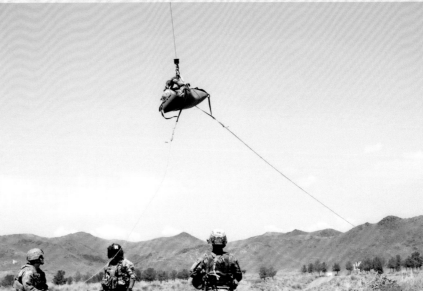

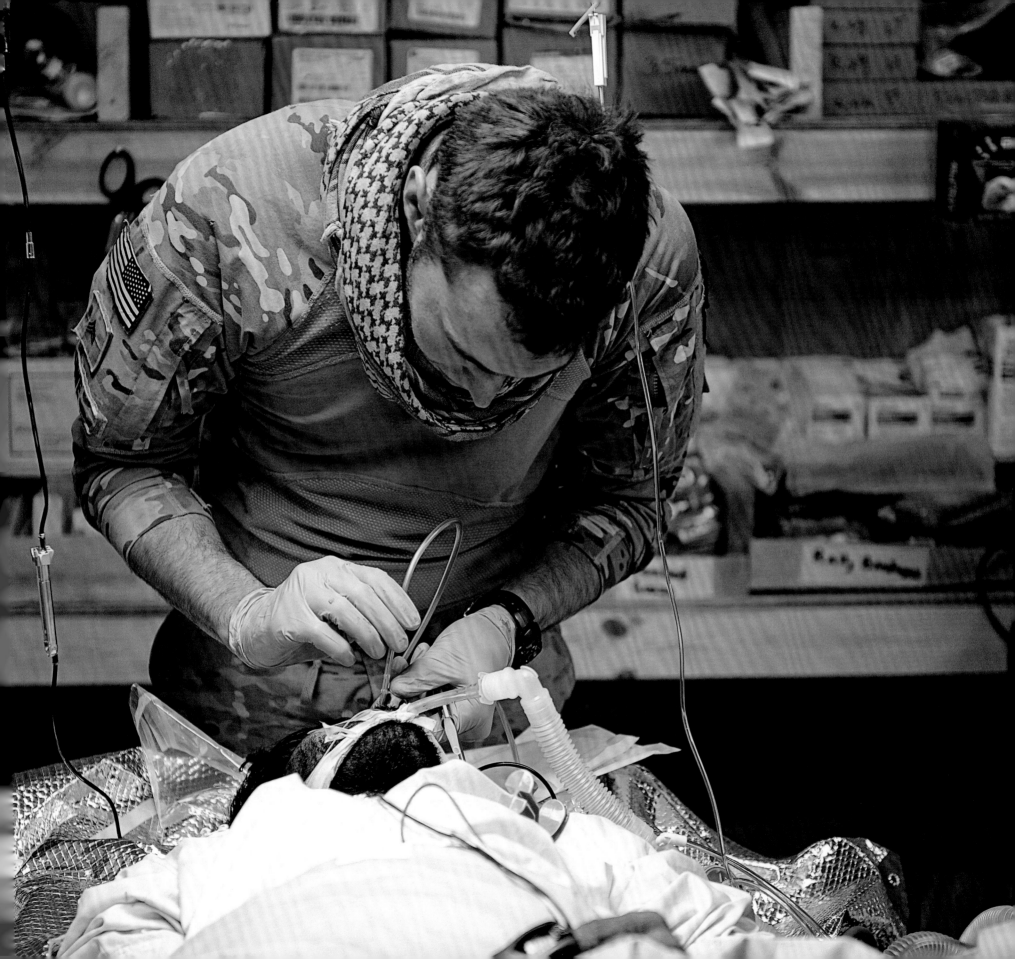

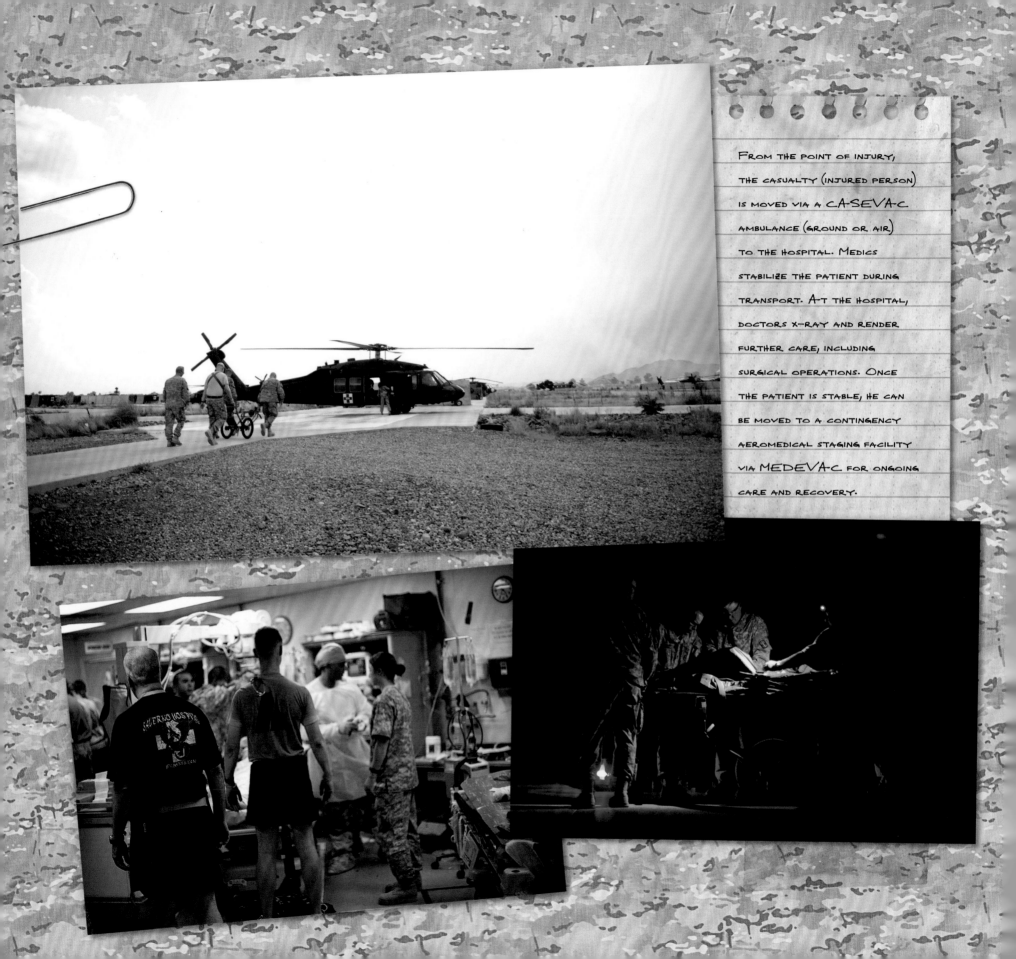

From the point of injury, the casualty (injured person) is moved via a CASEVAC ambulance (ground or air) to the hospital. Medics stabilize the patient during transport. At the hospital, doctors x-ray and render further care, including surgical operations. Once the patient is stable, he can be moved to a contingency aeromedical staging facility via MEDEVAC for ongoing care and recovery.

12

FLESH AND BLOOD

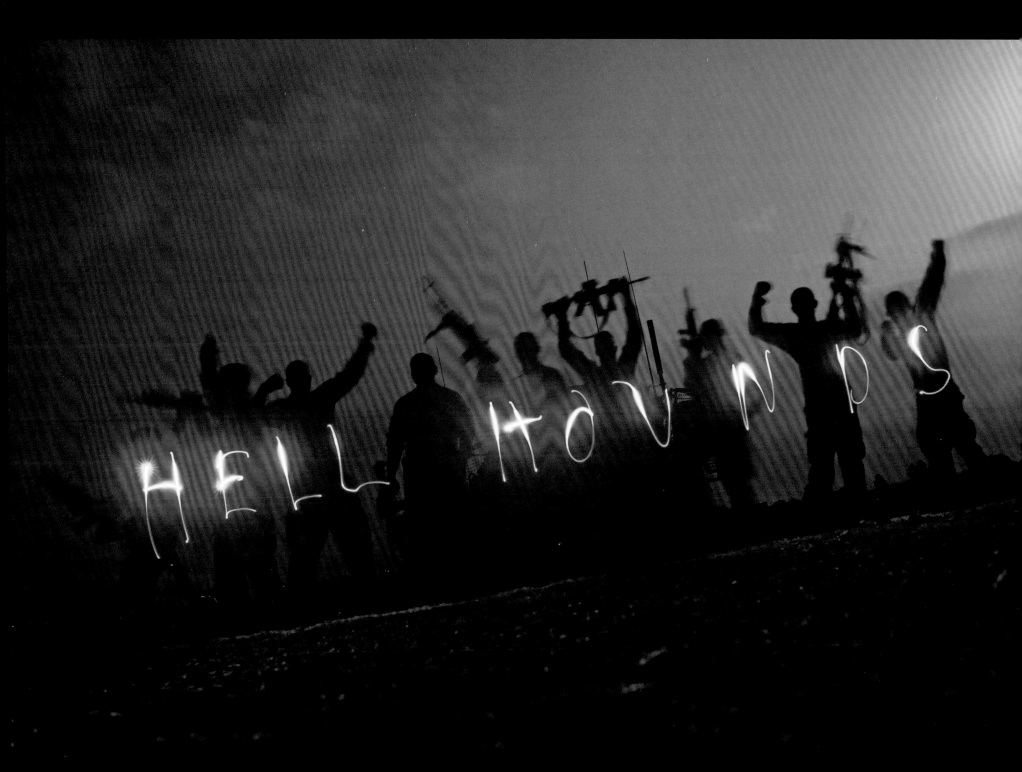

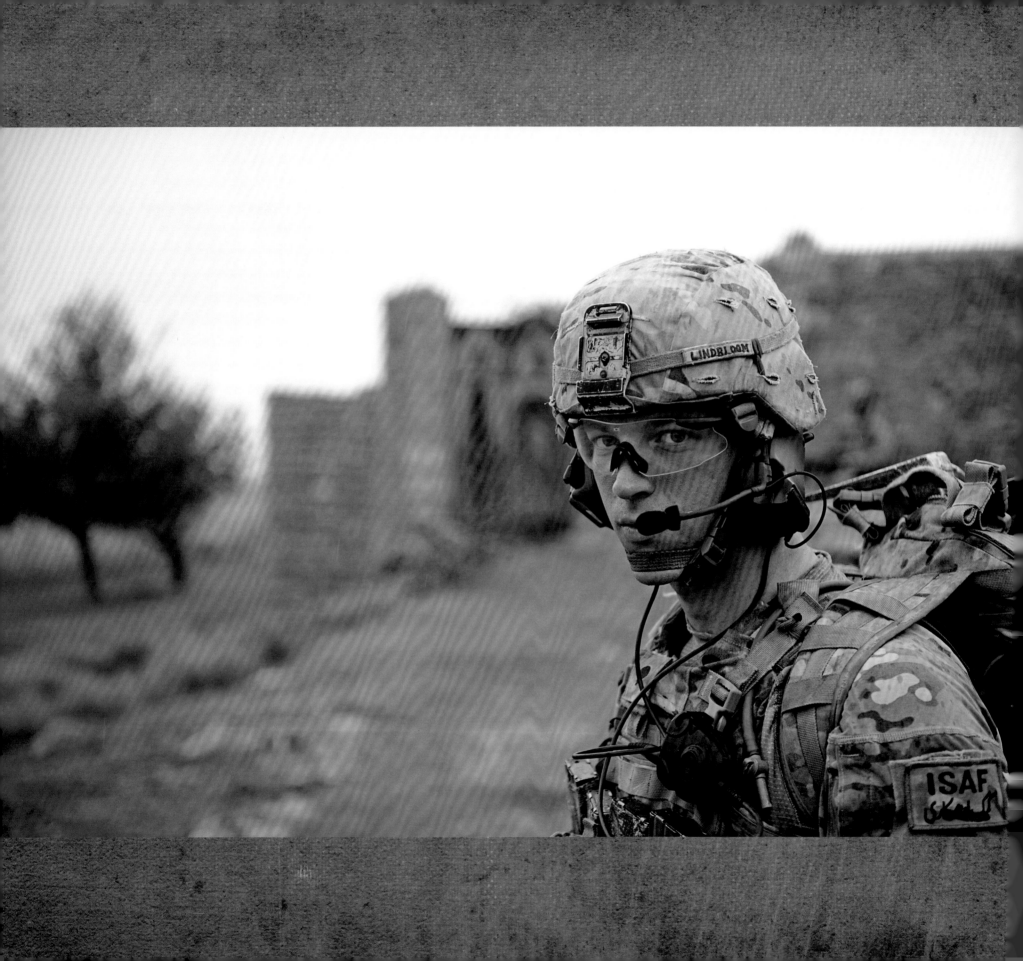

FLESH AND BLOOD

No soldier fights alone. In the midst of combat, which can be the loneliest, most desperate, terror-drenched experience of your life, the only saving grace is the certain knowledge that your brothers and sisters are there beside you. They may not be the siblings you were raised with, but they will certainly give their lives to save yours, and you'll do the same. When the bullets are flying, you're no longer fighting for some inscrutable ideal. You're fighting for love.

There was a time, not too long ago, when you barely knew these people. Now you know the names of their boyfriends or girlfriends, their favorite pets and fast foods, the music that takes them away for a while. Some of them irk you like annoying cousins, but they're your family now. Some of them you've grown so fond of that you can't picture the rest of your life without them, and it's something you'll never say. It doesn't need to be said. The unspoken secret is that everyone in your unit feels the same way. People don't join the military because they're loners.

War is a beast thirsting for souls. You wonder how you're going to remain human in an inhumane environment. How will you keep from becoming the monster you hunt? And the answer is in those short happy moments, bursts of laughter over a joke, a song belted out around a makeshift barbecue, a hug for a comrade who's just gotten bad news. Your unit is a larger form of life, the flesh and blood of its unique soldiers sinewed together to build the whole.

Eventually, and inevitably, you discover that it wasn't the war that got you into a uniform. Maybe a part of you sensed it when you decided to sign up. It's this love for the brother on your left and the sister on your right, and theirs for you. You couldn't have gotten that anywhere else.

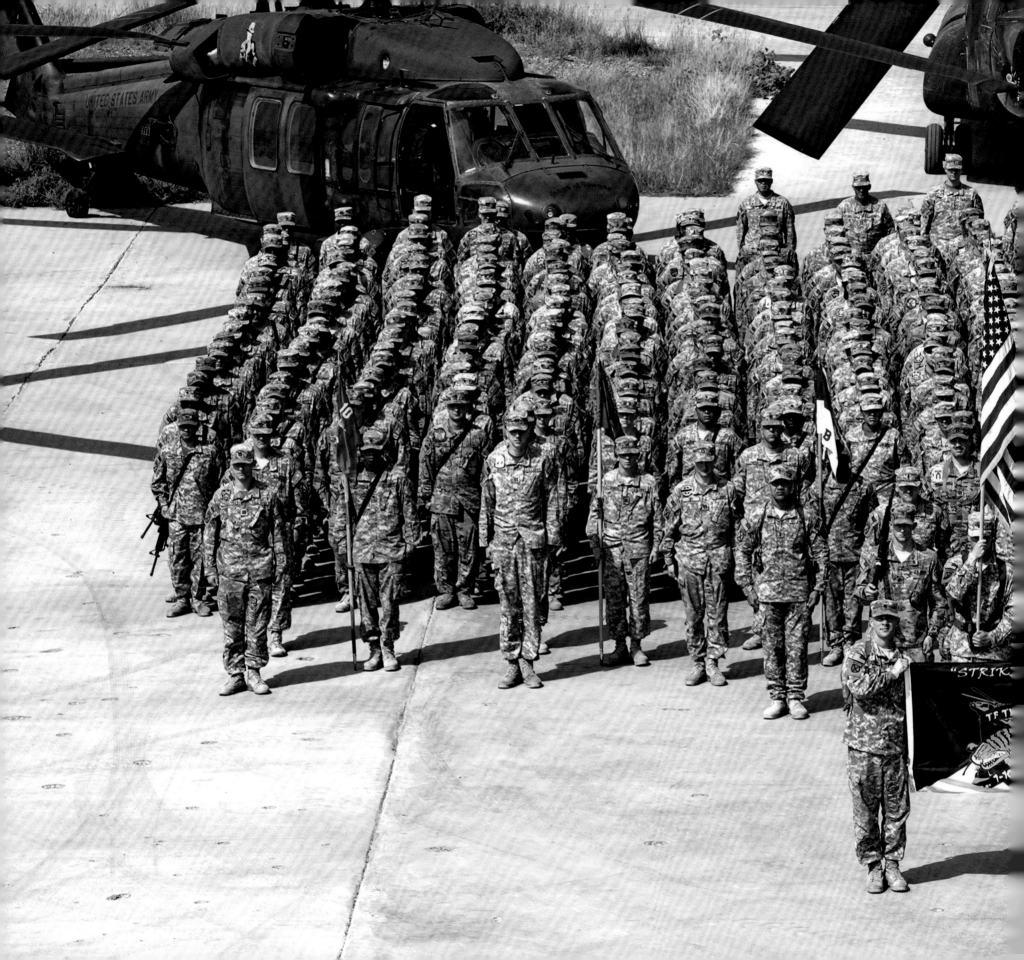

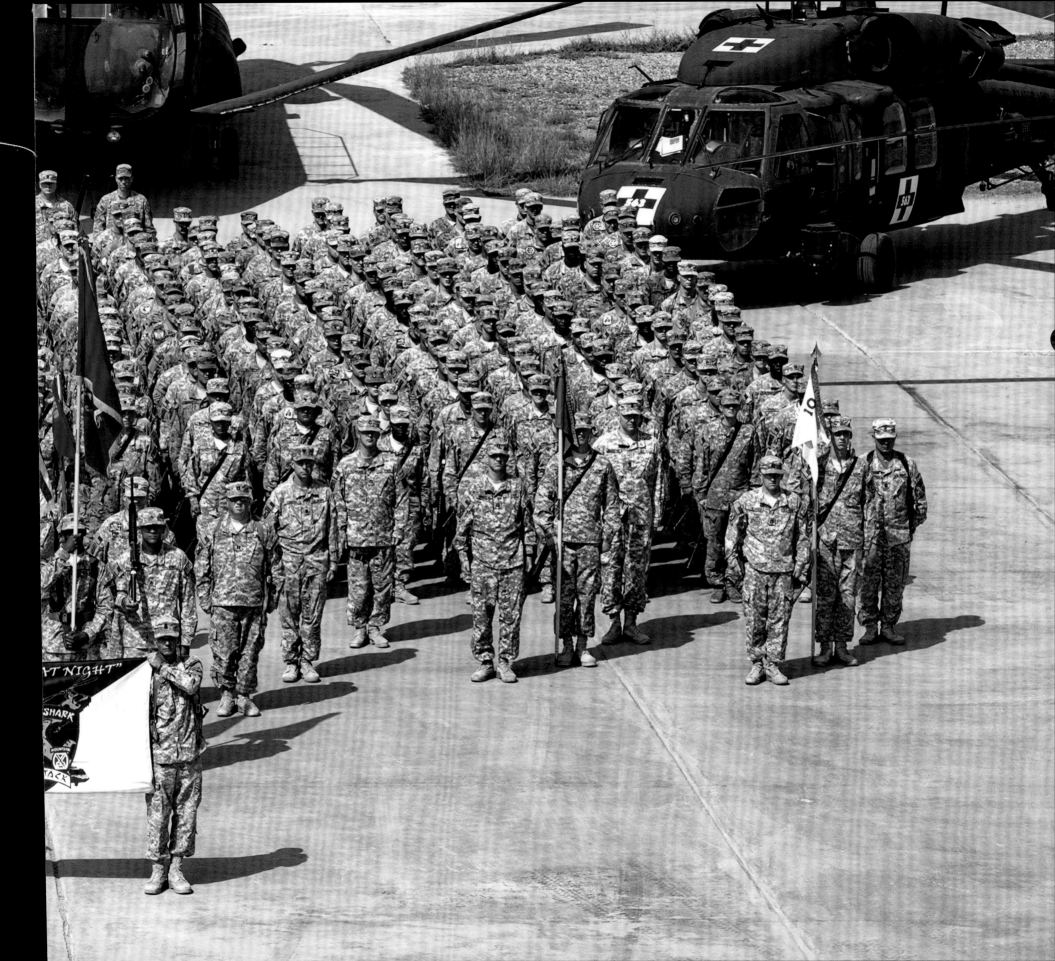

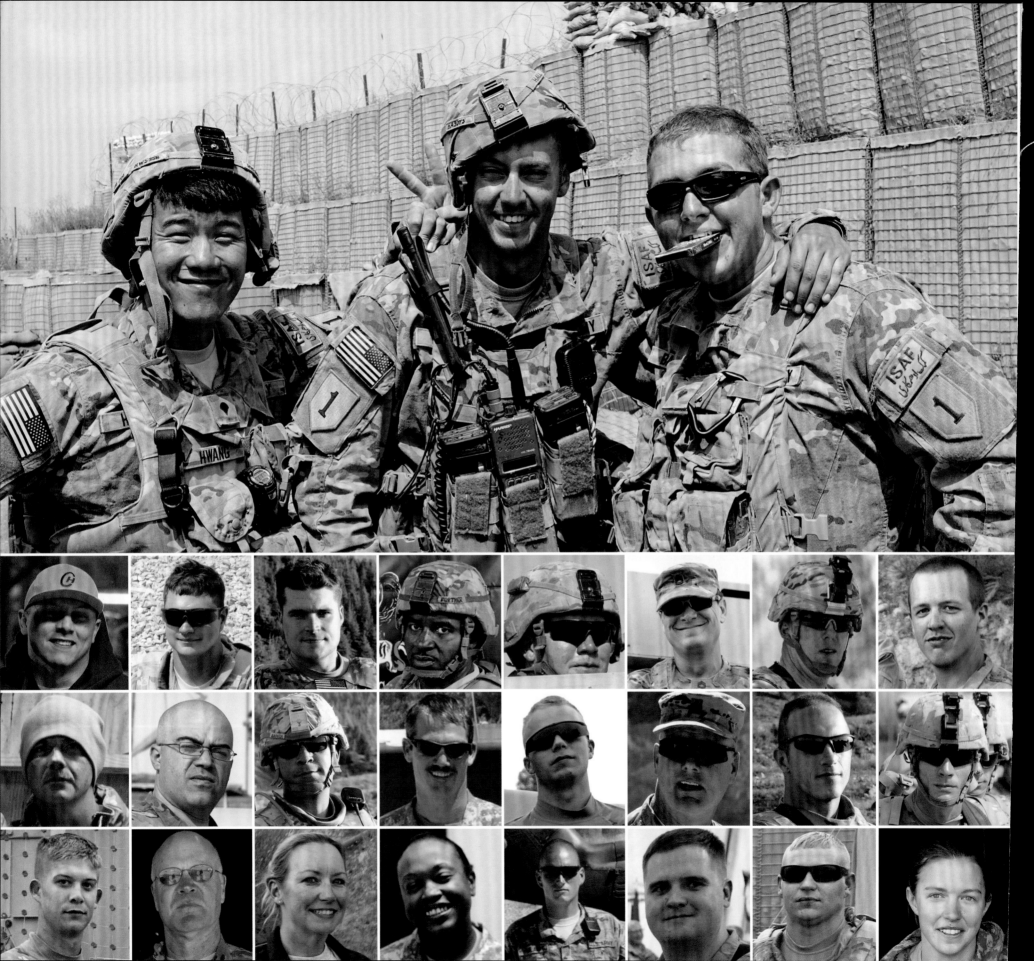

13

PRAY FOR ME

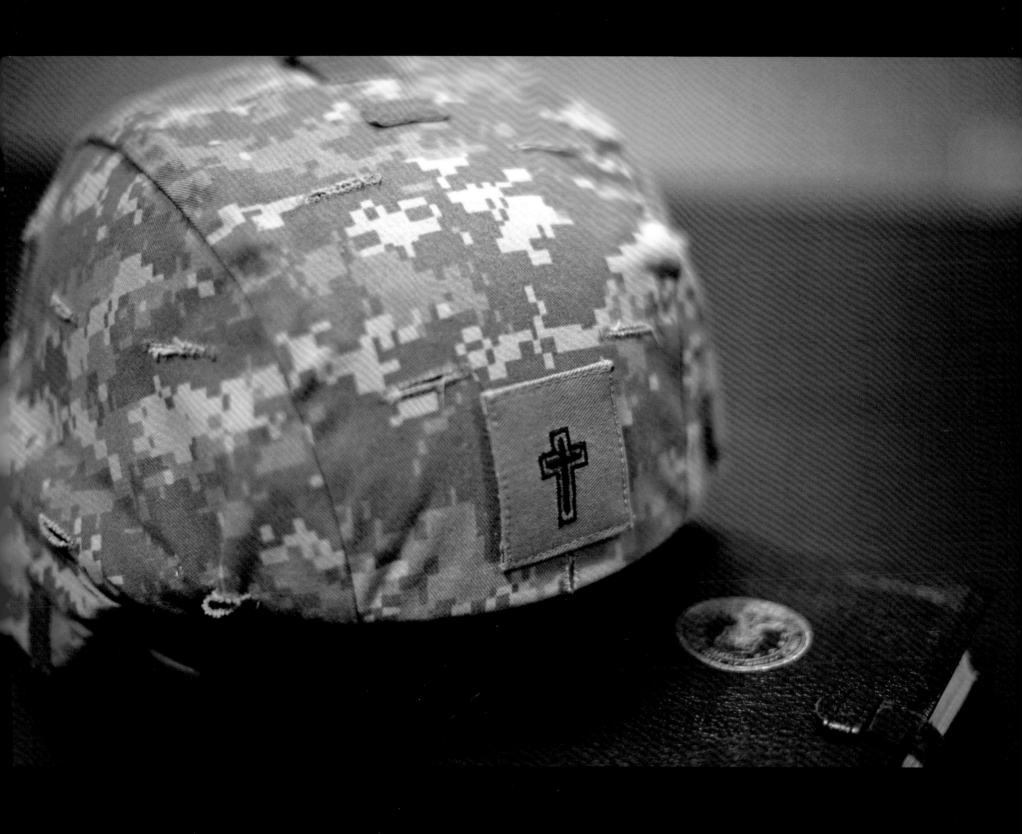

PRAY FOR ME

"There are no atheists in foxholes."

It's an often-repeated maxim, though it's not accurate. Being on the battlefield doesn't create religious convictions; it only enhances whatever was already there. A Wiccan doesn't suddenly renounce her beliefs under shellfire, and an atheist doesn't suddenly see Jesus. When you're over there, you're away from your congregation, your coven, your minyan, your support system, your circle of like-minded coreligionists. Your combat buddies don't know your pastor, your priest, or your rabbi. You find yourself alone in a world where that day of the week you believe is holy is just another day. Your first Saturday passes, and you weren't in the temple. Your first Sunday rolls around, and you're not in church. You find yourself trying to reach out to other people, and you shift your connective criteria. Here, it doesn't matter what denomination your buddy follows. You're just glad he believes in something.

When times are tough—and they will be, at war—you can turn to the nearest military chaplain. He's a pastor to some, a shepherd to all. He's attained some sort of rank, but he's probably the only soldier you know for whom that rank is almost meaningless. And, in a sense, it doesn't matter what religion he follows because he's likely to know more about yours than you do. His primary job, which is generally misunderstood, is to ensure the right of all soldiers to freely practice their religion, whatever that might be, without any attempt at conversion. He's almost an ethereal being. You'll find a three-star general seeking his counsel, but that general might have to wait because a private was first in line.

"It never hurts to have a chaplain on board." You'll hear that often, from everyone from helo pilots to convoy leaders. Even those who profess to believe in nothing somehow understand that if there might be a human bridge between the cruel real world and some better place after death, it's that guy with the easy smile and soft demeanor. You might never share a personal problem with your commanding officer or even your best buddies, but the chaplain is always a safe, completely confidential, nonjudgmental bet. And if you're going to die today, it would be just fine if he's the last man you see.

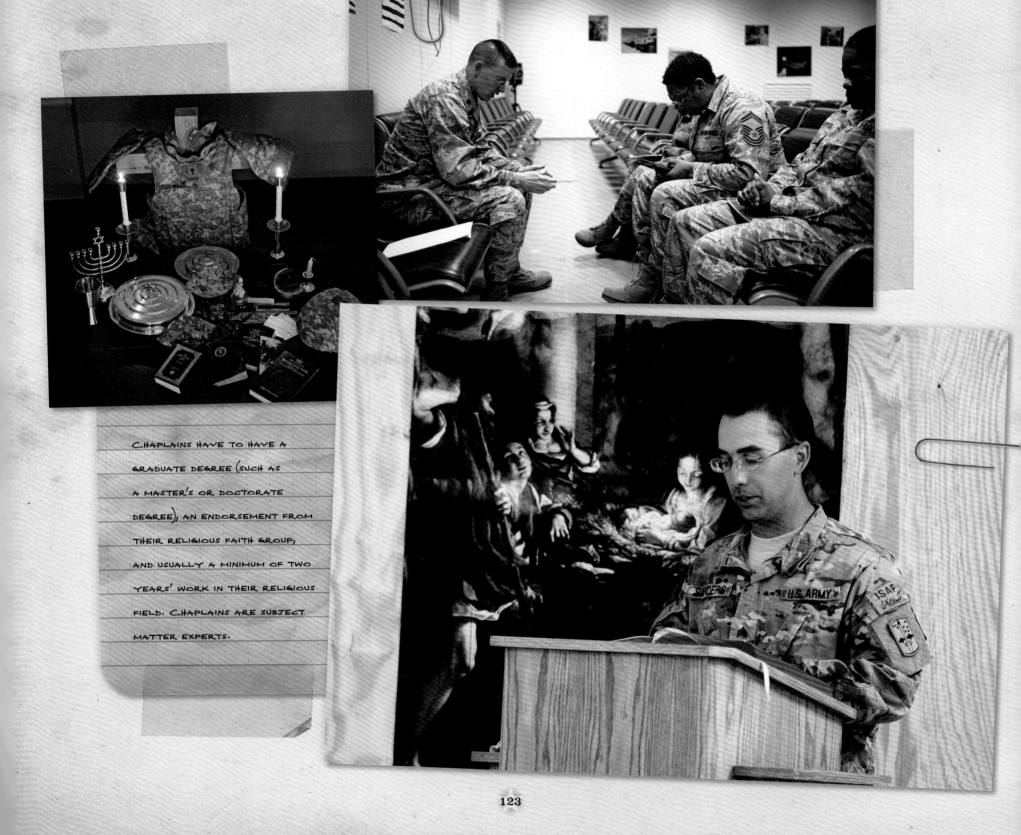

Chaplains have to have a graduate degree (such as a master's or doctorate degree), an endorsement from their religious faith group, and usually a minimum of two years' work in their religious field. Chaplains are subject matter experts.

Fulton Sheen's
WARTIME
PRAYER
BOOK

Given the ratio of servicemembers to chaplains, deployed chaplains spend a large amount of time doing battlespace rotation. A chaplain might be at your base today and across the country tomorrow.

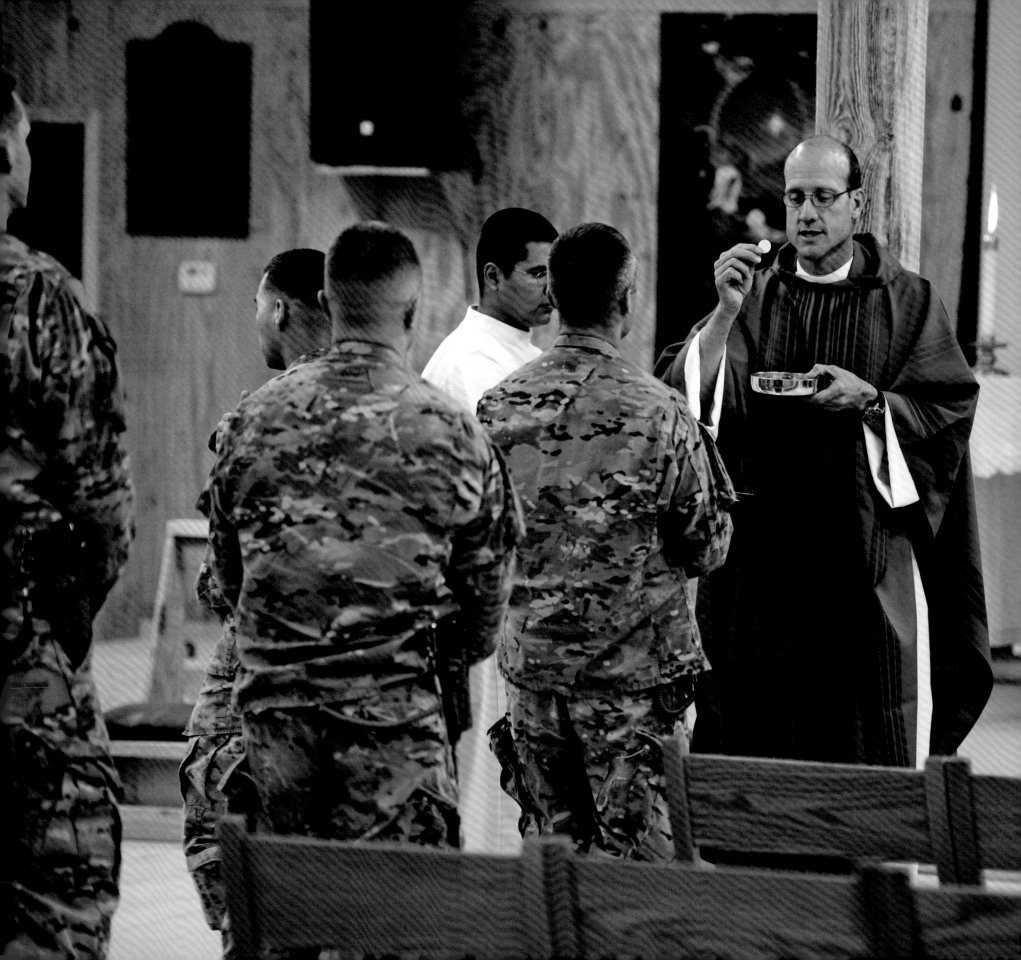

14

DOWNTIME

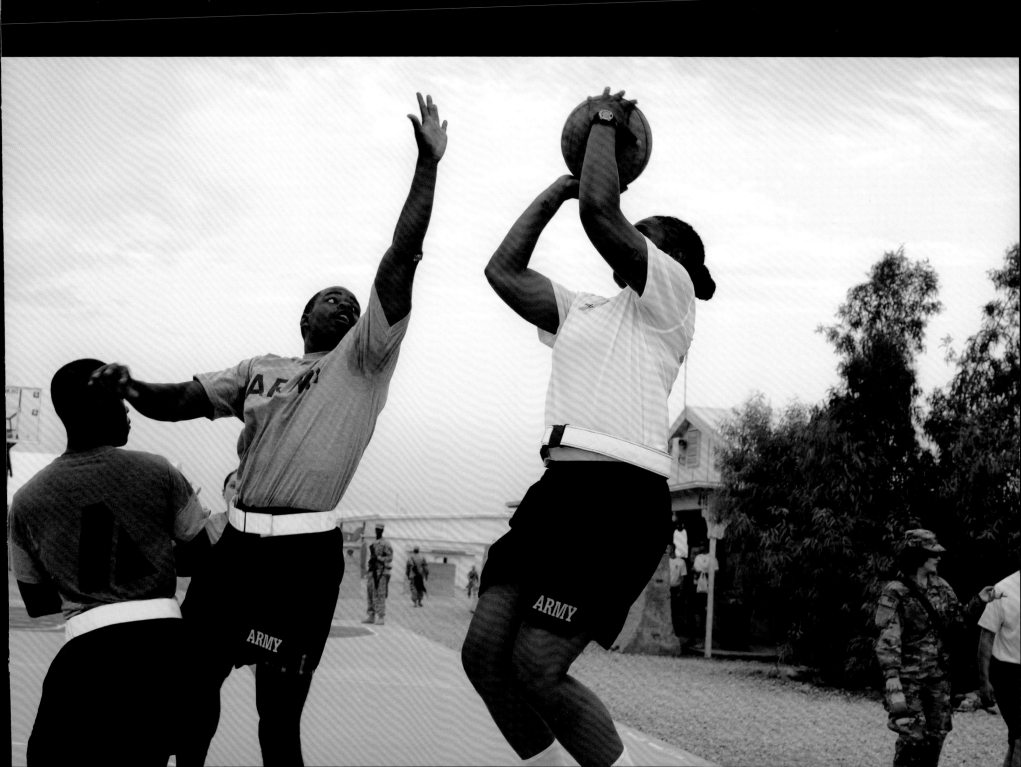

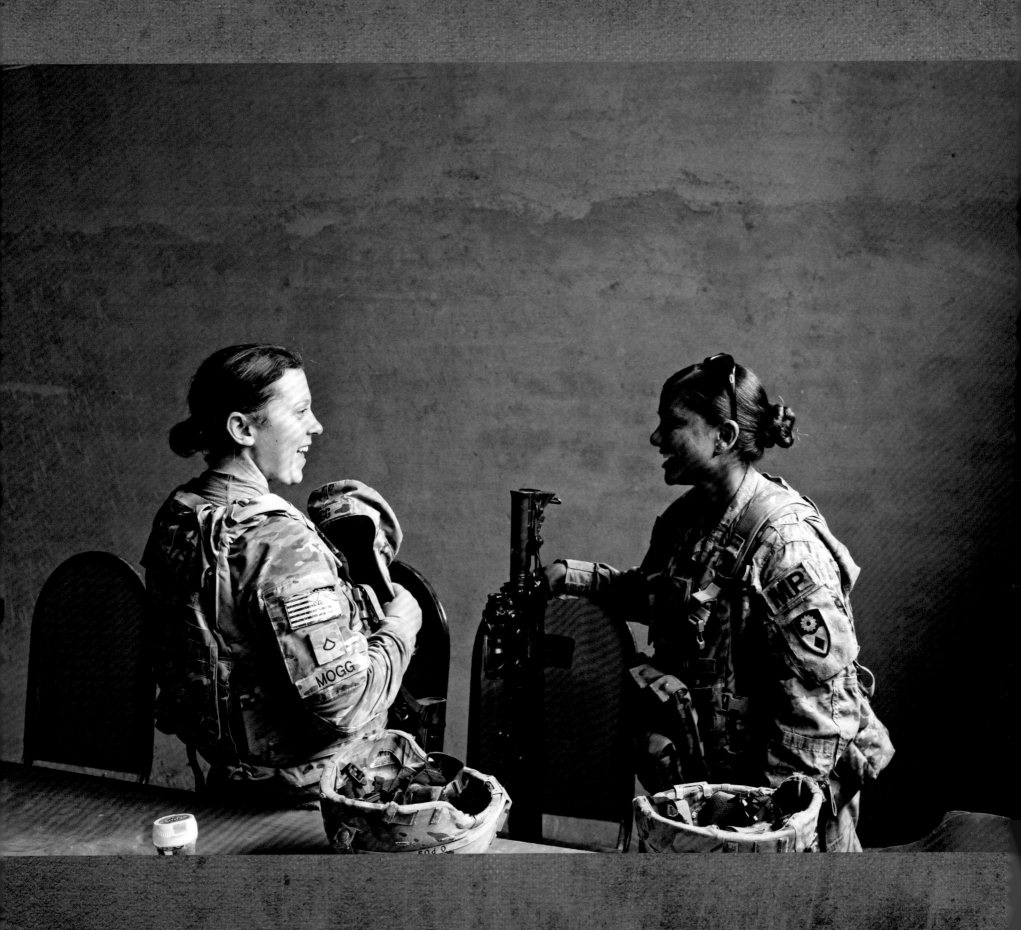

DOWNTIME

It's been said that war consists of long stretches of boredom punctuated by moments of sheer terror. But here in Afghanistan, boredom is a foe as dangerous as the Taliban, and it simply isn't allowed through the gate. Boredom would make the time slow and soupy, like a Salvador Dalí clock, so you pack those hours with something else.

Down near the helicopter landing zone, there's a rousing game of basketball in play. Sure, the guys and girls are wearing the requisite eye protection and neon PT belts, but it's still the same game. On an ammunition crate table out in the sun, there's the sound of poker cards flipping on wood and accusations of "dirtbag cheater" flying around, all with grins. Even at the filthiest combat outpost way out on the line, there's a computer room with ten soldiers waiting their turns to Skype with home, and while they wait they're slaughtering each other in a game of *Call of Duty: Modern Warfare*. Everyone gets the irony; no one mentions it. Outside, you can hear the slap of baseballs in leather gloves and the silence of troops losing themselves in their favorite novels. Soldiers squeeze into their bunks to watch movies on their laptops, and there seem to be more LEGO kits around than when these young guys and girls were still kids at the mall. And if none of that works, there's always physical training—more push-ups, more sit-ups—because soon enough, you're going to have to haul your gear again for a long walk in the snow or the sun.

Every other soldier seems to have a guitar. Some of them can actually play and sing. Someone with real carpentry skills has decided that the roof of the tactical operations center would make a fine penthouse balcony. Suddenly, a set of stout stairs has been constructed, along with benches and a barbecue pit. Night falls and the fire leaps and sparkles, and beyond that you can't see anything, just endless waves of darkness and maybe the lights of one distant fire base, floating out there like a ship at sea. Someone starts singing, cigars are lit, and tall tales are passed around like popcorn. You're no longer in Afghanistan. You're back at summer camp, in a heavily armed version of the Boy Scouts. You could be anywhere but here, and that's good for now.

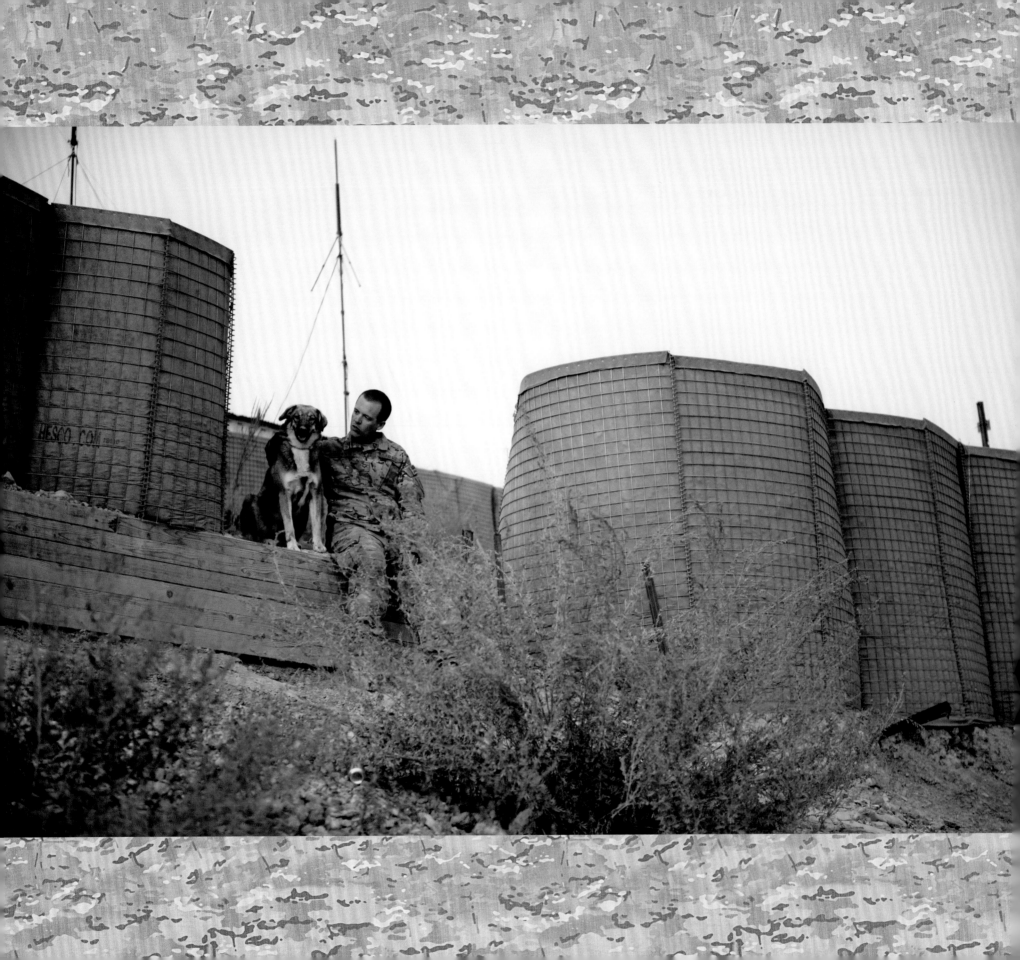

Deployed servicemembers have to find something to occupy their minds during the hours between missions. It could be spending time with an adopted dog, recreating a favorite TV show, doing homework for a distance-learning college course, or singing songs on a deck around a firepit that a soldier built in his spare time.

REAPER AMU

Vivere Commune est, sed non Commune Mereri

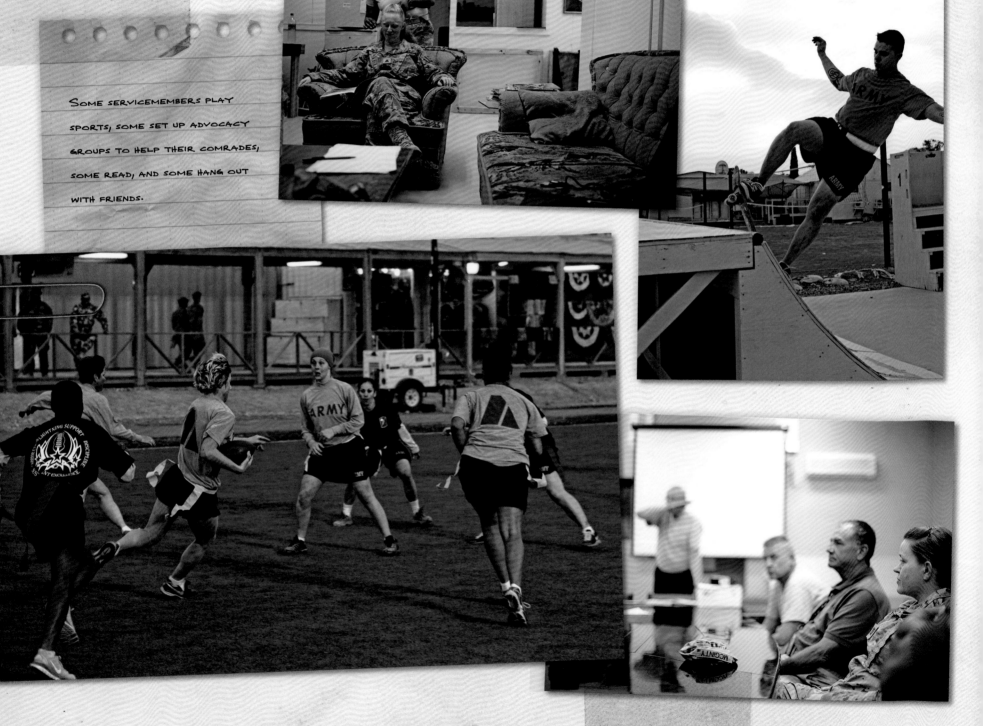

Some servicemembers play sports, some set up advocacy groups to help their comrades, some read, and some hang out with friends.

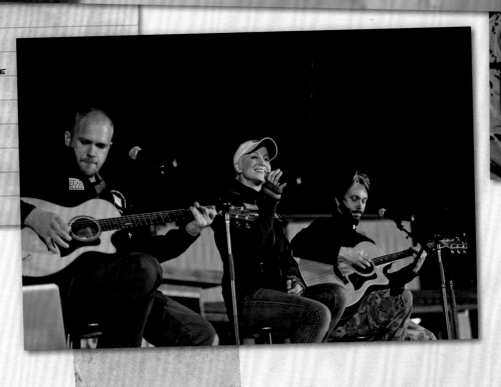

Some servicemembers volunteer their time to educate the local children and advance humanitarian aid.

When a dignitary or a celebrity like Kellie Pickler pops over for a morale visit, it's a huge occasion!

15

THE HERO RAMP

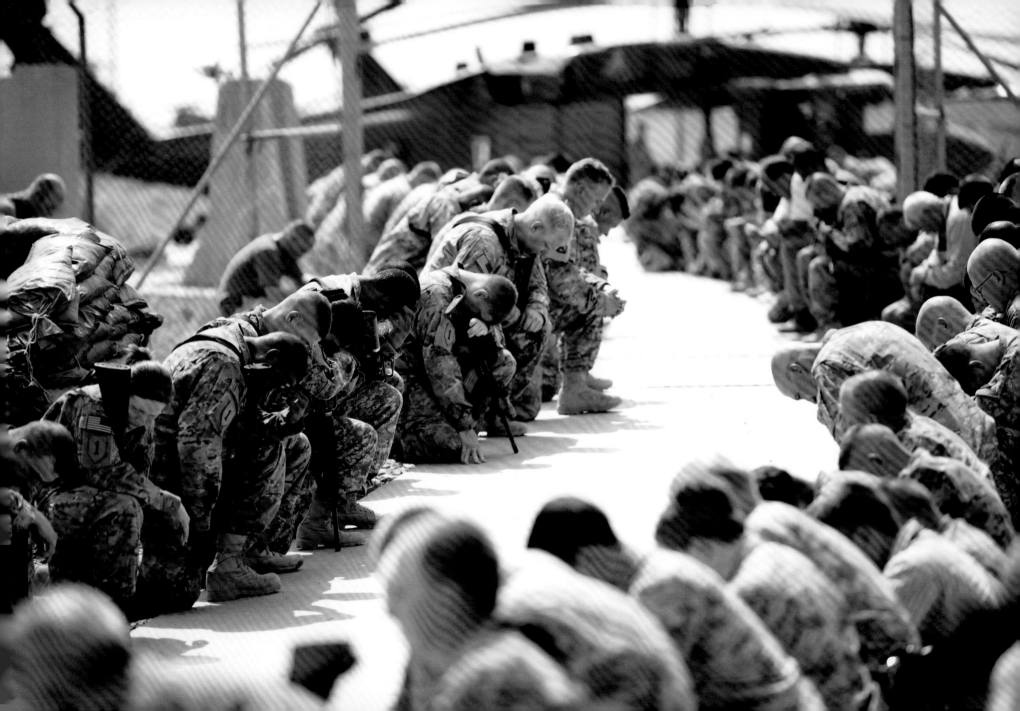

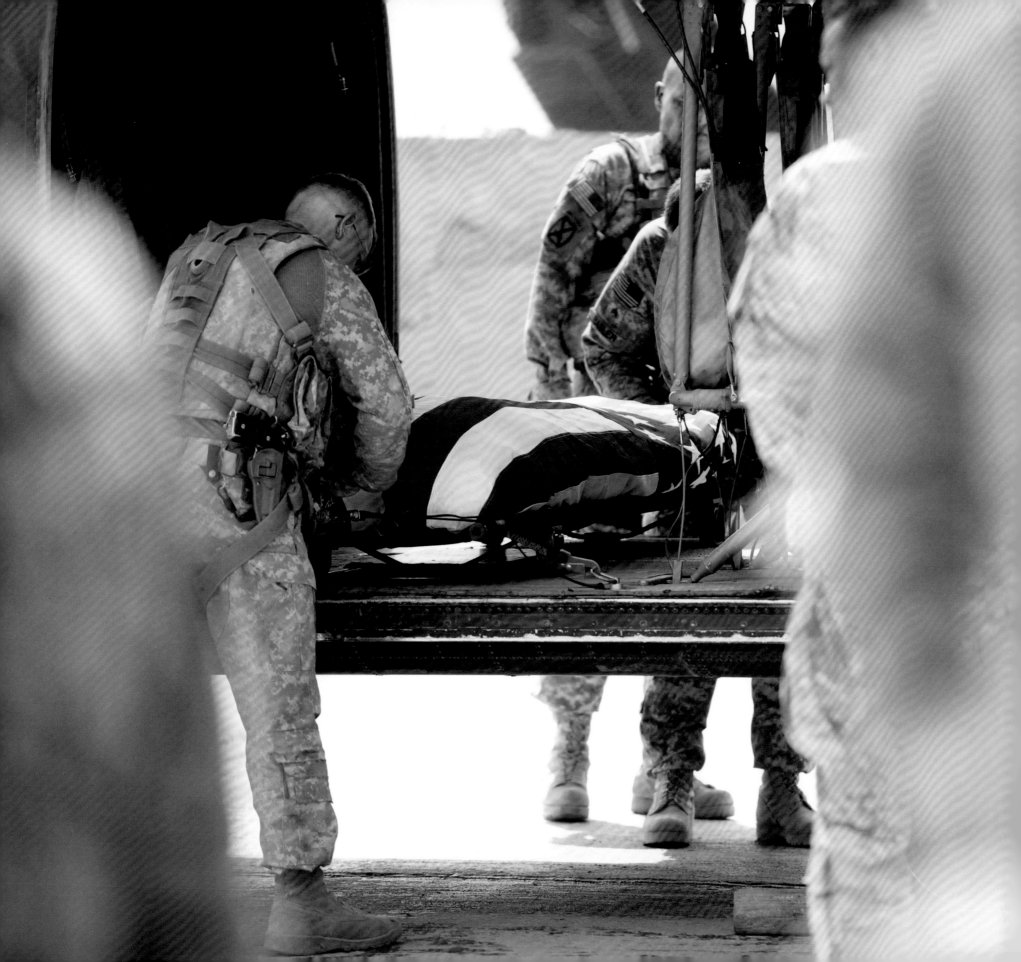

THE HERO RAMP

It's a beautiful, bright, sun-washed day at a forward operating base in eastern Afghanistan. The skies are clear, the air imbued with a hint of dust and pine. It would be the perfect afternoon to take a day off from the business of war, except that today will be the final journey of a fallen soldier. He survived the many furies of active combat until he finally fell and was carried onto a CASEVAC helo by the loving hands of his brothers. But in spite of the efforts of the medics, doctors, and nurses, and the prayers of the chaplains, he did not survive Afghanistan. In many ways, few soldiers do.

We are told, with cynicism, that we are born alone and we will die alone. But from the moment of his very last breath, no American hero is alone out here. The word is relayed in whispers. There's a Hero Ramp ceremony today. And they begin to gather, from all over the base. Soldiers, airmen, Marines, nondescript civilians from other government agencies, contractors and cooks and drivers. No one needs to tell them where to stand, how to form up, what to do. They know this, and they swirl into a silent cordon of respect, lining that final path from the hospital to the pair of Black Hawk helicopters, one of which will serve as his riderless horse.

Encased in a rubber cocoon, draped in the American flag, escorted in silence on a wheeled gurney, he is never without guiding hands, prayers, or salutes. This is a moment of secrets kept, for only this soldier's warrior brothers and sisters know that he is gone. It will be some time until his wife gasps with the news. His parents and children haven't yet been informed. Only later will they know that two hundred souls wept here with him and served as his most devoted bearers to that final flight. When it's over, and the helicopters have faded away into that perfect sky, the mourners will disperse in absolute silence. He has given his last full measure, and their comfort is in knowing that should their time come, they will also be delivered by a brace of angels.

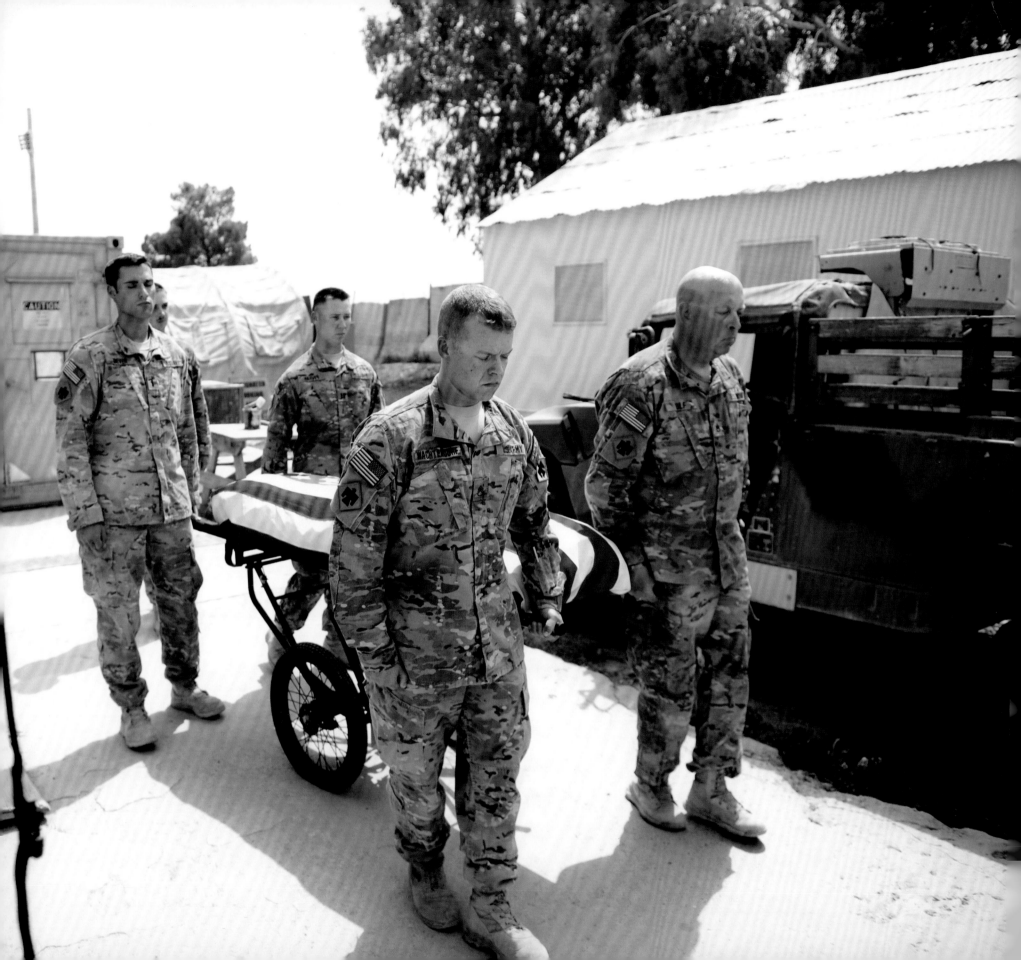

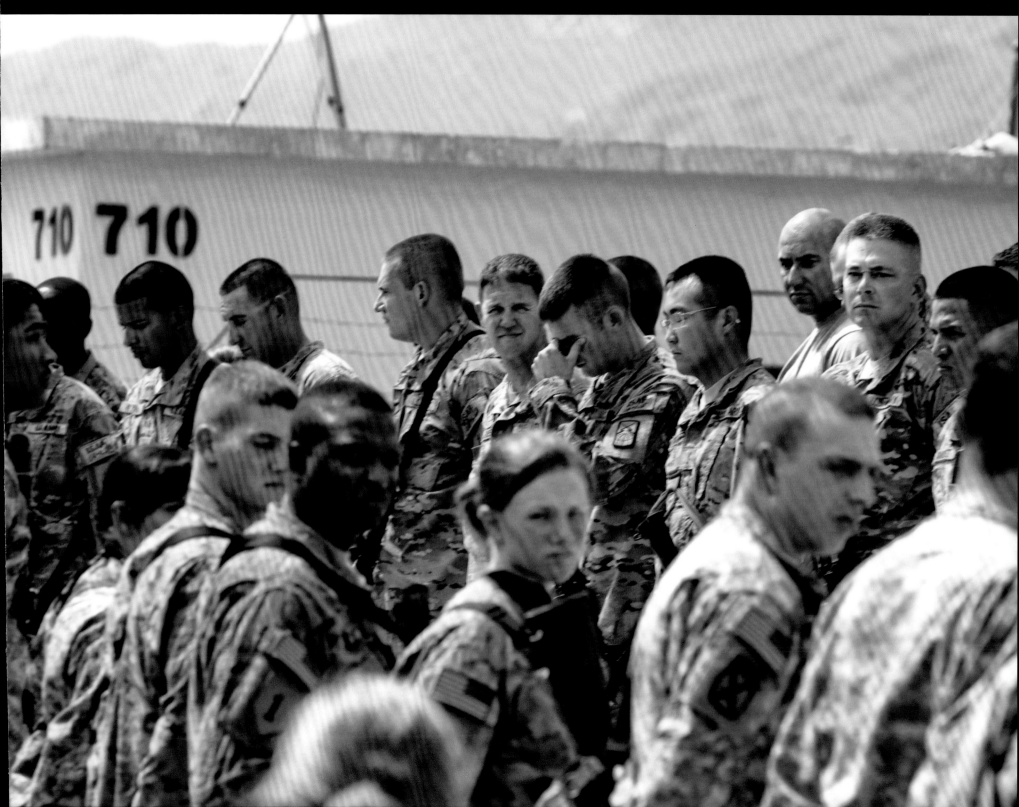

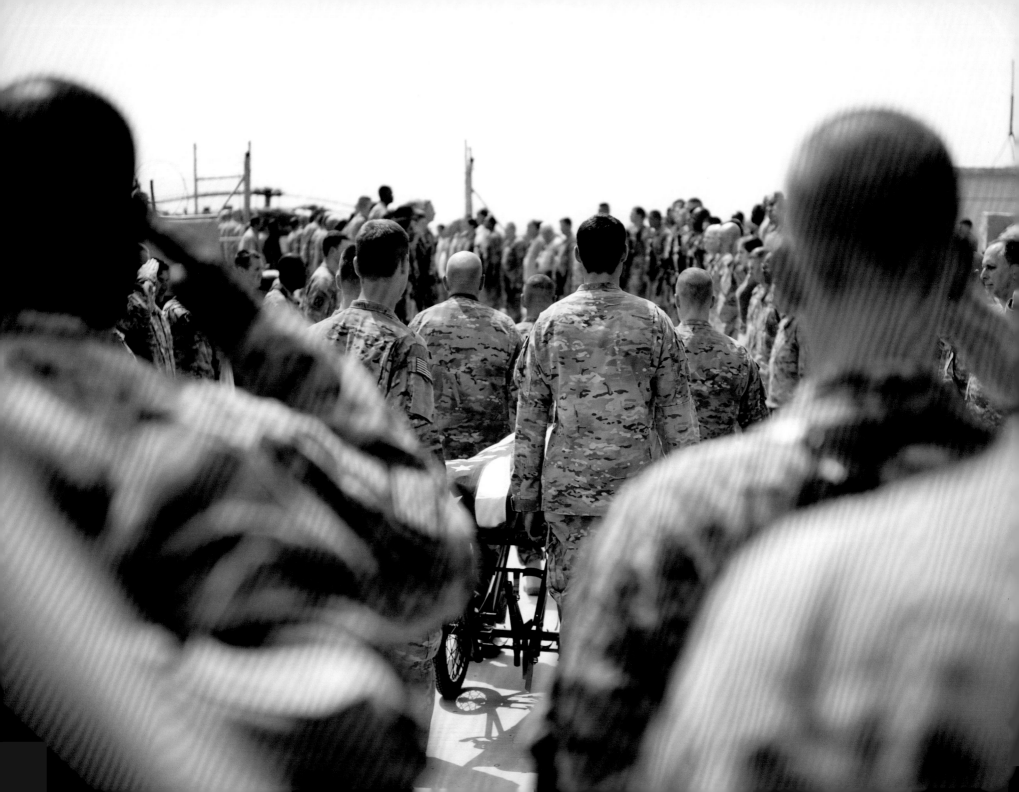

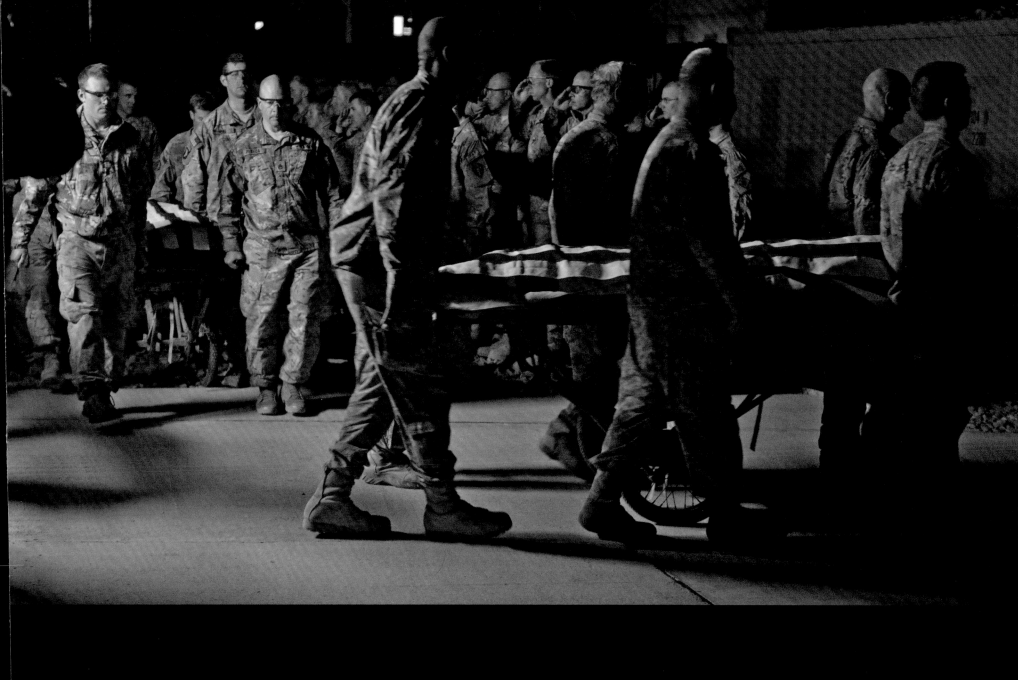

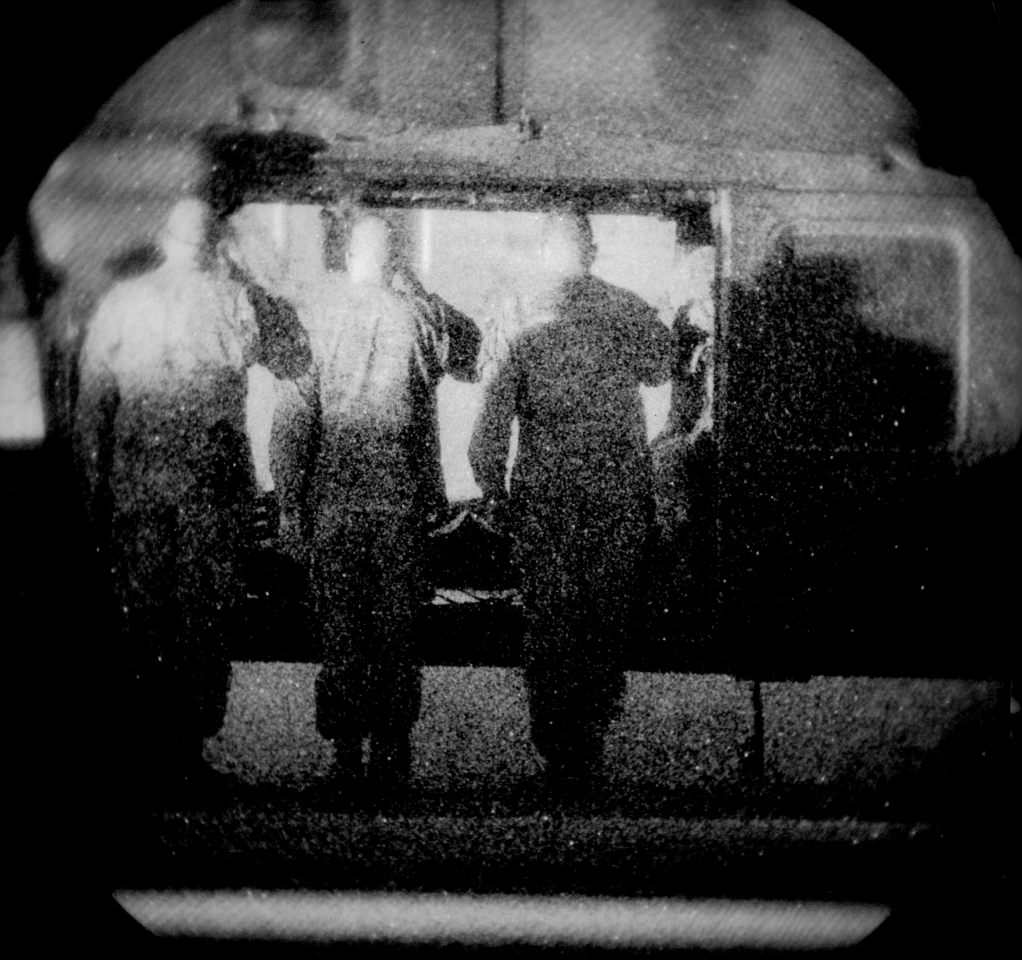

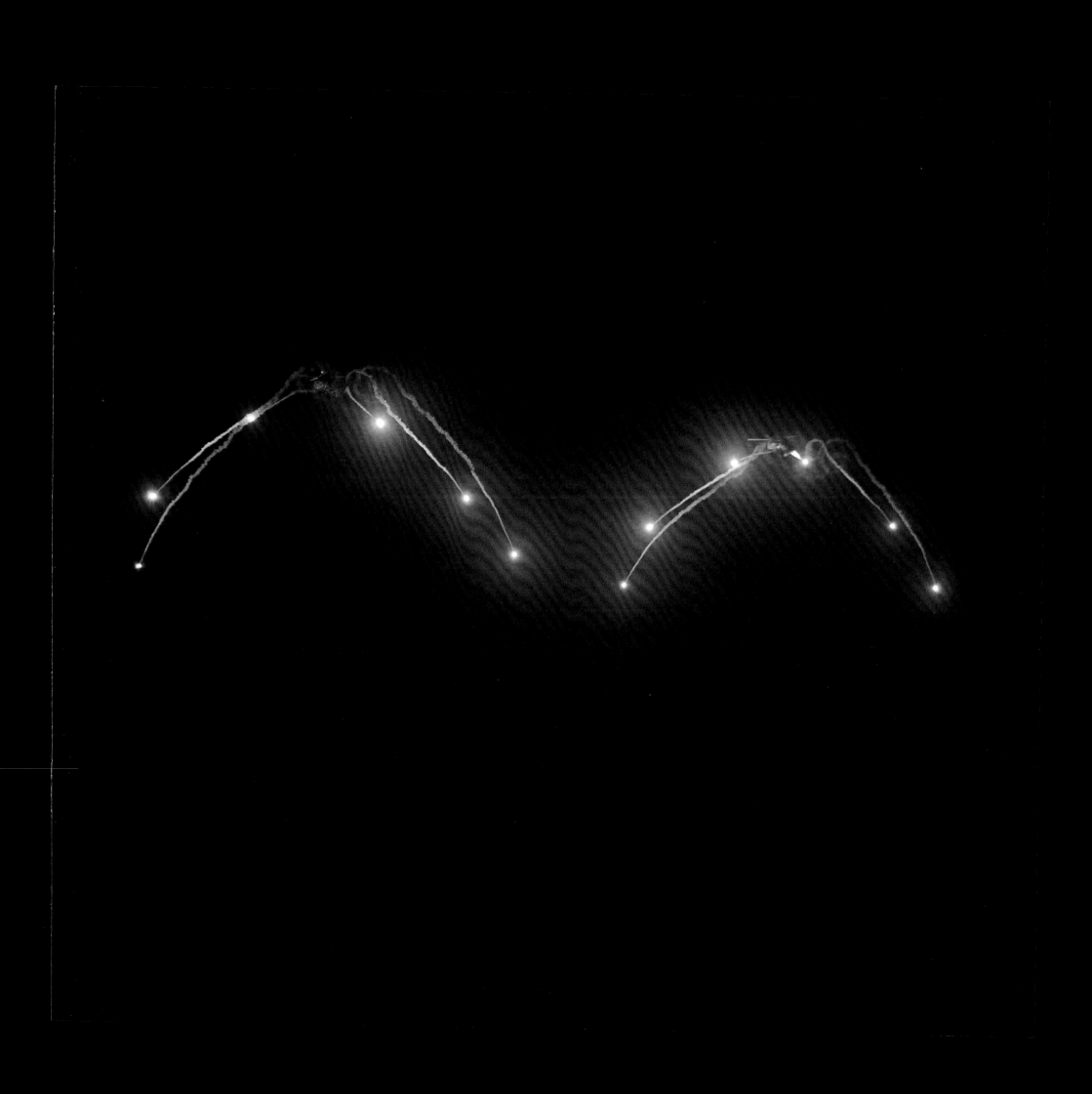

16

BACK IN THE WORLD

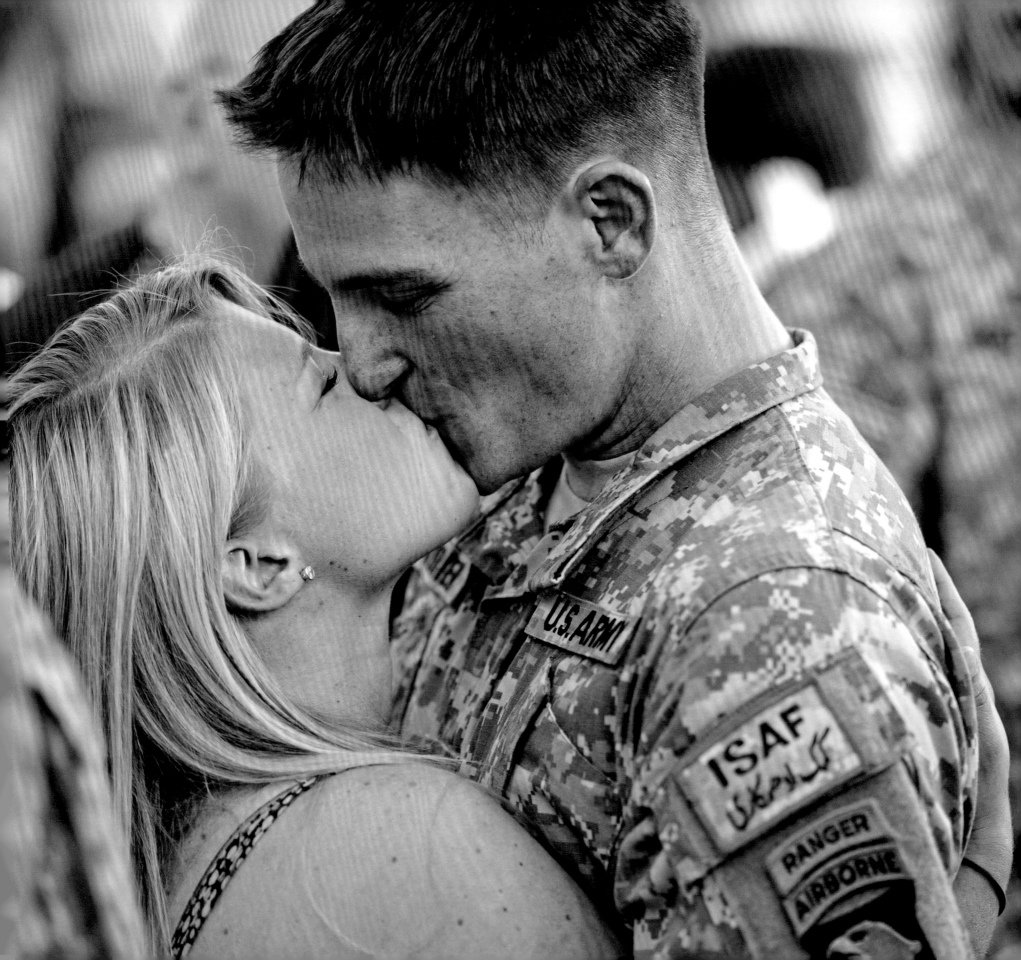

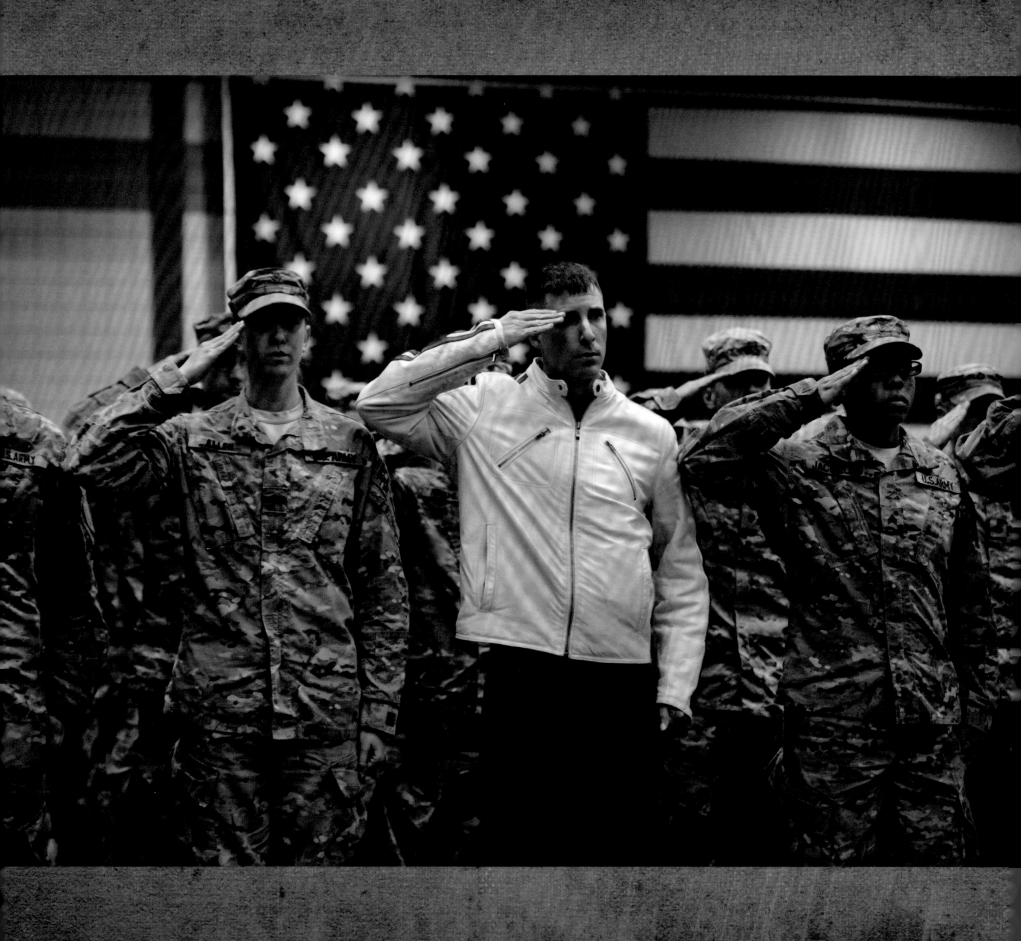

BACK IN THE WORLD

Somewhere in the States there's a hangar full of American soldiers standing in formation, waiting to be liberated. Their commander is making a speech, flags on guidons are being snapped, the Soldier's Creed is droning, and "The Star-Spangled Banner" echoes off the steel walls. Between those men and women and the loved ones who've longed for their return is an invisible barrier of military formality. It seems that if someone doesn't break it soon, there's going to be a riot. But these soldiers and their families have learned the art of waiting.

Then, at last, the reunions. Beneath the banners and the flashing cameras, soldiers clasp wives and husbands, parents envelop their heroes, children leap and weep, and the pristine floor is stained with tears and boot-crushed flower petals. There are two hundred soldiers and triple that in families, swarming and hugging and laughing. But it's not all celebration. There are those few who've come here only to look into the eyes of the men who were the last to see their loved ones alive. There's a pretty young widow wearing a T-shirt. It has a gold star on the back, and beneath that the name of her fallen husband. Printed below his name are the words "Deployed to Heaven."

There's unbridled joy, and there is unspoken fear. No one really knows how to do this. How to be at war and then not be. How will a combat veteran ever explain to his young wife that he adores the warm curl of her body in their bed, but he is unable to sleep without hearing the familiar snores of his best friend? How will that girl in the dust-encrusted uniform tell her boyfriend that she has no greater love than that for her comrades, a love that cannot be replaced? She can't say it, and she won't.

There are a thousand new battles to face here at home. There will be bills to pay, new children to meet, doctor's visits, and endless lectures on domestic bliss and post-traumatic stress disorder. It's no longer life or death. This is the way it should be.

Maybe the war was the easy part.

The waiting game is horrible. You have been away from your family for over a year. They showed up at the base before you were even in US airspace. And now, as you deplane, you get your first glimpse of your family. They made signs. They shout your name. You smile, but you march on by. You line up in formation. There are some last-minute details to handle.

Welcome Home
Benjamin Waldron
YOUR COUNTRY THANKS YOU!

WELCOME HOME!

Your superior officer stands in front of the formation. He calls you to attention. You hear him report that you are all present and accounted for. This hurts, as some of you didn't come home. Some of your teammates came home early because of injuries. Then it's on to the army song and your unit song. The whole time you are thinking of your family.

In moments, mere moments, you will embrace them for the first time in months.

"Ten-hut! Fall out!" And with those words, pandemonium. Embraces, kisses, tears. After a few short moments, you hear "Form up!" Now, as hard as it is going to be, you have to form up again and go finalize some paperwork and equipment returns. Then, mercifully, you are at liberty to stay with your family for some brief days before you report back in.

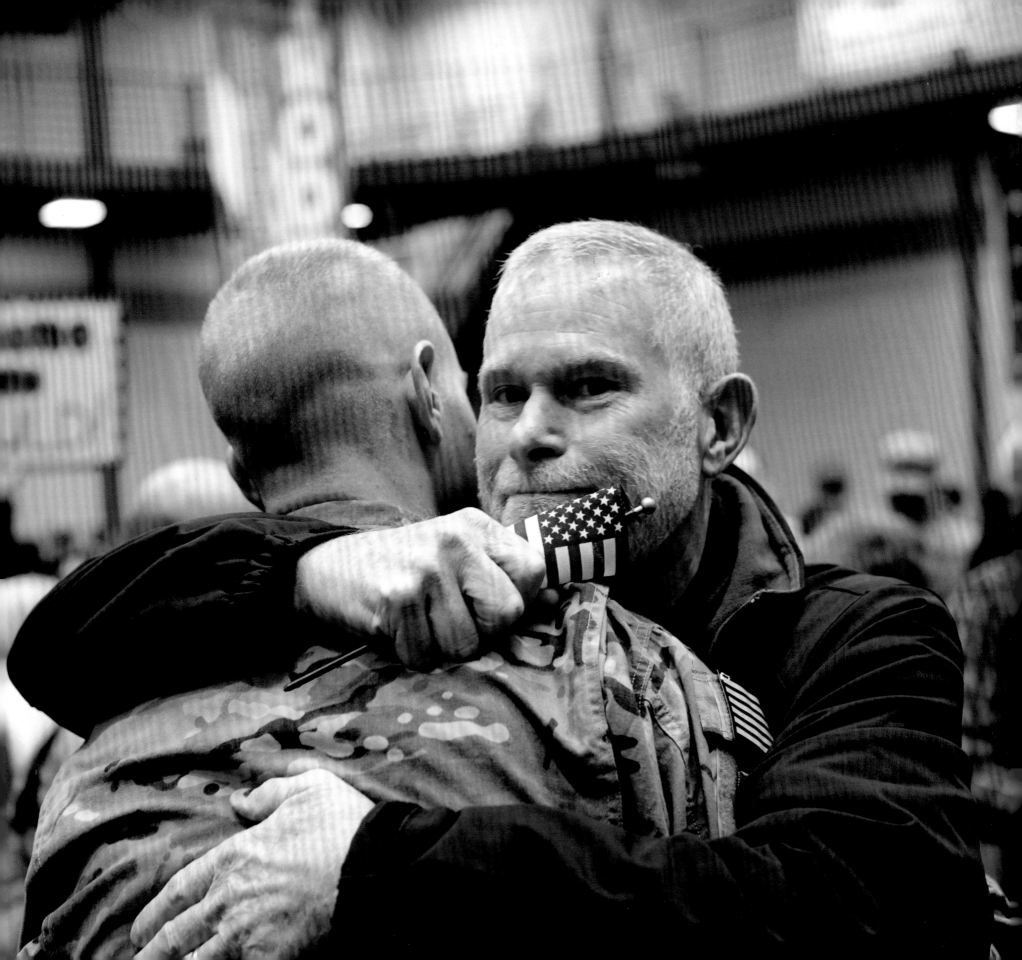

TAKE A MOMENT TO THANK A SERVICEMEMBER

17

AUTHOR'S REFLECTIONS

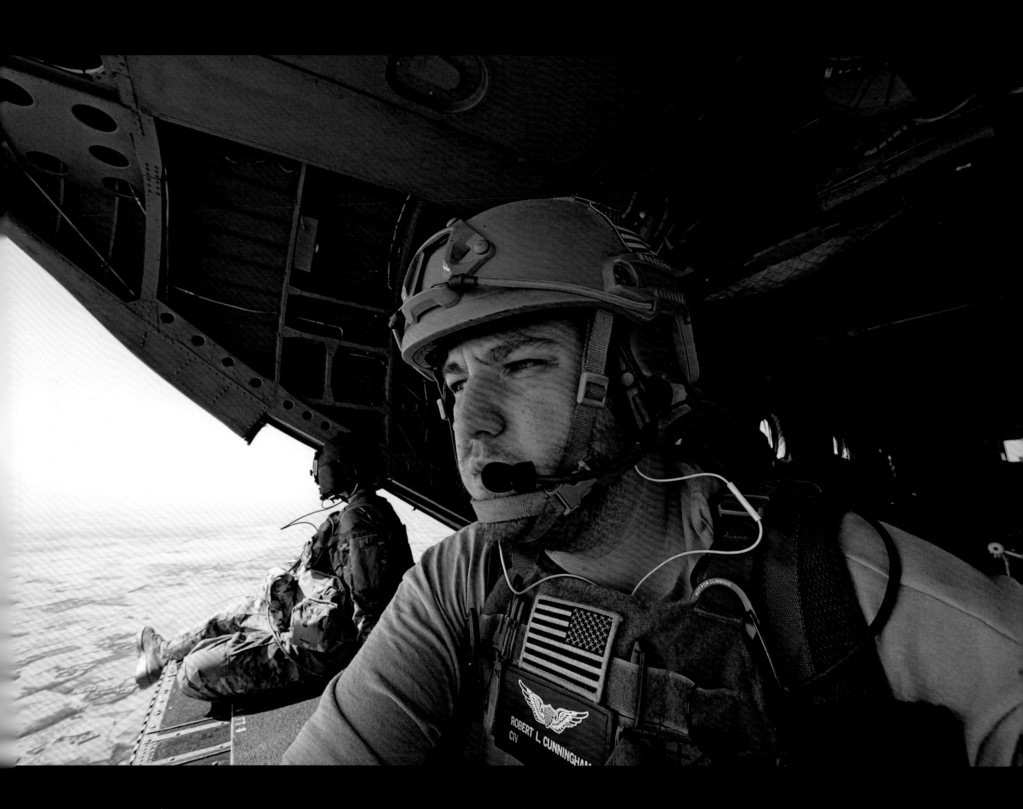

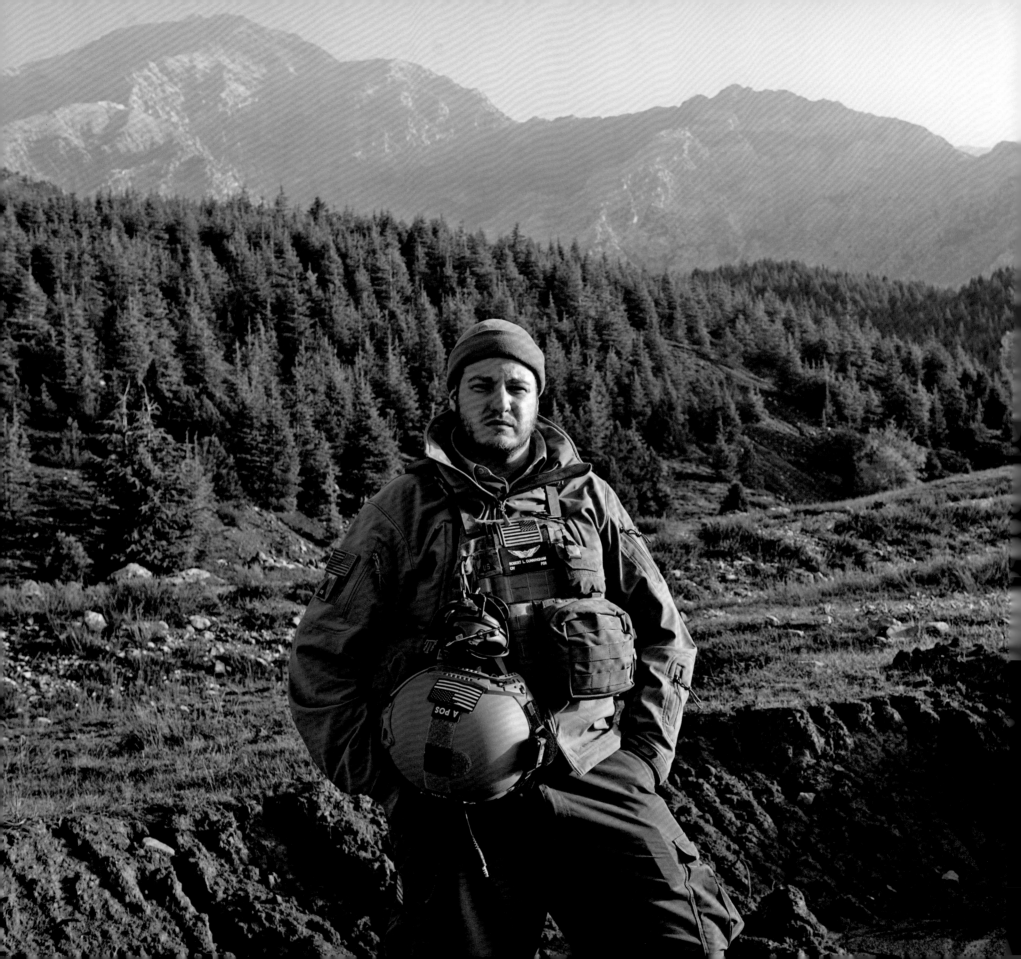

AUTHOR'S REFLECTIONS

My Grandpa Harry used to say that everyone has their New York. It's a place you dream about, a goal to reach, the pinnacle of your aspirations. There are many ways to get there, by ship, airplane, or train. But what you'll discover is that it's the journey that is most valuable, how you overcome hardships, while always keeping your eye on the prize.

My New York has always been the desire to wake up every day knowing that what I was doing was helping my country. For me, the ultimate way to reach that goal would have been joining the military, but because of my fibromyalgia, that path was blocked. At first, I felt an embittered reject. I was frustrated by my family's long history of service, while I was denied the privilege, and by watching my peers go off to war, while I wallowed in the freedoms they assured me. There had to be a way to honor those Americans who would don a uniform and be prepared to set aside their own aspirations in defense of a way of life that is, bar none, the most blessed on this earth.

My cameras. The lightning bolt struck me one day when, ironically, I was aboard a ferry en route to the Statue of Liberty, where I encountered combat photographer Josh Williams. He suggested that if I couldn't enter the fight myself, I could document it and memorialize the heroic deeds of this Great Generation of Americans. Yes, that was it. I had a good eye and no lack of reckless courage.

Josh explained what it meant to be an "embed," a photographer accompanying combat troops at war, and the complex yet achievable process involved. But it was my friend Jason Kostal, a former army officer, who told me that I *should* do it, that it was the thing I was destined for.

Less than a year later I found myself in a hotel room in Dubai, staring at a magnificently opulent skyline that I knew might be my last vision of a civilized world. Strewn around the floor were my camera bags, digital recorders, notebooks, boots, combat clothing, first aid kit, and sixty pounds of body armor. At dawn, I would be boarding a flight for Bagram Airfield, Afghanistan. There was no turning back. I knew I was feeling what every soldier in history had felt before his first leap into combat. I had too much equipment and not enough experience.

Visions of action and glory abound in the heads of young soldiers, and war photographers are no different. I was filled with excitement and anticipation as I moved from one base to another aboard roaring machines filled with gunfighters. Landing long past midnight at a forward operating base called Salerno, and exhausted from seventy-two hours of nonstop travel, I was happy to be roused from a short nap and asked to photograph a Hero Ramp ceremony. I had no idea what that meant until the flag-draped body of Staff Sergeant Kirk Owen, Oklahoma National Guard, arrived with a funeral cortege for the first leg of his final journey home. It was my first assignment and a sobering baptism.

I never had illusions about the nature of warfare, but the death of Kirk Owen was a watershed moment. It set the tone, and I knew from then on that every photograph I took of an American in uniform might be his or her last. With one shot of my camera I would preserve forever what one shot of a bullet might take away. My mission and goal became to record them and their heroism, their sense of duty and modesty in sacrifice, for themselves, their families, and, if fate deemed it, for eternity. I had always planned to engrave those images and stories in a book, but I had no idea that after one trip to Afghanistan, and then another, there would be enough to fill an entire library. I would have to choose carefully from more than 35,000 photographs, videos, and audio notes.

But my first battle was getting the images. The average soldier endures a traditional process of acceptance by his unit and comrades based upon his performance in training and his combat prowess. Once that's done, he's a trusted member of his martial tribe. An embed, however, may work with a multitude of units, moving quickly from one area of operations to another, as I did. All in all, I was embedded with more than forty different units. Each time I arrived, the process of gaining acceptance and proving myself and, more important, proving that I wouldn't be putting their lives at further risk, began anew. Most soldiers regard the press with a jaundiced eye. Quite frankly, I do too. Sometimes it was hard to wear that badge. But in the end, I would like to think that I comported myself well at war and that no soldier was ever sorry that I was there.

Afghanistan gave me a gift that I could never have gotten at home: walking foreign fields in distant lands, touching hands with a culture completely different from my own, enduring the same hardships as the brave souls who were my hosts, and treasuring every breath as if it might be my last. Afghanistan is always with me now. The images like those on pages 68 and 69 of a gunfight that took place in Khost Province, one of many I experienced, not only exist as digital bytes but are forever etched in my mind. Those firefights return unsummoned, along with the sounds and smells no photograph can capture—gun smoke, sweat, mortars crumping, urgent radio calls, and the stench of cow dung in a canal where I once took cover. The images on pages 96 and 97 capture just a few of the beautiful, curious children who only wanted to hold my hand and were thrilled with the simple gift of a ball-point pen. Page 143 shows a pair of Black Hawk helicopters carrying two fallen soldiers from the site of their last battle and firing flares in salute. I'll forever see that glow against the curtain of a night sky.

For those intangible gifts I carried home from Afghanistan, I owe my thanks to hundreds of heroes, too many to name, whom I walked beside, spent guard duty with, lay with in a ditch during a firefight. All those people touched my life, their hands molding me like a clay vessel, and I owe them a debt for maturing me. I will always cherish the words of one soldier who, after a long night together on watch at a firebase, said, "Thank you. You make us feel important." I never expected these great privileges, and I hope that with this book and books to come I can in some way repay my debt to those soldiers I walked with.

With Utmost Respect,

Robert L. Cunningham
Omnia Audax
July 4, 2013, Phoenix, Arizona

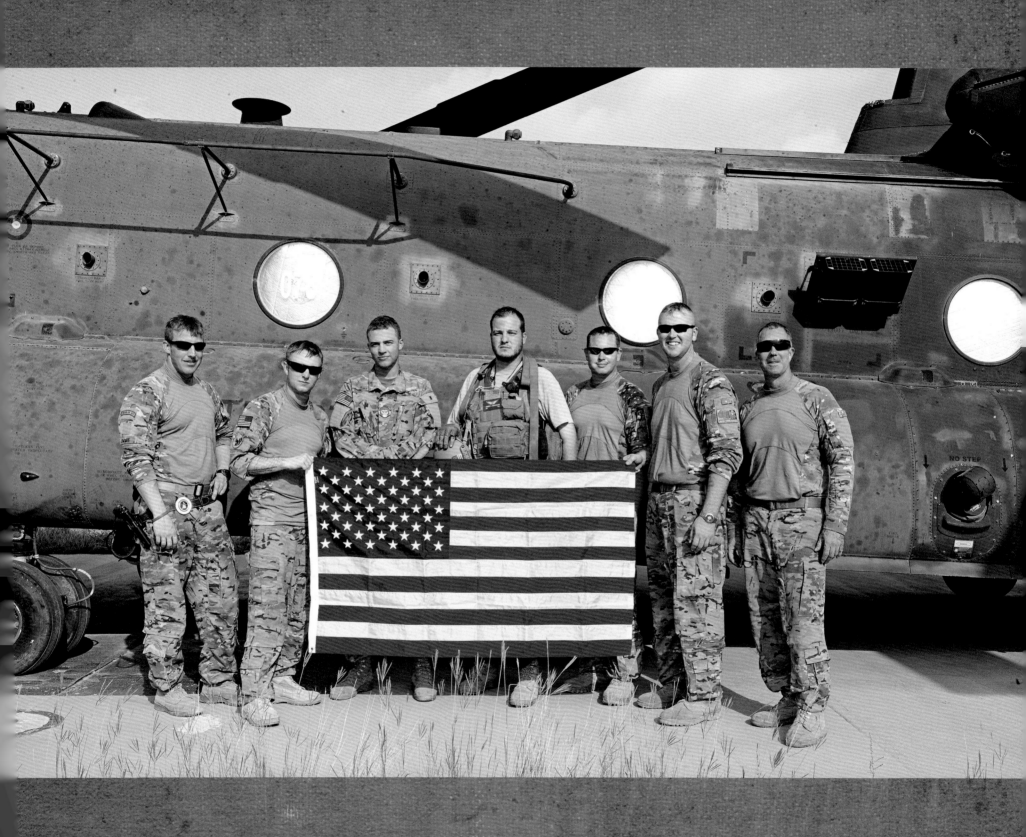

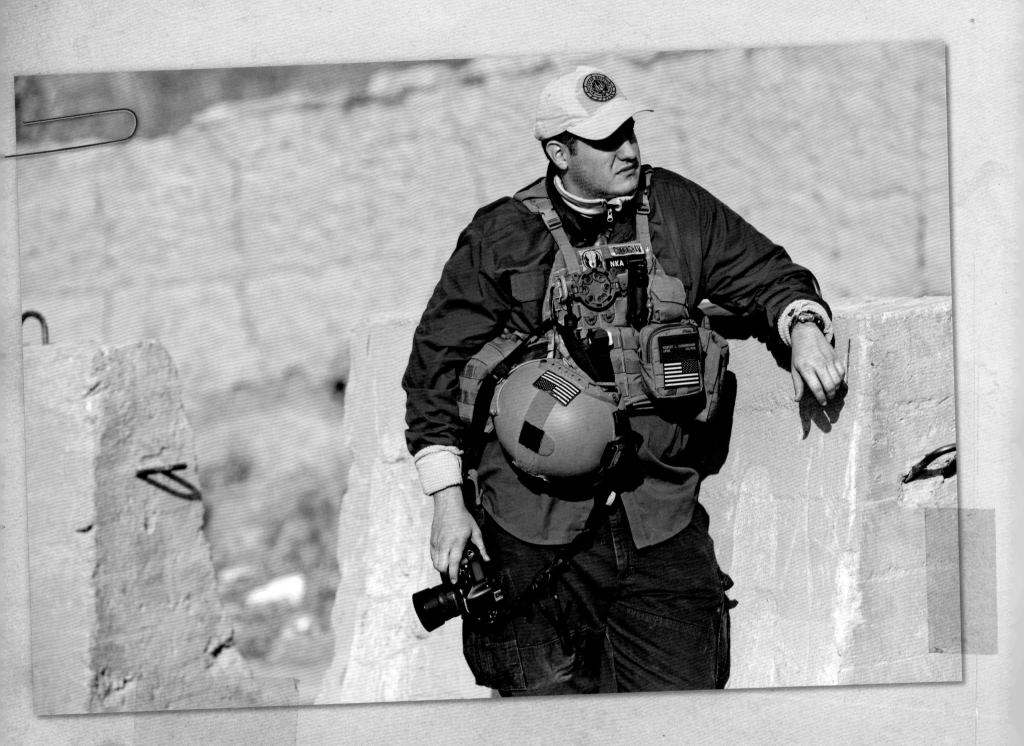

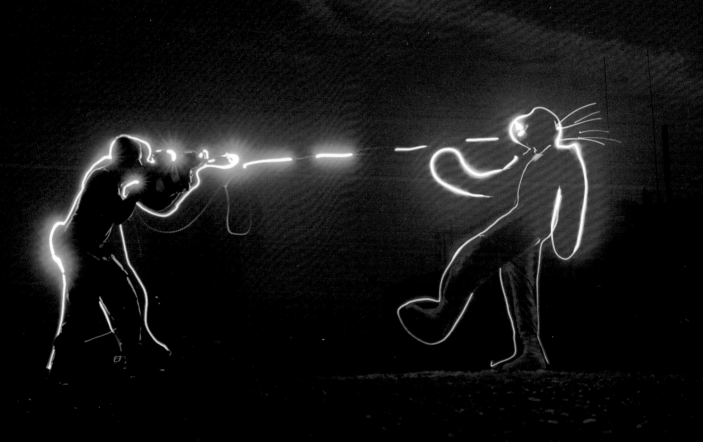

ACKNOWLEDGMENTS

This book is dedicated to the memory of Major General Donald L. Owens and Nancy Jean Bradford Robertson for all the years of friendship, guidance, mentoring, and endless support.

And to Chris Rataczak, Kirk Owen, Raymond Border, Jorge Olivera, Christopher Gaily, Sarina Butcher, T. J. Lobraico, Michael H. Ollis, and the crew and passengers of BIG WINDY 25, BOUNTY HUNTER 11, COLOSSAL 31, EXTORTION 17, RAZOR 01, TURBINE 33, and aircraft tail numbers 185, 472, and 747. All of these fine men and women fell from injuries sustained in Afghanistan, some visible, some not. May you all find peace in heaven, as you have already seen hell.

The author would also like to thank Jesi L. Cunningham, my support, my refuge, my proofreader and editor, Lux Mea Mundi; the fine soldiers, sailors, airmen, Marines, and Coast Guardsmen of Regional Commands East, South, West, and Capital, as well as the fine men and women of Task Forces Attack, Blackhawk, CJSOTF, Creek, Duke, Maverick, Tigershark, and AFCENT; the staff of Insight Editions for helping my vision to become reality—their expertise was unparalleled, their vision and imagination boundless, and their help sine qua non—Al Zuckerman, Writers House, and Steven Hartov.

The publication of this book was made possible by the generous support of Pamela Jose, Kurt Cunningham, Andrea and Nathan Crane, Daniel and Courtney Cunningham, Dan and Carla Enriquez, Dr. S. Harry and Linda Robertson, David and Andrea Robertson, James and Dana Craddock, Jason and Tanya Hayes, Jason T. Kostal, Meghan A. Lyons, William R. Mank, the McCredies, the McRandles, the Partridges, the Warfs, the Watts, Lia Yang, the COP Herrera Camera Club, Brady's Fireside Musical and Comedy Show in Narizah, and Floyd's BBQ and Coffee Shop in Jaji, Afghanistan.

The photography in this book was shot on Nikon cameras acquired at Tempe Camera, in Tempe, Arizona. The author and staff were fueled by coffee from The Coffee Rush in Gilbert and Chandler, Arizona.